The
BIRTH *of a*
CENTURY

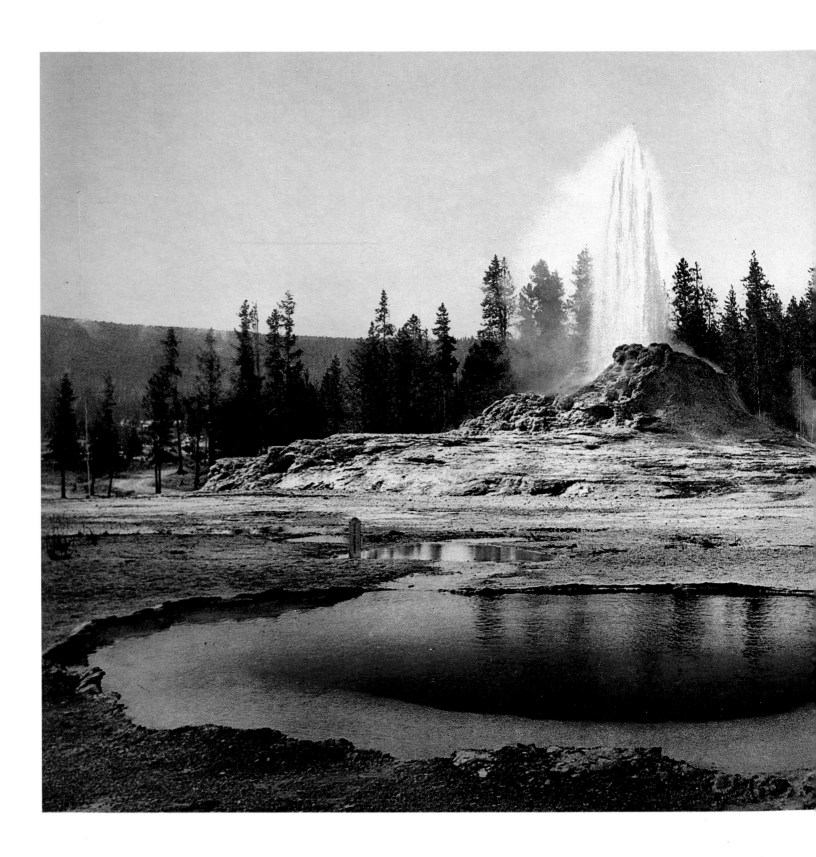

The —
BIRTH *of a*
CENTURY

EARLY COLOR
PHOTOGRAPHS
OF AMERICA

TEXT BY
JIM HUGHES

PHOTOGRAPHS BY
WILLIAM HENRY JACKSON
AND THE DETROIT PHOTOGRAPHIC COMPANY

TAURIS PARKE BOOKS
LONDON AND NEW YORK

FRONTISPIECE
Castle Geyser in eruption, Yellowstone National Park, Wyoming.

JACKET FRONT
*The circular bridge lookout on the Mt. Lowe Railway, offering adventurous
tourists a magnificent vista west over what is now greater Los Angeles.*

JACKET BACK
An unnamed Ojibwa brave, identified simply as an arrowmaker.

Project conceived by Luigi de Angioy in Santa Fe, New Mexico
Originals photographed by Francesco Venturi
Editorial direction by Judy Spours

Published in 1994 by Tauris Parke Books
45 Bloomsbury Square, London WC1A 2HY
in association with KEA Publishing Services Ltd, London

In the United States of America and Canada
distributed by St. Martin's Press, 175 Fifth Avenue, New York, NY 10010

Exact attribution of the authorship of all the Photochrom images published
in this book has not been possible. See also *Acknowledgements*, p.223.

The Cataloguing in Publication Data for this book is available from the British Library.

ISBN 1-85043-646-0

Design and Typesetting by Karen Stafford, DQP, London
Color separation by Amilcare Pizzi S.p.A., Milan, Italy
Printed by Amilcare Pizzi S.p.A., Milan, Italy

Contents

Introduction
The Final Frontier

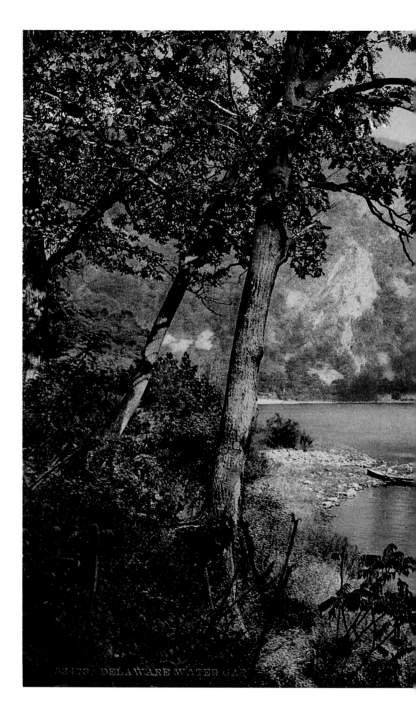

Recreational boaters navigate the Delaware Water Gap, near Stroudsburg, Pennsylvania, and the Kittatinny Mountains.

T hey found me,' Greg Franzwa is saying from Santa Fe, New Mexico about the remarkable colored photographs reproduced in this book. 'It was one of the great adventures of my life.'

Franzwa, president of Patrice Press, publisher of books about the American west, was attending a meeting of the Oregon Trails Association in Oregon City several years ago. While talking with one of his authors, the historian Aubrey Haines, Franzwa learned of the existence of a cache of what were termed W. H. Jackson 'chromolithographs.' Of course, Franzwa knew of the legendary Jackson, the pioneer photographer who explored the advancing frontiers of the old west with huge wet-plate cameras and a portable darktent strapped to the back of his trusty mule 'Hypo.' Like most Americans of his generation, Franzwa had seen many of Jackson's famous photographs, such as the 'Mountain of the Holy Cross,' made in 1873, or Jackson's influential documentation, made in 1871-2 during the Hayden expedition, of the indescribable hotspring cauldrons and spouting geysers of Yellowstone that helped persuade the United States Congress to establish the area as the country's first National Park – thereby opening the wilderness to an onslaught of tourism that continues to this day.

These photographs were all in black and white, as they would have had to be, given the photographic technology of the nineteenth century. But Haines, who had seen some examples from the intriguing archive, was talking about color. As Franzwa remembers it, Haines said he had a friend named Isabelle Haynes (no relation) who had for many years been trying to sell a large collection of photographs, the greater part of which was the Jackson color. Originally she had wanted $500,000, but now, according to Franzwa, all she wanted to do was find a good home for them. Otherwise, the whole lot might have to be hauled away for trash: the warehouse in which they had been stored for years was about to be sold and closed.

Franzwa remembers Haines telling him, 'I think she'll just give them to you.'

'Have her mail them,' Franzwa responded.

'I don't think that's possible,' Haines said. 'The collection weighs 8,000 pounds.'

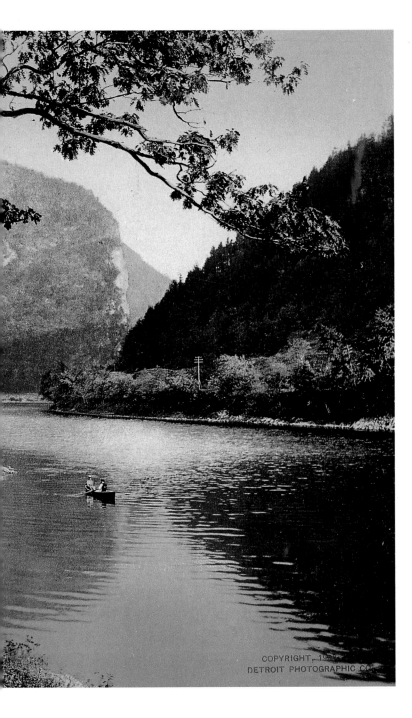

COPYRIGHT, 1901
DETROIT PHOTOGRAPHIC CO.

Although Franzwa was not a collector, he knew a bargain when he saw one. He contacted Isabelle and discovered she was the widow of J. E. 'Jack' Haynes, who was the son of Frank Jay Haynes. Both men, first the father, then the son, had been official photographers of Yellowstone, together covering a span of over fifty years that began in 1884. Although there is no clear indication of when or how Jack Haynes came into possession of the collection, many of the surviving prints were wrapped in early 1930s newspapers from St. Paul, Minnesota. The conjecture now is that at a bankruptcy proceeding Jack bought the entire package because it contained a number of Thomas Moran paintings and drawings, which Haynes then sold off over the years through his Yellowstone concession. The remaining works he simply stored in a warehouse, evidently over time adding some of his own and his father's Yellowstone prints. The whole lot passed to his wife at his death. She told Franzwa that the collection occupied approximately 160 cubic feet, not counting containers. He visualized a compact cube.

Franzwa's publishing offices were in St. Louis at the time, and he asked a trucker who worked for his printer to make a sidetrip from his normal route to pick up the collection. From the information provided, the trucker thought it would be a comparatively small load that he could fit in with his normal pickups, and offered to do the job for $500. He ended up 500 tortuous miles out of his way, and must have gone into shock upon coming face to face with his 'small load.'

'He arrived in St. Louis in a snowstorm,' Franzwa recalls. 'I had some tenants, and I enlisted all their help to unload. There was a full row of heavy oak file cabinets filled with pictures, plus at least another forty file-cabinet sized wooden crates, all with dovetailed joints and twenty-seven inches deep. The truck was *filled* to the roof, from the rear door forward to the back of the cab.

'No inventory ever surfaced. It cost me $10,000 at $2 an hour to hire a high school kid to do one. He found some 500,000 images, ranging from 20 x 24 mammoth plates to neatly packaged and dry-mounted Haynes prints from Yellowstone to color photo-postcards from the Detroit Publishing Company.'

The Haynes prints alone later sold for $140,000, but it was the Detroit Company work that proved to be the historically significant gem of the collection. One of the first packages opened that snowy day in St. Louis contained eighty copies of a full-color, 17 x 21.5 inch print titled, in gold legend across the lower left, 'Ruby Castles, Canyon of the Grand, Utah.' Although it bore a 1900 copyright from the Detroit Photographic Company, 'from the appearance of the railroad train in the picture, the photo was evidently taken as much as twenty-five years earlier,' according to Franzwa. 'And the detail was extraordinarily fine and crisp. It seemed possible the negative had been the same size. Then and there I made up my mind to search out the details of Jackson's process.'

According to an early advertising claim of the Detroit Publishing Company, the Photochrom process '...of color photography is the only successful means yet known of producing directly a photograph in the colors of nature. The results combine the truthfulness of a photograph with the color and richness of an oil painting or the delicate tinting of the most exquisite water color.'

The Detroit Photographic Company name, as the Detroit Publishing Company was originally known, first appeared in city registers of Detroit, Michigan around 1888. Managed by a bookseller and stationer named Kilroy, the small company's specialty was religious material, its income apparently supplemented by supplying photographs for local publishers and for educational lantern slides. There is some dispute whether this company is the same Detroit Photographic Company that surfaced a decade later, under the direction of William A. Livingstone, whose father was a man of local prominence and considerable wealth. In addition to having large holdings in shipping and newspaper publishing, the elder Livingstone was president of a large Detroit Bank.

In 1896, at the urging of a new acquaintance, the photographer Edwin H. Husher, who had recently relocated his photographic business to Detroit from California, William Livingstone began investigating a little known and apparently unique photo-reproduction process whose results had astonished Husher when he had happened to see some examples. Developed in 1890 in Switzerland by the graphic arts publishing house Art Institute Orell Fussli, the Photochrom process, later also known as Aäc, was actually a cross between stone lithography and traditional photography, allowing multiple reproductions of photographic prints without the use of so-called halftone screens that break images into discrete patterns of dots or lines.

Color photography as we now know it, with dye-coupler emulsions for life-like transparencies and color negative film for drugstore prints, were decades away from invention. Early attempts at color photography required three separate exposures for each primary color, then cumbersome projection through filters to 'combine' the plates into the illusion of a single image. A more contemporary method, the Autochrome process, developed in 1904 by the Lumière brothers of Lyon, France used potato starch grains dyed green, red and blue through which exposures were made onto a thin glass plate coated with a panchromatic emulsion. The *pointillistic* Autochromes, which did not become commercially practical until 1907, were popularized in art photography circles by Alfred Stieglitz and Edward Steichen and were anything but life-like.

Hand-colored or tinted black-and-white photographs had long been a staple of photographic studios, but these invariably lacked the verisimilitude that photographs taken directly from life, by their very definition, ought to have conveyed. Imagine the reaction of a business visionary like Livingstone upon learning not only that such pictures in 'living color' were already being made, but that the secret process might even be available for licensing. In 1897, Livingstone traveled to Zurich, where he negotiated an exclusive license for all of North America. Upon his return to the U.S., Livingstone established the Photochrom Company of Detroit under the aegis of the Detroit Photographic Company. Husher became a supervising partner of both companies. The Photochrom secret technology came to the U.S. in the form of Albert Schuler, who a decade earlier had been apprenticed to Orell Fussli. Accompanied by his young wife and four co-workers, Schuler arrived from Zurich to become foreman of the art department of the Detroit company, a post he would hold for the next twenty-five years as he further refined the original Swiss process until the American version became the standard for quality.

A Photochrom is not a color photograph. Nor is it a screened, halftone photolithograph, although there are similarities with the collotype process. A Photochrom is a continuous-tone color rendition of a black-and-white photograph that uses multiple impressions from lithographic stones. The stones used by Detroit were imported from Bavaria and coated with a special Syrian 'asphaltum' substance that would be chemically sensitized to light, put in contact with a photographic negative, exposed to the sun for up to several hours, then developed, as it were, in oils of turpentine. The areas of the very thin asphalt gel most exposed to light would harden, becoming insoluble; the less exposed residue would be washed away. Tonal values of the remaining positive image could be manipulated by varying the chemistry and development times. Technicians could do the equivalent of 'burning and dodging' by retouching with a brush and polishing with fine pumice powder. The final steps in preparing the stone were an acid etch to bond the remaining image with its very fine grain, and a glycerin bath.

A separate stone would be made for each color to be used. A minimum of four stones – for magenta (red), cyan (blue), yellow and black – and as many as fourteen stones, all kept in absolute register, might be used for a given image. A transparent ink would be applied to the stone, then transfered to high-quality paper whose texture resembled the smooth photographic printing paper of the day. Inks were individually mixed and applied by pressmen according to the color intensity required. Although it seems highly unlikely, one theory about the now lost process held that the colors were actually laid down upon black-and-white photographic prints – thus testifying to the high quality generally achieved. Indeed, Photochroms from the time stand up quite well to photographic color prints made today.

A hand-fed flatbed press could produce perhaps 200 impressions an hour. Stones would need to be re-ground and surfaced after no more than 5,000 impressions. As a result, substantial variations may

be noted between editions of the same image over the years. At the height of its success as a publisher of picture postcards, and the larger so-called 'views' suitable for framing that form the basis of this book, the Detroit company employed some forty artisans and a dozen or more traveling salesmen. In one fairly typical year in a not too distant future, the company would publish an estimated seven million prints.

In 1898, however, the Detroit company was a fledgling operation. The United States Congress had just authorized the One-Penny Postcard – with or without pictures. William Livingstone, an astute businessman, immediately saw the lucrative potential of the souvenir postcard illustrated with color photographs, a field in which he had the means to be a pioneer. Later that same year, at the urging of Husher, Livingstone invited the famous landscape photographer William Henry Jackson to join his Detroit company as a partner. Jackson had just returned from a financially disastrous photographic trip around the world to find that his own photographic publishing operation in Denver, Colorado had foundered in his absence.

Livingstone offered Jackson $30,000, $25,000 of which was in stock in the newly incorporated company, plus what Jackson later termed a comfortable salary. Jackson used the $5,000 cash to cover his most pressing debts, of which there were many. He then moved to Detroit, bringing with him, as agreed, an estimated 10,000 negatives which, when added to Husher's California work and Livingstone's own file of Great Lakes shipping photographs, would provide the core of the company's now wide-ranging photographic archive.

That the partnership would be a boon to all involved – and to the American public as well – is borne out by the following quote from the definitive book *Picture Postcards in the United States, 1893-1918* by George and Dorothy Miller:

One Publisher of American views surpassed all others in terms of technical proficiency and scope of issues. That firm, the Detroit Publishing Company, a part of the Detroit Photographic Company, covered the length and breadth of America shortly [before and] after the turn of the century and chronicled as no other publisher attempted the diversity of people, activity and industry found in the United States.

...The hustle of the large cities, the languor of small towns, farming and light industry, steel and other heavy manufacturing, harbors and shipping, the mansions of the wealthy and the tenements and ghettos of the poor, the varied social minorities: taken as a whole, a Detroit collection forms a rich and varied tapestry of what might well be termed 'The American Scene.'

*Looking down at the Old West mining town of Deadwood,
nestled among the Black Hills of South Dakota.*

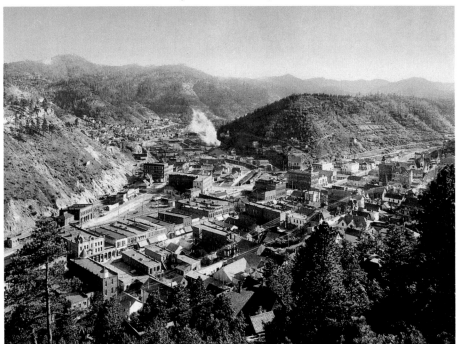

During the early years of World War II, a young Naval photographer stationed near New York City regularly visited his father, who was living in a midtown hotel. One day his father said he had a friend, an elderly photographer who was a fellow resident. Perhaps his son might like to meet him. The father said the man's name was Jackson, and he was 99 years old.

'William Henry Jackson, no doubt?' the incredulous son joked. 'That's his name, and he wants to meet you,' the father replied. So the young photographer, Bill Belknap, got to meet a living legend, a Civil War veteran and member of that small cadre of pioneer photographers who had documented the old west and the taming of the American wilderness. Indeed, Jackson's very life spanned virtually the entire history of photography to that time. What wonders he must have seen. What adventures he must have had.

Jackson had recently published his autobiography, *Time Exposure*, which young Belknap had read, and was working on a series of paintings of the old West based on those memories. Obviously, the old man was still vital: Belknap remembered Jackson's warm greeting and that his hand was firm and steady. The once robust Jackson was frail and wore glasses now, but his hearing was intact and he had the voice and bearing of a much younger man. He boasted of having marched down Riverside Drive in a Memorial Day parade in 1940, erect and unsupported, surrounded by Boy Scouts, while some younger comrades had to ride. One could easily imagine this wiry little man clambering up craggy cliffs to get his monumental pictures.

When asked whether he still photographed, Jackson pulled out a tiny vest-pocket 35mm camera, a folding Kodak Retina. 'I like this little camera,' he said. 'It seems like a miracle after all that cumbersome stuff I used to pack around with a horse – great big wooden cameras and wet plates and a developing tent.'

By then, he had also discovered Kodachrome. 'In the summer of 1939, for the first time in my life,' he had written in *Time Exposure*, 'I experimented with color film. All I need say is this: if I were at the beginning of my career, I should wish to do everything in color.' As the contents of this book testify, his eye for the color of life was well developed, even when the technology for recording it was not.

William Henry Jackson was born in 1843 in Keeseville, New York. Only four years earlier, in 1839, William Henry Fox Talbot was presenting to the public his 'Account of the Art of Photogenic Drawing' in England while, almost simultaneously, Louis Jaques Mandé Daguerre, following the earlier discoveries of Joseph Nicèphore Niépce, was showing the first successful daguerreotypes. 'From today, painting is dead!' proclaimed Paul Delaroche upon seeing an image not only taken directly from life in a relative instant, but preserved for perpetuity on a shiny, metallic surface.

When Jackson was but a year old, Fox Talbot published *Pencil of Nature*, the first book illustrated with photographs. By then, the daguerreotype was sweeping the world. In America, Oliver Wendell Holmes called it 'the mirror with a memory.' The flame was bright, but brief. Within a decade, the one-of-a-kind daguerreotype had been replaced by the more democratic glass negative, from which multiple paper copies could be made with comparative ease and economy.

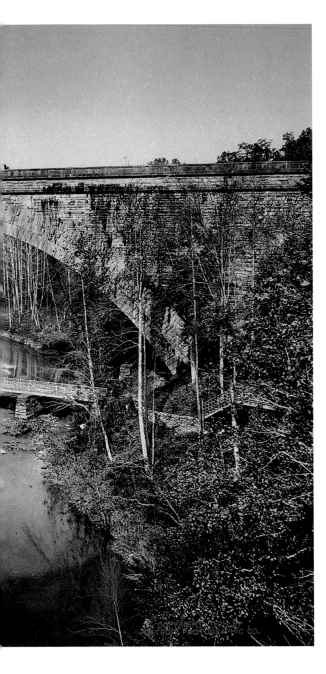

The Cabin John Bridge frames a quiet brook in a wooded glen near Washington, D.C.

Among the several peripatetic careers of Jackson's father was a failed stint as a daguerreotypist. Jackson remembered that, as a young boy, he played with various discarded parts of the camera apparatus his father once assembled. Jackson's mother, a cultured woman, provided the firm grounding of home and family, despite the father's entrepreneurial flights of fancy, which often took them far afield. The mother encouraged the son to learn drawing and painting, art being one of her favorite pastimes. When he was ten, she gave him a copy of the *American Drawing Book*, by J.G. Chapman. According to Jackson's most recent biographer, Peter B. Hales (*William Henry Jackson and the Transformation of the American Landscape*), 'For Jackson the *American Drawing Book* was... a set of instructions about how one might construct oneself and the world so that the two fit together well – it provided laws of composition and design that were in essence keys to the ways an entire civilization constructed and communicated its beliefs, its meanings.'

By the time he was thirteen, the young Jackson was beginning to make a little money by painting, doing mostly small commercial jobs, such as posters, a few portraits, occasional theatrical backdrops – and window screens, a common middle-class conceit in the nineteenth century. By having scenes painted directly on the screening, home-owners could announce their worldliness to their neighbors, and expand their own limited horizons in the process. As Jackson would note in *Time Exposure*, 'Here were....parlor windows parading the virtues of home life among the Romans... travels through the Black Forest... an idyllic honeymoon on Lake Lucerne... My usual fee was fifteen cents a screen.'

In 1858, Jackson was employed as a retoucher by a studio portrait photographer, C. C. Schoonmaker, of Troy, New York. The young man's fees, which varied according to the amount of work accomplished, added up to about $4 per week. Using a soft pencil or a fine-tipped brush dipped either in India ink or water colors, his job was to sharpen lines and edges and enhance details. Jackson never touched a camera at the Schoonmaker studio, nor at his next job, also as a retoucher for another portrait studio, this one operated in Rutland, Vermont by Frank Mowrey. In addition to full, half and quarter plate photographs, the Mowrey studio also produced Ambrotypes (glass negatives turned positive with black backing), tintypes (prints on sheet iron japanned black), and the ubiquitous *cartes-de-visite*. Jackson was now paid a princely $6 per week, and received a basic education in photography to boot.

'I was still not a photographer,' Jackson wrote. 'But while busy with my retouching I learned more and more about the camera and the art of processing plates and making prints. I also began to pick up a store of knowledge concerning the economics of photography, and with it some very practical hints on pleasing the customers.'

So-called whole plate portraits (6.5 x 8.5 inches) cost customers from $2.50 to $5 per contact print. But clearly, Jackson's interest in

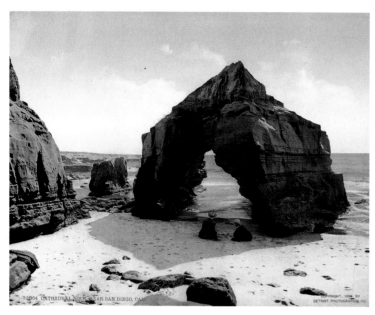

Two men peer through the arch of Cathedral Rock, a natural formation on the Pacific coast near San Diego, California.

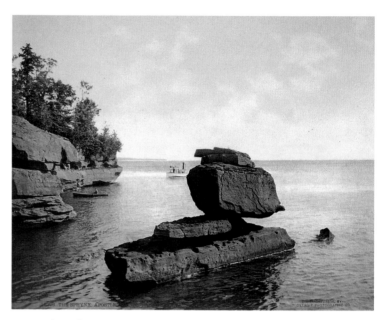

Another of nature's sculptural wonders, The Sphynx, in Wisconsin's Apostle Islands, Lake Superior.

color began early, as no doubt did his frustration at photography's inability still to record the full palette of human vision. 'With my assistance, for a small extra sum, the whole plates could now be had in full color,' he wrote. 'Many persons ordered them. When occasional customers demanded more exotic backgrounds than the portable columns and tasseled draperies of the studio, we had the means of transporting them to Niagara Falls, the pyramids of Egypt, or the ruins of Athens. I furnished the transportation.'

The mid-nineteenth-century photographer's studio was a hermetic world of romantic visions where the art of illusion smoothed reality's rough edges. For young William Henry Jackson, dreams were the stuff of photography.

Jackson's dream was interrupted by the harsh reality of the War Between the States. In 1862, at the age of nineteen, and along with the other members of a local social club, he enlisted in the Union army. He served for one year with no particular valor, since he participated in no battles – although he did get within earshot a few times. His idle time, which he seemed to have in abundance, was filled with drawing and painting. He took to sending home pencil sketches on 3 x 5 inch cards. 'That practice has brought me a small fame,' he would write many years later in *Time Exposure*, 'which is, I regret to say, quite undeserved. Somehow or other the legend has grown up that I am the 'inventor' of the picture postal card. I don't know who really devised the first picture postal...but I am not the man.'

'Among the boys,' he also noted, 'I was in pretty constant demand as a 'portrait artist.' While we were in the capital the tintype photographers had done a whacking good business...but down here in the woods there were no cameras. (I never saw the great Mathew Brady, or any of his assistants, while I was in the army.) Many of my companions-in-arms were lads whose beards were just beginning to be visible across a campfire, and they wanted to be sure that the straw-colored stubble on their chins would be recorded for the families.'

Jackson's army days were marked by endless drills and long marches through a countryside he found increasingly fascinating. To relieve the tedium and the anxiety over battles that never came, 'I sketched...more and more landscapes,' he wrote of the preoccupation that would one day lead to a lifetime calling in a newly parallel field. 'I [also] drew many pictures of our fortifications.'

At one point, his pictures came to the attention of the company commander, and he was actually put to work to make, 'as much as anything, a record of camp life,' according to Jackson. '...I roamed at will.' In addition to his greatly increased – and officially sanctioned – sketching activities, he was also asked to make detailed maps of the surrounding country. The artwork he produced was certainly nothing out of the ordinary, but the experience, and the feelings of creative and individual freedom it doubtless engendered, would stay with Jackson and ultimately change the course of his life.

Upon mustering out of the service, Jackson returned to Rutland and the Mowrey studio, where his old job was waiting for him. But

instead of a flat $6 salary for his retouching and hand-tinting duties, he was allowed to charge per piece. In addition, for a nominal fee he rented out a large room in the same building that housed the studio. There he also painted portraits in oil, and provided occasional painting lessons to certain young ladies. He was now an independent contractor, '...substantially my own boss,' he wrote, and his take-home income virtually doubled.

An important new source of income for the studio turned out to be portrait photographs of national figures such as General Ulysses S. Grant and President Abraham Lincoln. 'We did a profitable business supplying hand-finished portraits of these two,' Jackson wrote. 'I doubt, though, whether both of them combined ever won more enthusiastic devotion than George A. Custer. Promoted a brigadier of cavalry at the age of twenty-three, just before Gettysburg, he rose to be a major general and never knew anything but brilliant success throughout the war.

'...Never was there a subject who offered more to a retoucher handy with colors. Even then this hero had long mustaches and his famous flowing golden hair. He scorned the blue service uniform and wore instead a green-gray suit of velveteen richly trimmed with gold braid. He likewise spurned a regulation headgear and chose a wide-brimmed cavalier hat. All those adornments still did not suffice: a long scarlet tie streamed invariably from his collar. General Custer was the artist's dream beyond compare.'

Jackson had learned another valuable lesson: at any given point in history, certain subjects have the capacity to tap into the public consciousness. By embellishing their images through his own vision and skills, thereby making them his in a sense, the entrepreneur-artist creates additional demand for his product, and even shares a bit in the celebrity.

The final phase in William Henry Jackson's early training in photography occurred in Burlington, Vermont where he moved after being offered a job at the Vermont Gallery of Art by the proprietor, F. Styles. (It is perhaps a telling comment on the formalities of the day that young Jackson worked at the gallery for more than a year without ever having learned Mr. Styles' first name.) This was, in every sense, a portrait factory. Wrote Jackson:

> ...The studio itself...was a single-story extension roofed entirely with glass; artificial lighting for portraiture was unknown, and a photographer without skylights would have been helpless. The furnishings consisted of a few elaborately fashioned chairs, several screens and back-drops, headclamps, cameras, and sundry photographic props. Walled off on one side were the finishing room and the dark room.'

> Styles, whose younger brother was chief 'operator,' employed six assistants, and we were occupied almost constantly.... In this present day [1940] of magnificent equipment

which makes every amateur a competent photographer (if there are any brains behind his eyes) it is hard for many people to comprehend the universal importance of the professional in the decades preceding the '90s. But remember that the Leica and even the simplest Kodak were still undreamed miracles. If you wanted a picture, you sat in a chair, put your head in a vise, watched the birdie, and laid your cash on the barrelhead. There wasn't any other way.

Jackson now earned $25 per week, and lived nearly rent free in a room above the gallery. He had a comfortable life, belonged to a literary society, developed an affinity for expensive clothes and rich restaurant food, learned after a fashion to play the flute, and was engaged to a beautiful young woman back in Rutland. One day, over something trivial long since forgotten, according to Jackson's own account, they had a falling out. Suddenly, the engagement was broken, and Jackson's world turned upside down.

At the age of twenty-three, ashamed, he said, to face his friends, he boarded a train for New York City and left his sad past behind. The romantic notion of a rejecting love causing renouncement and ultimate renewal is a common theme in literature, but less so in life. What seems more likely is that the relationship failed because Jackson wanted it to, providing him with a convenient reason to abandon a regimented life that constrained his freedom and stifled the innate creativity he felt welling up somewhere inside himself. The war had enabled the young man to see something of the world outside himself. He wanted more. What, he did not know.

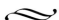

Thus began Jackson's first journey west and second rite of passage, this one grounded not in patriotic zeal but in dreams of wealth and adventure. In New York he happened to meet up with a comrade from the Civil War who planned to make his way to Montana, where the riches of silver were said to await those industrious enough to heed its call. The idea appealed to Jackson, and the pair at first tried to have their ways paid by one of the mining companies with offices in the east who were said to be recruiting young men. When no such berths materialized, they joined forces with a third acquaintance, pooling what little funds they had, much of it Jackson's from pawning a gold watch after losing his cash to a pickpocket, and headed west by rail. They ended up in Detroit, stranded and out of money.

Still dressed in his eastern finery, stovepipe hat and all, Jackson sold the clothes off his back and, with the help of odd jobs along the way, managed to get to Chicago and finally to the frontier town of St. Joseph, Missouri. Just outside town, a violent thunderstorm struck. 'Noses pressed against the water-smoothed panes,' Jackson

wrote, 'we had our first sight of the prairies that stretched to the edge of the lightning-streaked sky. The storm ended as the train pulled in, and in the dim morning light we stepped out into a city of mud. This was the gate that opened upon the West. This was the shining frontier. This was St. Joe.

'...We were still clinging to the original notion of striking into the Montana mining country; but by this time we were ready to take any job in any direction – so long as that direction was west.'

In St. Joseph, the three 'soft-skinned, white-handed dandies from the city,' in Jackson's words, each paid a $1.50 fee for the privilege of working as a teamster on a wagon train scheduled to depart the next week for, as providence would have it, Montana, a 1,300 mile trek by way of Nebraska and Wyoming. Since the rails had yet to be laid to carry them any further toward their destination, they journeyed by steamboat up the Missouri River to the staging point, Nebraska City. There, all three were finally hired on as bullwhackers, and issued $40 worth of supplies from the company store which at trip's end would be charged against their earnings of $20 per month.

The three eastern boys were ill prepared for the grueling work of rounding up and driving teams of a dozen or more oxen needed to pull each of the twenty-five wagons lurching their way along a rutted trail, at a pace of fifteen miles a day, across the prairie and into the mountains beyond. As Jackson wrote in *Time Exposure*:

> Bullwhacking is not an art to be learned in a week or a month, and the animals knew our deficiencies even better than we did those first days. Only the voice of a master can make twelve bulls gee or haw with a single word. Only a cunning hand can make an 18 foot whip crack out like a rifle shot – or cut a notch in a lagging bull's hind quarter.
>
> ...A hot dry wind blew continuously, choking us with dust and burning our faces and lips with powdered alkali...and by the end of the second day every new man had a cracked and bleeding mouth. Then there was the hazard of the whips...a green driver can easily chop a piece out of his own person!
>
> All in all, the first two weeks of this 'adventure' on the plains was the severest physical hardship I have ever known, and every day I cursed the folly that had prompted me to throw up my well-shaped career in Vermont. There I had worked at most ten hours a day, doing something I enjoyed, at the princely salary of $25 a week. Here, stinking and sweating, I choked through fifteen, sixteen, seventeen hours a day at a task that maddened me – and they were going to pay me $20 a month!

Ultimately, his body hardened and his senses began to take in the magnificence of what he finally came to call 'that glorious atmosphere.' In what little spare time he had, Jackson again began making sketches and an occasional water color of the strange landscape that was ever-so-slowly revealing itself to him.

We were now in a new and exciting country. The rolling plains and rounded ridges had given way to high bluffs and sharply chiseled buttes. The yellows were turning into reds and saffrons, while the blues were becoming deep purples. And the air was so clear that the highlands to the west seemed almost within grasp. What deception!

At South Pass, Wyoming, some three months into the arduous trip and as winter began to slide down into the mountain valleys, Jackson decided to abandon his quest for silver and strike out for the fabled California city of San Francisco. He left the wagon train outside of Salt Lake City, but in so doing managed to forfeit his entire earnings. Once in Salt Lake, his feet frozen and his body worn, he found more civilized work with a friendly Mormon farmer. And with the receipt of some requested money from home, Jackson was able to stay on for a while after his short-term duties were finished. His artwork benefitted. As noted by his biographer, Peter B. Hales:

> Over the next days, he made a number of drawings of...mountains. Taken as a group, they differ markedly from both the quick sketches and the conventionalized drawings Jackson made during the journey itself; they are attempts to understand the intersection, the interaction, between human and natural spheres.....The resulting pictures have lost some of that hard-staring accuracy in their rendering of mountains and range – the environment looks a bit more picturesque, a bit more like 'scenery' – but the more important change lies in the sense we get of a symbiotic relation between man and nature....

Two days before Christmas, 1866, Jackson joined another wagon train – this time as a paying passenger in a berth of soft hay. His destination: Los Angeles, California. As he wrote in *Time Exposure*:

> One of the things I had been looking forward to on this trip was sketching. While crossing the plains I had seized every opportunity; but most of those drawings were done hurriedly, in the form of notes, really, and had to be completed during my stay at the [Mormon] farm. Now I could arrange to keep the 'models' before me and do more finished work on the spot. Accordingly, I started off on foot early on Christmas Eve, walked several miles, selected a pleasing view of Utah Lake and set to work. When the [wagon] train passed me, I kept right on, stopping only in mid afternoon when I calculated that a stiff hike would bring me up with the wagons about the time camp was

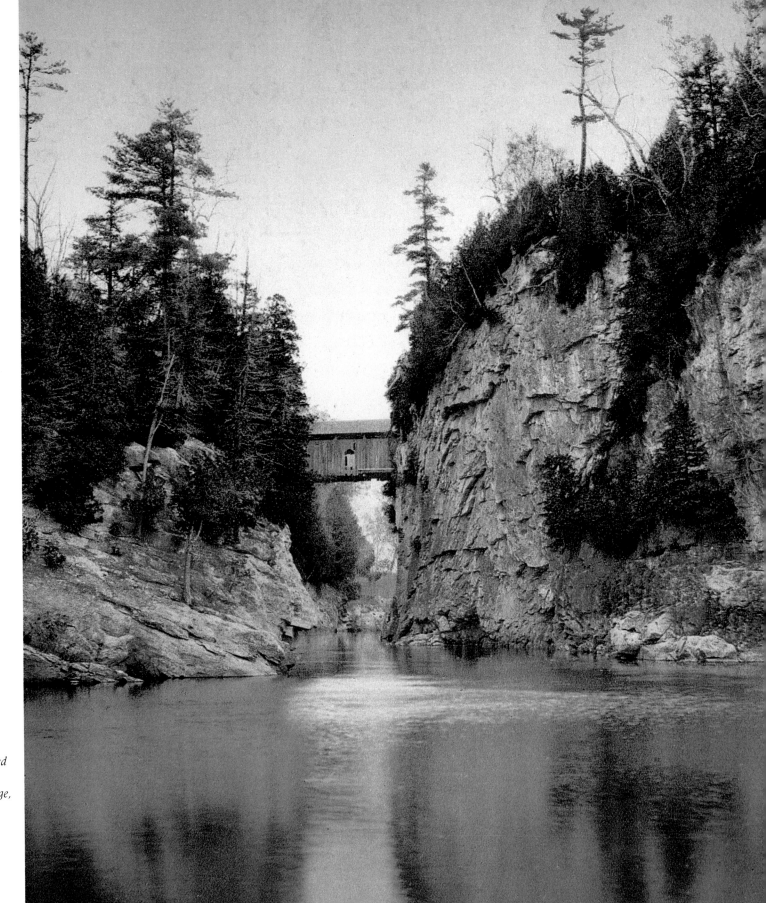

An old covered bridge over Winooski Gorge, Burlington, Vermont.

View from inside the Cliff Palace ruins, Mesa Verde, Colorado.

being made. This system worked so well that I followed it almost every fair day thereafter, and by the time we reached Los Angeles at the end of January, I had a sizable portfolio to record my trip down through Utah, across the north-western tip of Arizona, the lower end of Nevada, and Southern California.

There seems little doubt that whatever the original motivation for Jackson's westward journey, the lasting result could only be art. He sketched and painted when and where he could in an increasing need to describe what he saw and felt. Otherwise, his existence was peripatetic at best; at each destination reached, the bounty he sought eluded him and he would find himself moving on, energized and impoverished by the continuing adventure. In California, he worked at more odd jobs in and around Los Angeles, making temporary friends and little money. He never got to San Francisco. In May, he hired on as a wrangler for a herd of 200 horses being driven to market in Omaha, Nebraska, some 2,000 miles back across the mountains to the east. The trip took three months and, at least

according to one of the several fictionalized accounts of his life that would be written many years later, he became widely known at the time as 'Mustang Jack.'

In August, having survived Indians and rustlers and the ever-present elements, Jackson's group arrived at Cheyenne Pass, Wyoming, loaded the horses into freight cars, and let the railroad take them the remaining two days and nights to Omaha, Nebraska. There the trailboss gave Jackson a $20 bill for his work, which Jackson said he spent on a new suit, a shave and a haircut. 'I felt like a man again,' he wrote.

In Omaha there were two photographic establishments, E.L. Eaton's and Edric Hamilton's. Jackson visited both, looking for employment. Hamilton offered to hire the young man by the week, or trade him shares and put him in charge of a branch gallery. Considering Jackson's cash situation, or lack thereof, it comes as no surprise that they agreed on the former. Wrote Jackson; 'Hamilton

arranged to pay me $15 for the first week, $18 for the second, $20 for the third, and then $25 regularly if all went well.... My troubles were over.'

By the fall of 1867, in fact, Jackson had put aside enough to buy Hamilton out with a small down payment, in effect giving the previous owner a share in the business's future without his having to do the work. Jackson had confidence in Omaha, a boom town that in seven years had grown from a population of less than 2,000 to more than 12,000.

Jackson must have written some convincing letters home, because his father back east not only seemed to share his son's confidence, but was willing for a second son, Ed Jackson, who had some business experience but no photographic background, to join his brother in Omaha. The father paid Hamilton the balance of his son's debt, and even provided the new business with enough money to invest in some additional equipment. By 1868, Jackson Brothers was a going concern, having bought out Eaton, the other photographic establishment in town, as well. As would be the case with almost any franchise that changed hands, with both purchases came not only paraphernalia and clientele, but stock as well – which in the case of photographic studios meant negative and print files. As was the common practice then, and lacking U.S. copyright laws to the contrary, any photographs thus obtained would henceforth be sold under the purchaser's imprint.

> For the first year we stuck pretty closely to the usual work of studio photographers – straight portrait jobs; group pictures of lodges, church societies, and political clubs; and outdoor shots that gratified civic pride. There were many commissions to photograph shop fronts and, occasionally, interiors. Now and then, too, somebody would order pictures of his new house; or of his big barn, and along with it the livestock. We were kept busy.
>
> Ed took care of the front office and did the canvassing. Ira Johnson, a boyhood friend, who had come west with my brother, handled the portrait jobs. I did the outdoor work, and my seventeen-year-old brother Fred (who had also come with Ed) was general studio assistant.

Jackson's outdoor work soon expanded beyond its traditional community boundaries to several Indian encampments located within a few days' travel. He wrote:

> South of Omaha lived the Osages and Otoes; to the west, up the Platte, dwelt the Pawnees; north, along the Missouri, the Winnebagoes, and the tribe for whom the city had been named, the Omahas. They were all friendly – and there was money there, both for the red man and the photographer. Those

Indians would pose for me by the hour for small gifts of cash, or just for tobacco or a knife or an old waistcoat. And I in turn was able to sell the pictures through local outlets and by way of dealers in the East.

Both Hamilton's and Eaton's existing files, especially Eaton's, contained substantial numbers of studio-type portraits of native-Americans. Jackson's own recent western experience probably had a lot to do with his willingness, and ability, to go out into the field to explore further such alien territory in a more direct manner. That photography itself had been unchained from the studio by the popularization of the wet-plate, collodion process was another factor.

Photography had not become easier. Indeed, in some respects it had become more difficult. Glass plates to be exposed in the camera first had to be evenly coated with a collodion containing potassium iodide, then immediately dipped in a silver nitrate solution to sensitize them. Since plates so treated lost their sensitivity if allowed to dry, they were exposed while still wet, and needed to be developed and fixed shortly thereafter. Thus the name wet plate. Obviously, with all the laborious work that had to be done on the spot, a darkroom was as much a part of field operations as the camera. Jackson's solution was elegant in its simplicity.

> I devised a traveling dark room, a frame box on a buggy chassis, completely fitted with water tank, sink, developing pan, and other gear essential to a wet-plate photographer. Soon my one-horse studio (which at first scared the daylights out of all livestock) ceased to be considered 'bad medicine,' and I was welcomed equally before the tepees of the Poncas and the earthen houses of the Pawnees.

Before long, Jackson further enlarged his field work to include documenting the railroad, whose steel lance was relentlessly dissecting the still wild and uncharted territories, scribing a path that would carry all that was good – and bad – about civilization and so-called progress. Soon, a visionary might have realized, the frontier with all its danger and challenge would be gone; in its place would be a settled land, a wilderness forced into submission and diminished in the process. Whether Jackson was a visionary with a zeal to record for posterity an awesome natural beauty that might not be seen again, or simply an astute entrepreneur who himself saw the commercial possibilities inherent in that beauty, is open to question. Probably, he was a little of both, which may explain the lasting power of the images he was soon to produce. Certainly, he was destined to become an agent of the very changes his photographs so often seemed to decry.

On May 10, 1869, the same day that east and west were finally joined by rail at Promontory Point, Utah, twenty-six year old

William Henry Jackson married Mollie Greer, whom he had met while she was visiting relatives some months earlier in Omaha. After a honeymoon trip to St. Louis by steamboat, Jackson put his new bride on a train to Ohio for an extended visit with her family while he headed west on an excursion that was expected to keep him away from home for at least several months. With Jackson went Arundel C. Hull, an experienced photographer who a few months earlier had hired on as an assistant at the Jackson Brothers establishment, and whose pictures too would become commingled under the Jackson banner.

> The new enterprise was launched largely on the strength of
> one order. The stereoscope – to me still a very wonderful
> device, with its convincing third-dimensional illusion – was
> on the threshold of a tremendous and long-enduring popularity,
> and Jackson Brothers, after some intensive soliciting, got an
> order for ten thousand stereographs of scenes along the train
> route. With that as a nucleus, I was sure I could establish myself
> as a front-rank scenic photographer. It was a great opportunity
> to start a collection of negatives. And it was also an opportunity
> to travel upon the railroad I had seen building.

The Union Pacific promised passes for Jackson and his new assistant, and on June 23, a full twenty-four hours out of Omaha, they arrived in Cheyenne, Wyoming, a new western town of wooden storefronts that had not existed only two years earlier. A week later they boarded the train with a profit of $60, the result of selling photographs of various commercial establishments to their proprietors, plus one successful day of making portraits of the ladies at Madame Cleveland's, a western saloon straight out of 'Gunsmoke.'

The pattern would repeat itself at settlement after settlement, helping in great measure to pay for the essentially speculative trip as it unfolded. On the train, an enterprising trainman bought for resale the collection of Indian photographs Jackson had smartly thought to bring along. This same man placed an order for 1,000 stereo views of Weber Canyon to offer to passengers who would not be able to see such views from the moving train, but who might certainly want visual souvenirs to show the folks back home. 'The trainmen were, on the whole, very obliging about letting us off between stops,' Jackson wrote, 'and equally so about picking us up when we flagged them.

'Hull and I, on our part, took pictures of the locomotives and their crews, and we gave away as many prints to the trainmen as we sold them. We spent most of July out on the line, riding in the cars, on the cars, and, not infrequently, right out on the cowcatcher of Number 143.'

The print sales to railroad crews proved to be lucrative, in terms of travel and cooperation as well as income. Unfortunately, not many of the negatives made survive because Jackson and Hull could only bring with them a limited number of the heavy and fragile glass plates – perhaps as many as 100 in the larger 8 x 10 size and 200 4 x 8 plates for stereos. As a result, they would make their commissioned negatives, contact print them, often in multiples, and then clean, polish and reuse the plates for the next job.

For this trip, Jackson had contrived an even more portable darkroom than his earlier horse-drawn version. An expandable wooden box, 30 x 15 x 15 inches when collapsed, contained all the pans and trays necessary for developing and printing. What with the two large stand cameras and lenses and all the chemicals and plates, Jackson estimated his photographic baggage at a ton or more.

> This was a period of great experimentation for me. The art of
> timing exposures was still so uncertain that you prayed every
> time the lens was uncapped, and no picture was a safe bet until
> the plate had been developed. Working in a fully equipped
> studio was hazardous enough. Going at it in the open meant
> labor, patience, and the moral stamina – or, perhaps, sheer
> phlegmatism – to keep on day after day, in spite of the
> overexposed and underdeveloped negatives, and without regard
> to the accidents to cameras and chemicals.

At the end of July, Jackson and Hull arrived in Salt Lake City, and at one point lacked the funds to pay for a package of chemicals they had had sent to them; they therefore had no way of turning their exposed negatives into cash because they had no means of printing them. Finally, they borrowed the money from the baggage master of the railroad, and spent the remainder of their time photographing landmarks and scenery in eastern Utah.

> From many angles, I took the spectacular bridge just completed
> at Devil's Gate. I recorded Thousand Mile Tree (exactly one
> thousand Union Pacific Miles west of Omaha). And, of course,
> Hull and I made expeditions to all the striking natural views of
> the surrounding country. Devil's Slide, Pulpit Rock, Death Rock,
> Monument Rock, Hanging Rock, Castle Rocks, and Needle
> Rocks are only a few of the wonders we visited and bagged for
> our collection. We barely managed to meet our expenses on the
> road – but I returned to Omaha late in September with just
> about the finest assortment of negatives that had yet to come
> out of the West.

Before long, having negotiated an arrangement for his stereo views to be published by the Edward Anthony Company of New York, W. H. Jackson's increasingly clear and precise photographs made along the route of the Union Pacific would begin to earn him a national reputation.

Soon after crossing the line into Kansas the train slowed down. Then it stopped. Buffaloes covered the track ahead.

...All that day, with the cars seldom moving faster than twenty miles an hour, often slowing down so that we could have walked alongside, occasionally stopping dead, we saw buffaloes. I cannot estimate the number we saw making their southern migration that day; but I would *guess* not less than half a million....At this time, sober-minded plainsmen believed that a *billion* buffaloes still roamed the West, while the most conservative calculation placed the number at 60,000,000....

A great buffalo herd was an extraordinary thing to see. A mile-wide valley would be filled from side to side, and as far ahead as the eye could reach, with buffaloes so closely packed together that they looked like a moving carpet.... A herd crossing the Missouri could, and did, stop steamboat traffic for hours; and passengers on the early railroad trains were quite accustomed to waiting for the buffaloes to pass – and to shooting them from the car windows, just for fun.

The Indian, when he killed a buffalo, used everything: meat, horns, sinews, hides, even intestines. The white man might take the tongue, and leave all the rest of the carcass for the wolves; or perhaps he might chop off the prime cuts of delicious meat from the hump; or possibly he wanted robes and took nothing but the hide. Thousands upon thousands of buffaloes were slaughtered for the tongues alone. Thousands were killed for sport by hunters from Europe. And many thousands more were legitimately killed for meat to feed the men who were building the railways; Buffalo Bill Cody was employed for eighteen months by a railway construction camp, and received $500 a month to supply it with the hind quarters of ten to twelve buffaloes a day.

At this rate the defenseless creatures disappeared rapidly. Soon the plains were so strewn with buffalo bones that it was possible to make a comfortable fortune by selling the bones for fertilizer and buttons. The herds lay where they had grazed, whitening the valleys. Stray skulls were used by surveyors to mark sections of land, and by travelers for written messages to other parties on the trail. But, in less than a generation, the roaming buffalo was gone.

General Phil Sheridan was asked to support a bill placing the America bison under government protection. He refused. 'The best way to get rid of the Indian,' he said, 'is to destroy the buffalo by which he lives. The more buffaloes killed, the better – and what good is a buffalo, anyway, except for slaughter?'

WILLIAM HENRY JACKSON, *Time Exposure*, 1940

A boathouse on a lake at Mount Holyoke College, South Hadley, Massachusetts.

And, according to prevailing nineteenth-century opinion in America, what good were the seemingly endless plains if not for farming and fencing? Western civilization, meaning capitalism, would tame the wilderness, even if it meant the ultimate destruction of all the nomadic creatures, human or otherwise.

Certainly, even at twenty-seven, Jackson understood the implications of Washington's expansionist policies. But he was an artist and businessman, not a politician. His voice might never be heard, but his pictures would be seen. His vision of America, a romantic one still, did not preclude his participation in what he no doubt considered a process of discovery and description rather than an escalating, and already inevitable, exploitation of the natural wonders he seemed most to value. Indeed, the very information he helped disseminate contributed in large measure to enlarging the western myths that proved most attractive to the eastern hordes.

On July 23, 1870 Jackson received a prominent visitor to his Omaha studios. Ferdinand Vandiveer Hayden was a doctor of medicine who had never practiced commercially, opting instead to be a geologist. 'As early as 1853 he had gone into the West,' wrote Jackson in *Time Exposure*, 'and until his death in 1887 this unexcelled leader and gentleman never rested from his efforts to inform Americans about America. Even the Indians, some of whom regarded him as insane, were awed by Hayden's industry. They named him Man-Who-Picks-Up-Stones Running.'

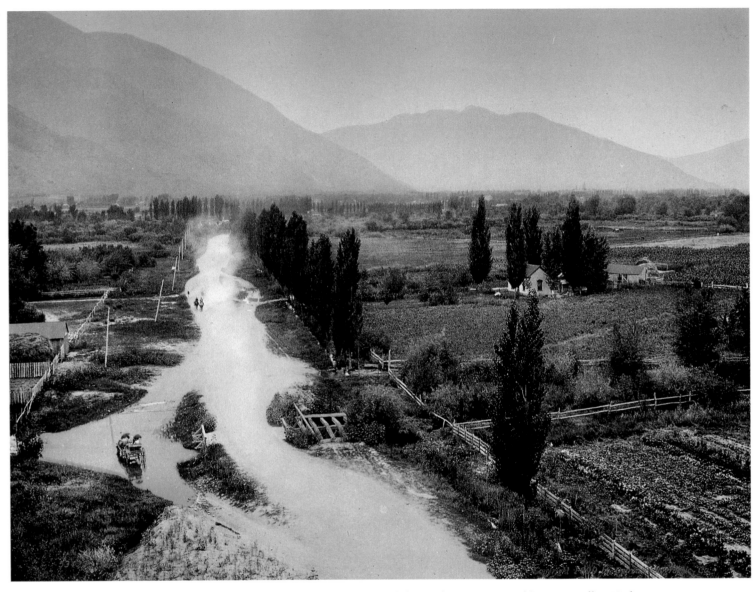

Pausing to give their horse a drink, travelers take a break from a dusty wagon road in Provo Valley, Utah.

The U.S. Geological Survey had been set up in 1867, under the auspices of the Land Office of the Department of the Interior in Washington. Dr. Hayden, whom Jackson apparently had met previously, spent a good deal of time going through the photographer's Union Pacific and Indian files. Finally, he offered the young man the opportunity to spend the summer in Wyoming photographing for the survey, for expenses only, no salary. Jackson accepted. Since his brother Ed had recently left the firm to manage his father-in-law's farm in Nebraska, he put his wife Mollie in charge of the studio in his absence. Jackson then joined the survey group, which consisted of about twenty men, including, in addition to Hayden and his topographers, a meteorologist, an ethnologist, and two artists – who would attempt to record on canvas, in color, some of the same scenes Jackson was expected to capture on film in black and white.

For every mile on the map we covered between two and three on the ground – up mountainside, down stream bed, across country – to gather rock specimens, to survey and map, and to paint and photograph. My equipment, plus extras and

refinements, was the same I had carried the previous summer: the double-barreled stereo, and the 6 1/2 x 8 1/2 (also adaptable to stereo work); the portable dark room, completely rebuilt and improved; a full stock of chemicals; and enough glass for 400 plates. The whole must have weighed not less than 300 pounds; but since I had one of the two ambulances [small, lightweight wagons] at my disposal, neither weight nor bulk mattered much.

I had also Hypo. A fat little mule with cropped ears, Hypo was almost as indispensable to me as his namesake, hyposulfite of soda, was to dark-room chemistry. Carrying my cameras, tripod, dark box, chemicals, water keg, and a day's supply of plates, all loaded in big, brightly painted rawhide containers called parfleches, Hypo was good for as many miles as my horse was, and together we covered an enormous amount of ground off the road from the wagon party.

...This, my first survey trip, began with our departure from Camp Carlin on August 7. Following the Oregon-Mormon trail as far as Fort Bridger, we then went up into the Uinta Mountains for some two or three weeks and returned by way of the old Overland Trail.... For Dr. Hayden and the veterans it was more or less routine... but for me the expedition was priceless – it gave me a career.

As Jackson wrote in *The Pioneer Photographer*, a 1929 account of his adventure-filled life:

There were many beautiful vistas, including grassy meadows and little lakes, with glimpses of the distant snow-clad peaks.... All were up at the break of day to make an early start for the higher elevations. We chopped and blazed our way for three miles through the aspens and jack pines, then came out into a long, meadow-like park that led up to Photograph Ridge. It was given this name because of the commanding view it afforded....

We passed through several snow flurries on the way up through the timber, and out on this exposed ridge above the timber line we caught the full force of the storms that occasionally rage over it. Clouds were continually gathering and sweeping over us, then breaking to let the sun shine out warm and bright for a few moments.... During the sunny intervals we managed to get several negatives. Finding no running water at this high elevation, we caught falling snowflakes on a black rubber blanket, and when the sun shone out there was sufficient warmth to melt enough snow for the developing and fixing solutions. Our final washings were deferred till later.

When the party reached Fort Sanders, 'about which the town of Laramie had sprouted up,' Jackson noted in *Time Exposure*, Dr. Hayden proposed that Jackson become a permanent and salaried member of his survey staff. Jackson accepted, then went off to

photograph Pike's Peak. 'It was just about the last chance anyone had to see the "old" Colorado,' Jackson wrote, 'for the Denver Pacific was just coming in. There was as yet no city at Colorado Springs, but by the following autumn, when I again happened to be there, men were at work plowing the lines for its streets.'

From Colorado, Jackson traveled by rail to Washington, D.C., where he finished printing and cataloguing his many new negatives, and finalized his contract with the government, which would pay him $150 a month, on a twelve month basis. When he returned to Omaha, he tried to sell the portrait studio, to no avail. When he embarked on the following summer's survey, however, at least it was with the knowledge that Mollie could continue to manage the portrait studio, with an 'operator' actually making the photographs, without the risk of the financial disaster that up to then had shadowed their days together.

The skeptics, which is to say anyone who had never actually laid eyes on the area called Yellowstone, derisively called it 'Colter's Hell.' John Colter had been a member of the Lewis and Clark Expedition when in 1807, having decided to do some exploring on his own, he stumbled upon a physical universe that defied description. 'When he came back to civilization,' wrote Jackson, '...no one believed his tales of grottoes and geysers, tumbling cataracts and boiling sulphur fountains.' Others followed Colter's trail through the years; the legend grew, but few believed. 'Even Jim Bridger,' Jackson noted, 'who had no peer as a guide in all the Rocky Mountains, had been laughed down when he tried to tell about the wonders of the Yellowstone.'

Before the war, Bridger had guided a small group, which included F. V. Hayden, through a part of the Yellowstone's 3,300 square miles. In 1870, the Washburn and Langford expedition did make its way in 'that glorious and nearly impenetrable country,' and N. P. Langford wrote about the experience in *Scribner's Magazine*. Mere words still failed to convey the reality.

The public's curiosity was piqued, but doubters remained. One corporate believer was the Northern Pacific Railroad; correctly gauging the potential for tourism, railway management lobbied strongly for the rights to connect into the Yellowstone. An accurate topographic survey was the next logical step. According to Jackson, Hayden, who had managed to get his Congressional appropriation for continuing the survey work in the west doubled to $40,000 for 1871, saw in the Yellowstone '...how a widespread public interest could keep his Survey alive permanently.'

Hayden knew that Congress would keep on with its annual appropriations exactly as long as the people were ready to foot the bill, and he was determined to make them keep on wanting

to. That was where I came in. *No photographs had as yet been published*, and Dr. Hayden was determined that the first ones be good. A series of fine pictures would not only supplement his final report but tell the story to thousands who might never read it. Photo-engraving and ten-cent picture magazines were still unknown; but an astonishing number of people bought finished photographs to hang on their walls, or to view through stereoscopes.

To his previous kit of field equipment, Jackson added a larger 8 x 10 inch camera. To complement the usual method of exposing plates by removing and replacing lens caps, he also devised a 'drop shutter, actuated by a rubber band.' At high noon on bright, sunny days, he was thus able to shorten exposures to about one tenth of a second 'to shoot action.' Mostly, however, he continued to expose his plates for from five seconds to upwards of twenty minutes, depending on time of day, intensity of light, and weather conditions. 'When speed was no consideration,' he noted, 'I always stopped my lens down to get maximum depth of field and definition.'

The excitement of finally reaching the fabled land was palpable in Jackson's own accounts of photographing Mammoth Hot Springs.

'The delicate tracery in the deposits about the hot spring pools and terraces afforded an endless variety of details for picture making,' he wrote in *The Pioneer Photographer*. In *Time Exposure*, he expanded:

We were, so far as records show, the first white men ever to see those bubbling cauldrons of nature....The subject matter close at hand was so rich and abundant that it was necessary to move my dark box only three or four times. My invariable practice was to keep it in the shade, then, after carefully focusing my camera, return to the box, sensitize a plate, hurry back to the camera while it [the plate] was still moist, slip the plate into position, and make the exposure. Next step was to return to the dark box and immediately develop the plate. Then I would go through the entire process once more from a new position. Under average conditions a 'round trip' might use up three-quarters of an hour. At Mammoth Springs, however, there was so little shifting to do that I was able to cut the average time to less than fifteen minutes. Another thing that helped was the hot water at our fingertips. By washing the plates in water that issued from the springs at 160-degrees Fahrenheit, we were able to cut the drying time more than half.

The old mining town of Silverton, Colorado, at the base of Sultan Mountain.

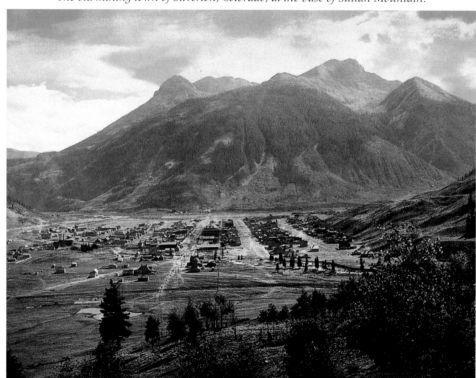

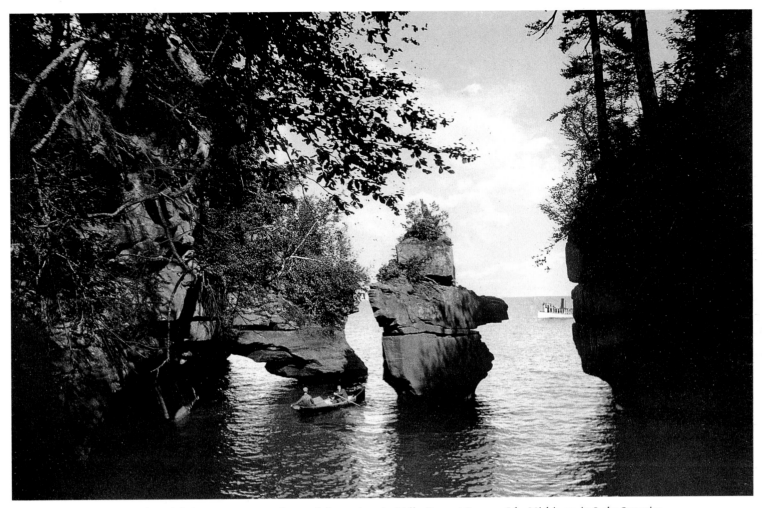

Boaters thread their way among ancient rock formations in Stella Cove, at Presque Isle, Michigan, in Lake Superior.

Most situations were more difficult. At Tower Falls, for example, the stream 'runs a tortuous course between fantastic pinnacles of conglomerate rock and makes a final leap of one hundred and fifty-six feet into a deep ravine,' Jackson explained in *The Pioneer Photographer*.

To get any comprehensive view of the falls, it was necessary to go to the bottom of the ravine below, a descent of about two hundred feet, through steep sides covered with a thick growth of small timber and brush. Rather than take the dark box down to the bottom, I worked from the top. Backing my plate with wet blotting paper, and wrapping the holder in a wet towel and the dark cloth, I scrambled and slid down to the rocky bed of the stream, with plate holder and camera in hand. After taking the picture, I had a slow, laborious climb back again, and reached the top out of breath in a wringing perspiration. Four round trips gave me the desired number of negatives, a full half day's work....

Jackson was generally elated by his photographs, but at the same time frustrated by his inability to capture the full essence of Yellowstone. In addition to himself and another photographer, J. Crissman, the greatly expanded survey team included two painters. One of them was Thomas Moran, an English-born artist of note, six years older than Jackson, whose work the photographer held in high esteem. Moran often helped Jackson find just the right vantage point for his photographs, and Jackson provided prints to serve as 'sketches' for Moran's paintings, which, the photographer believed, 'captured...the color and the atmosphere of spectacular nature.'

Color, directly recorded on film, was simply beyond the technical capacity of Jackson's medium, based as it was on a still evolving amalgam of optics, mechanics and chemistry. But Yellowstone, with its bright golds and burnt reds and cobalt blues, *was* color. Also generally beyond the camera's limits were clouds (skies, unless they were retouched, were usually portrayed as bald white or gray) and the fine steaming mists of spouting geysers, one of the Yellowstone's most dramatic features. In several photographs from the region, at least, the results of Jackson's frustration are evident as he fell back on painting techniques to retouch, opaque, abrade and otherwise manipulate negatives to obtain the desired effects.

The Hayden party spent forty days and nights in the Yellowstone, during which time Jackson's photography, in the main, became increasingly more focused and mature, more concerned with aesthetics as well as literal description, better able to articulate a vision, perhaps as much Hayden's as his, of so-called civilized man's place in relation to the natural wonders he was destined to dominate, if not consume.

'Within the next few months,' Jackson wrote in *Time Exposure*, 'I was to begin to taste that little fame which comes to every man who succeeds in doing a thing before someone else.' There were three photographers in Yellowstone in 1871. 'One of them was Crissman, whose pictures never passed the confines of a purely local market. The second man was the expert T. J. Hine of Chicago, who had been attached to the Barlow-Heap party. Hine got back to Chicago just in time to have every single negative destroyed in the terrible fire of 1871. And so the fact that my pictures were the only ones to be published that year is something for which I have to thank Mrs. O'Leary's cow.'

In 1872, after considerable lobbying, Congress voted to create Yellowstone National Park, the country's first such preserve of nature set aside specifically for the enjoyment of its citizens. William Henry Jackson's photographs played no small part in the ability of Hayden, Langford and the railroad interests, among others, to make so persuasive a case. In a comparatively short time, the mystical qualities of Yellowstone would be popularized by the big business of tourism, and ultimately nearly trampled to death by millions of well-meaning visitors.

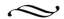

In the fall of 1871, prior to the landmark Congressional vote that took place the following winter, Jackson sold the Jackson Brothers studio in Omaha, and prepared to move to Washington, home base for Department of Interior operations. The task of running the studio had become too much for Jackson's wife Mollie, who was pregnant with her first child. It was decided that she would stay with Jackson's parents in Nyack, New York, while Jackson traveled to the nation's capital to make multiple sets of prints in preparation for the Yellowstone vote. Tragically, during his absence, Mollie died during childbirth; the baby girl died shortly thereafter.

Jackson, who had retained all his camera equipment in addition to his file of Indian and Survey negatives, still made the move to Washington. With an important piece of legislation added to its already impressive accomplishments, the Geological Survey received an even larger appropriation, to further explore Yellowstone and the Teton Range to its south. To his usual equipment, Jackson now added an 11 x 14 inch view camera, a move compelled, Jackson wrote, by 'the demand, as well as real need, for big pictures... since satisfactory enlargements from small negatives could not be made.'

Unfortunately, the larger plates used by this camera eliminated any possibility of Jackson's continuing to use his ingenious, and relatively portable, darkbox. Henceforth, he wrote, 'I now had to set up a dark tent every time I wanted to make a picture. This little tent had a conventional cover of gray-white canvas; but inside it was lined to orange calico to cut out the actinic rays.'

In the field, the Survey at first broke into two teams, and Jackson went with the group assigned to explore on horseback the unknown regions of the Tetons.

Our primary objective was the high tableland between the branches of the Teton River. Reaching the main plateau, an altitude of about 11,000 feet, was not difficult; but achieving a photographic vantage point was another matter. At one place we had to pass around a narrow, high ledge, an extremely dangerous undertaking through the deep, sloping snow. But we made it, and almost immediately we were rewarded with one of the most stupendous panoramas in all America. Thousands of feet below us lay the icy gorge of Glacier Creek, while on the eastern horizon the main range shimmered in the mid-morning sun. Above all this towered the sharp cone of the Grand Teton, nearly 14,000 feet above sea level.

In the mountains, Jackson's special photographic party, the men on horses, the gear on mules, 'lived in the open,' he wrote in *The Pioneer Photographer* 'without tents, depending entirely upon our tarpaulins to keep blankets dry at night when mountain storms broke loose.'

On one occasion camp was made in a canyon at the foot of a cliff several hundred feet in height. With two assistants and the pack mule I left this camp one morning for the timber-line regions, where I found so much photographing to do that the sun was well down over the Idaho plains before we packed up and started for camp. We tried to quicken the descent by taking advantage of short cuts and slides, but met with many delays, so that it was already quite dark when we got down into thick

51384 A LITTLE MUSIC.
COPYRIGHT, 1902, BY DETROIT PHOTOGRAPHIC CO.

An organ grinder plays for cash on the streets of New York.

timber.... After sliding down a particularly steep incline of sand and rock, we found ourselves on the verge of the cliff directly above our camp. A big fire illuminated the surroundings, and the boys grouped around it were preparing supper....

Our shouts brought a response but no help. A survey of the situation convinced us that it was not advisable to attempt, in the darkness, to try to get out of the pocket in which we found ourselves...the horses and the pack mule had to be considered.... Taking off saddles and pack, we tied up the three animals securely and then sat down on the edge of the cliff and watched what was going on in the camp below...as the boys prepared and finished their meal, which did not exactly lessen our cravings of hunger after a hard day's work of mountain climbing. As they leisurely turned in for the night and the camp fire flickered out in a thin column of smoke, we wrapped the saddle blankets around our shoulders.... With returning daylight we soon found a way out of our difficulty and were in camp in time for a hearty breakfast.

William Henry Jackson was perfectly suited to the role of pioneer photographer. He reveled in the visibility afforded by his unique stature in an enterprise sanctioned by his government for the public good, yet he thrived on the adventure and camaraderie of the wild, away from the civilizing influences that were sponsoring him. Perhaps it was this very cross-fertilization that caused his photography to bear such rare fruit. 'Subject matter, equipment (I was using my 11 x 14 exclusively), and working conditions, all contrived to give me a series of exceptional photographs,' he wrote in *Time Exposure* about the summer of 1872. 'Everywhere I went – from the Gallatin Mountain country, clear to the southern end of Yellowstone Park – everything favored me.'

In the fall of 1873, the tragedy of Mollie's death behind him, he would marry Emilie Painter, whom he had met two years earlier while photographing on the Omaha Indian Reservation. Emilie, the daughter of Dr. Edward Painter, then the agent in charge, had written Jackson a series of heartfelt letters following his wife's death, and the correspondence led to romance and an agreement to wed in October, following another summer of Survey photography.

In May of 1873, earlier than usual, Jackson took to the field again, this time in the direction of the Colorado Rockies. 'On May 30,' he wrote in *Time Exposure*, 'I set up my camera on Prospect Mountain for a close-up view of Long's Peak and started the season's harvest.' Negotiating the aptly named Snowy Range, Jackson's small photographic party frequently had to unpack the mules and free them from the still deep drifts they encountered. 'Finally,' he wrote, 'we arrived at the shores of a little lake, from which I was able to secure a fine view of the main range from Long's Peak to James.'

Following an abandoned road, the group came upon a deserted village, a ghost town surrounded by 'prospect holes, ore dumps, and

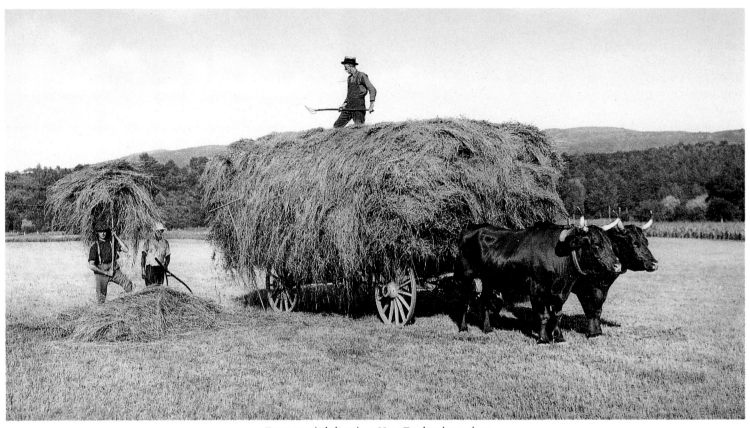

Farmers pitch hay in a New England meadow.

the ruins of three mills.' Jackson never was able to determine the town's name, or its origin. They forged ahead. 'The weather was a constant hindrance during those first weeks. Snow fell nearly every day, and two hours' work out of twenty-four was my average. Yet the views, when the sky cleared enough for my camera, were so rich and splendid that a stock of finished plates soon piled up.'

Jackson proceeded to climb to the summit of McClellan Mountain, then Gray's Peak, then on to Torrey's Peak, the latter two over 14,000 feet. 'For a month I photographed the Rocky Mountains,' he wrote, 'zigzagging the route indicated for me.... Twenty-five miles a day – an average eight-hour stint – is just about the limit for a heavily loaded pack train, and in order to end each day's journey by around noon we had to start very early.'

At Fairplay, Jackson met up with the main party, where he was assigned by Dr. Hayden to cross the Sawatch Range to the Elk Mountain region, and thence to 'wind up the season by photographing the Mountain of the Holy Cross....Criss-cross and detour was the rule as we struck a northwesterly course toward Holy Cross – there were so many pictures I *had* to take. Mount Massive – Mount Harvard – Mount Elbert, highest point in Colorado – La Plata

– Snowmass – these and many more fell before my camera. But many did not, and I regretted the lost ones deeply.'

Today [1940] favorable atmospheric conditions – clear sky, bright sun, still air, clouds to punctuate the background – are always desired by the photographer. In the '70s bright weather was even more important. We had no fast emulsions to counteract the effects of overcast skies, or to 'stop' wind-driven foliage, and we had no filters to define clouds and horizons against the sky. If the weather was good, I could take as fine a picture as can be made today. But on bad days much patient manipulation of the chemicals was needed to produce acceptable negatives.... Periodical notes came to me from Dr. Hayden by messenger from beyond some distant ridge. Always these notes included...the urgent plea: 'Hurry. You are losing golden opportunities.'

While negotiating the high divide between East River and Rock Creek, a mule named Gimlet slipped its pack. 'The Doctor himself was the first person to notice what had happened,' Jackson wrote.

'Following directly behind my party, he found plates along the trail and galluped [*sic*] up to learn the cause. By that time Gimlet had scattered most of his load, and it was too late to do anything except right the pack and go back to pick up the pieces. Many plates were unbroken or but slightly nicked; many more, however, all 11 x 14s, were irreparably shattered...my finest negatives lost before anyone had ever seen a print.'

Following Dr. Hayden's sage advice, Jackson retraced his steps, trying to reconstruct at least some of the lost photographs. 'The new negatives proved to be better than the old ones,' Jackson wrote in retrospect, 'and the delay brought me to the Mountain of the Holy Cross at the exact moment when every condition was close to perfection.' The story of the Holy Cross, with its perfect cross of snow etched into one side of its summit, was deeply ingrained in western legend.

No man we talked with had ever seen the Mountain of the Holy Cross. But everyone knew that somewhere in the far reaches of the western highlands such a wonder might exist. Hadn't a certain hunter once caught a glimpse of it – only to have it vanish as he approached? Didn't a wrinkled Indian here and there narrow his eyes and slowly nod his head when questioned? Wasn't this man's grandfather, and that man's uncle, and old so-and-so's brother the first white man ever to lay eyes on the Holy Cross – many, many, many years ago?

...But anyone who wanted to see Holy Cross could climb Gray's Peak on a clear day and pick it up with field glasses. As one comes close to the cross it always disappears behind Notch Mountain – and that is how the myth established itself.

On August 23rd, the group broke into two parties. The larger, which included Hayden, intended to climb Holy Cross to complete a triangulation from the summit. Jackson and two others headed for Notch Mountain across the ravine. They broke the necessary camera gear into three separate forty pound packs.

Near the top of the ridge I emerged above timber line and the clouds, and suddenly, as I clambered over a vast mass of jagged rocks, I discovered the great shining cross dead before me, tilted against the mountainside. By the time all three of us had arrived at the summit, the sky was too overcast for successful photography.... Below us as well as before us, the clouds billowed majestically. Then when the mist was heavy in the valley the sun came out – not enough for picture-taking, but enough to create a great circular rainbow at our feet.... We watched the evening approach.... Foodless, without blankets or even coats, we determined to spend the night on the peak. Leaving our equipment at the crest, we walked down to timber line and built a fire. There we rested on the stony ground until morning.

At dawn...I hurried wearily back to the top and set up my cameras. But I need not have rushed. The sun was still too low, even in midsummer, to have melted any snow, and without water I could not work. By the time I had enough to develop and wash a few plates the long flamelike shadows on Holy Cross were rapidly sweeping down into the valley, and, using two cameras, I had made just eight exposures when they were gone. But with the early sun, those shadows had already helped me to take the finest pictures I have ever made of Holy Cross.

On October 8, 1873, on his way back to Washington, Jackson married Emilie Painter in Cincinnati, Ohio, at the home of her brother, in a simple Quaker ceremony. Jackson had found a help-mate; the marriage would span forty-five years, until Emilie's death.

When William wasn't photographing in the field, the Jacksons lived a rather genteel life in Washington, given the constraints of his salary from the Survey, which never topped $175 a month. 'And extra income from my photography was neither large nor dependable,' he wrote. 'But it was the sort of life both of us found gratifying.'

The financial panic of 1873-4 threw Washington into turmoil. As a result, the annual appropriation for the Survey materialized so late in the summer of 1874 that Jackson did not get to leave for the west until July. He arrived in Denver, Colorado in the middle of that month, and anticipated the necessarily foreshortened season by carrying only the smaller of his view cameras. 'It enabled me to discard the developing tent and return to my less cumbersome dark box,' he wrote in *Time Exposure*. 'And since the plan was primarily to select fields of operation for the next full season, 5 x 8 plates and stereos would serve admirably.'

This year there would be several new men accompanying Jackson's photographic party, foremost among them Ernest Ingersoll, a young journalist with the *New York Tribune* who was also something of a naturalist. The two men struck up a friendship.

The plan called for Jackson's group to travel through Berthoud Pass to San Luis Park, then west up the Rio Grande to the San Juan Mountains. 'If conditions and time permitted,' he wrote, 'we might work down into New Mexico and Arizona.... I had my heart set on getting some fine Indian pictures before the summer was over, and with this in mind even the gorgeous landscapes of the Rockies failed to stir me greatly.'

By August 18, the party left Saguache and made its way up a canyon 'into a great grove of quaking aspens.... The aspens gave way to spruces, and then the spruces thinned out until we arrived at the broad open elevation known as Cochetopa Pass.... Down the western slope we came to Cochetopa Creek, and on the broad meadow lands, at its confluence with Los Pinos Creek, we found our Indians.'

Jackson counted more than seventy large tepees in a mile-square area, and the grazing land 'was dotted with ponies belonging to the visiting Utes.' The Indians had encamped to draw their annual supplies from the government agency established at Los Pinos. The irony of a once-proud hunter nation having been forced to live on a dole of beef, flour and sugar could not have been lost on Jackson.

> The agent, a Unitarian minister named Bond, greeted us when we rode up, and, when I had told him that our first object was photographs, he assured me that we might begin instantly. He seemed quite crestfallen when I ventured to suggest that our prime mission was not to take pictures of himself and his family but of the Indians.... The next morning the Reverend Mr. Bond took us over to meet Chief Ouray, head man of the Uncompahgre Utes. He lived in an adobe house that the government had built for him....

Not only did the chief live in a white man's house, but he wore, according to Jackson, 'a black broadcloth suit, polished boots and a derby hat,' spoke English – having previously acted as an interpreter in Washington – and was the recipient of a government pension amounting to $1,000 a year.

'Of all the Indians I have known Ouray was quite the most extraordinary,' noted Jackson. '...Most striking, his expression was indicative not only of good will but of great intelligence. Ouray was a lover of peace, and his career was unblemished by a single instance of violence against the whites....Ouray dwelt austerely with his wife; he used no tobacco, and he hated whiskey. Before he died, in fact, Ouray joined the Methodist Church!'

Chief Ouray seemed just the kind of token the expansionist government in Washington would want depicted for its citizens to show that the Indians presented no further threat to the well-being of future settlers and tourists. The once wild and dangerous 'Red Man,' the only true native to the North American territories coveted by the U.S., had not only been tamed, but co-opted. But had not Jackson, a willing accomplice in the selling of the American west, been co-opted as well? Jackson arranged to photograph Ouray in 'beaded ceremonial buckskin,' and set up his camera on agent Bond's porch. A sudden downpour cancelled the session.

> It was noon before the sun came out. Meanwhile every preparation had been made for a formal arrival before the tepees of the Utes, and as soon as the weather cleared Ingersoll and I, on horseback, followed the agent in his carriage and presented ourselves to the assembled chiefs. We were received with fitting circumstance and led into a tepee for a ceremonial pipe. Then we were politely informed that there could be no pictures. The Ute medicine men had said, *'No Bueno.'*

> We argued and pleaded and cajoled, but to no purpose. The chiefs Shavano and Guerro were resolutely opposed. 'Make Injun heap sick.' 'Squaw die.' 'Papoose die.' 'Pony die.' 'All die.'

Jackson did manage to convince one minor chief, named Tush-a-qui-not and known as 'Peah,' to pose, both alone and with his family and followers. Fortunately, wrote Jackson, 'If Ouray was the most extraordinary Indian of my acquaintance, Peah was certainly the most photogenic.' Again, the session was cut short by a thunderstorm. And by the next day, not even Peah would pose, convinced no doubt by his peers that the camera was, indeed, bad medicine.

> When I set up my tripod on a commanding elevation to take a panoramic picture of the whole village, three or four Indians were detailed to get in my way. As I attempted to focus, one of them would snatch the cloth from my head; or toss a blanket over the camera; or kick out one of the supporting legs. When I retired to the doorway of the agent's kitchen and tried to catch a view from just inside, a horseman galloped up and wheeled square in front of me. Then Peah came to demand the surrender of all the finished negatives!

> After three or four days of organized opposition I gave up. I had got a few really superb negatives, and I could foresee only mounting trouble if I persisted....The evening before we left...a chief who rejoiced in the name of Billy visited me. He had come, he informed me with an air of great condescension, to give me friendly warning: this country, regardless of treaties and boundaries, was owned by his people; it would be dangerous for us to proceed farther with my strange box of bad medicine.

On August 27, some eighty miles and three full days of travel out of Los Pinos, Jackson's party stopped to make pictures at the head of the Rio Grande. Shortly thereafter, they encountered three miners.

> One of them turned out to be an old friend from Omaha, E. H. Cooper, whom I had known in 1868. We all camped together that night, and when Cooper learned the business that had brought me to his corner of Colorado he suggested we might wish to visit the cliff ruins not far from their placer workings on La Plata River. He himself had not seen them....

> The ruins sounded so exciting that I decided to strike there directly. Numerous cliff dwellings, remnants of a civilization that had died long before the first Spaniards arrived, had already been found in the Southwest; but the ones Cooper described promised to be quite the most magnificent find of all. Even the name of the place was exciting – Mesa Verde, the green tableland.

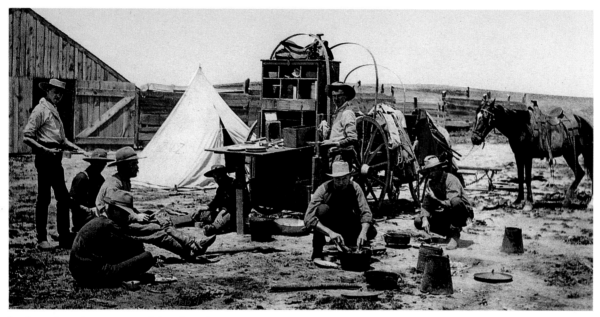

Cowboys chow down at a traditional 'grub pile' during a cattle roundup at the end of a long drive from Texas to Colorado.

At Cooper's mining camp, Jackson was introduced to John Moss, the camp's owner, who had seen the ruins, at least from a distance. Moss, who offered to guide the party there himself, proved to be affable and intelligent.

On the way Moss interested me very much by his remarks on the Indian situation. The Southern Utes had not been well treated. The boundaries of their reservation had been altered and their best hunting grounds taken from them by prospectors. Promised compensation had not been made, and, in consequence, the Utes were ordering white men – surveyors in particular – to leave the reservation. So far no hostilities had been reported. But Moss was none too sanguine about the future. He himself had no fears; for he had made a private treaty with the regional chiefs. In exchange for some twenty-five square miles of La Plata land he had agreed to pay an annual rental in the form of horses, sheep, and a little cash. It was worth it, he said, to live secure in the friendship of his neighbors. And it was also just and intelligent. Much good blood might have been saved if John Moss's course had always been the rule.

On September 9, Moss pulled up his horse and indicated to the group that they had arrived in the vicinity of the ruins. Where, Jackson wanted to know? There, replied Moss, pointing to the top of a plateau some 800 feet up, seemingly straight above their heads. 'In a moment all of us had managed to pick out something that looked like a house, with spots suggesting windows and a door, sandwiched between two strata of sandstone almost at the top,' wrote Jackson. They decided to attempt the climb, but after about 600 feet only Jackson and Ingersoll were willing to scale the final obstacle.

'We found ourselves facing a flat, vertical wall rising some 200 feet above the ledge on which we were standing,' Jackson wrote. 'Fifty feet above our heads, in a shallow cave, was a two-story house.'

Finding an old tree, they propped it up and shinnied themselves to a point where they could reach some 'ancient handholds and footholds cut in the rock. Invisible in the twilight, they served our need, and up we went to the house.

'It was worth everything I possessed to stand there and to know that, with Ernest Ingersoll, I was surely the first white man who had ever looked down into the canyon from the dwelling in the cliff.'

Ingersoll announced their discovery to the world in a series of dispatches to the *New York Tribune*. Although Jackson photographed the ruins in detail (and with great difficulty), Ingersoll's words would have to suffice: the technology for widespread dissemination of photographic images on newsprint was still in its infancy. With his straightforward description of a two-story house set into the side of a sheer cliff, a relatively sophisticated dwelling whose roof was defined by the contours of an over-hanging rock formation, Ingersoll managed to convey a complex and rather remarkable civilization.

This and the surrounding area were so rich in remnants of a once thriving people that Jackson was hard pressed to photograph it all to his satisfaction, and the mystery of their disappearance was

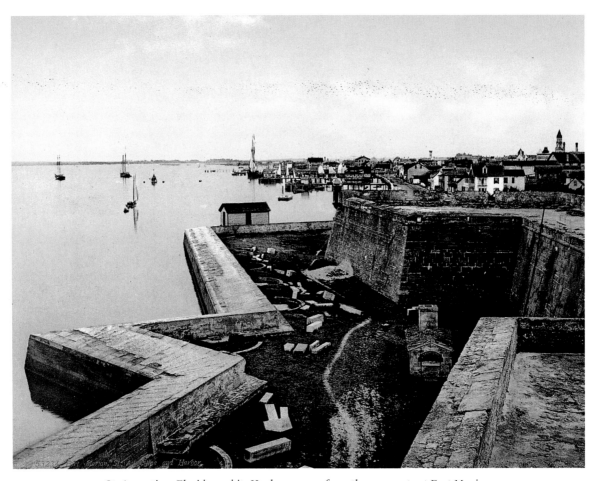

St. Augustine, Florida and its Harbor as seen from the ramparts at Fort Marion.

enough to draw him back the following year – with Dr. Hayden's enthusiastic backing. But for 1875, the photographer added a new piece of equipment to his mule's load – a mammoth-plate 20 x 24 inch camera whose 480 square-inch negative area was, according to Jackson, 'exactly twelve times the area of my 1874 negatives.'

The bulky camera was so heavy, in fact, that on at least one occasion it upended Jackson's pack-mule, carrying her down a steep mountainside until she lodged against a tree atop a precipice. The camera had to be unloaded before the poor animal could be set upright again and pulled back to safety. The negatives that this camera was capable of producing were worth the effort, however.

On June 6, Jackson set out to return to the Rio La Plata, not far from the New Mexico line, this time accompanied by another group headed by the geologist William Holmes, whose job in this case was to find and, where feasible, retrieve artifacts for an archaeological analysis of the ancient civilization Jackson's party had discovered

the previous year. Jackson continued to photograph, now apparently with the overriding objective of accurately describing their finds. In his book on America's early landscape photographers, *Era of Exploration*, Weston Naef argues that Jackson '...photographed...with the perception of the documentarian; he did not attempt to make pictures of the ruins but rather created archaeological records.'

In August Jackson's party again separated to go off on its own.

I pushed west in Utah along the San Juan. Not more than a dozen miles below the Montezuma [Canyon] we found a great circular cave cut by the water in some remote age, and forded the river to inspect it closely. The rock chamber was a hundred feet deep, and its vaulted ceiling was about twice as high. From almost any point under this enormous natural dome every sound, even a low whisper, echoed back with amazing clarity; and that phenomenon...prompted me to name it *Casa del Eco.*

The small party's next destination, the Moqui Indian country of Arizona, was more than 100 miles distant. An impassable gorge on the San Juan forced the group inland, and up to a plateau, where they encountered temperatures in excess of 125 degrees Fahrenheit. Because the extreme heat was likely to continue and water was scarce, the group, in an attempt to spare the mules, not to mention themselves, 'dug a hole in the sand and cached such implements and materials as were not absolutely necessary for a fortnight's expedition.' Shortly after resuming their journey, they again discovered extensive evidence of a past civilization.

In a shallow cave along the Chinle we discovered a whole little town of sandstone dwellings. Although it had been abandoned centuries before, the accumulated debris was rich in relics. Glazed pottery (mostly fragments), hollowed stone grinding basins, ax heads, arrow tips, and spear points abounded. Only our need to travel light kept us from departing with our immense haul.

In mid-August, Jackson's party arrived at the first of the *mesa* villages he was intent on photographing, the Moqui Pueblo of Tewa. In eastern parlance, the inhabitants were 'good' Indians who lived in towns, had adopted many of the white man's ways, and had begun to engage in an agrarian economy while managing to hold on to their picturesque rituals and ceremonies, thereby enhancing their potential as tourist attractions in a not too distant future. According to his biographer, Peter B. Hales, Jackson viewed the Indians' assimilation as progress, a view certainly shared by the railroad interests. As Weston Naef observed in his book, the photographs Jackson made of the Moquis '...lack the careful design of his panoramic landscapes of the previous season but are more compassionate human documents.'

Of course, Jackson's west still had its share of 'bad' Indians. The Utes, for example, were still unsettled and 'uncivilized,' still hunting for food and clothing, still resentful and warlike when crossed, as when government representatives reneged on their word. Jackson's party had at least one close call with some young renegades who, like 'howling savages,' drove the group and their horses and mules into a wild stampede down into a narrow canyon.

On an open plain at the foot of the canyon we came to a halt. Before us were a score of wikiups, the characteristic rounded wicker-and-canvas shelters of nomadic tribes in the Southwest, and from one of them the Pah Ute chief stepped forth to find out the cause of all the rumpus.

He was an old man, twisted and gnarled like a windswept tree, whose name was Pogonobogwint. We were welcome, he assured us in a quaint mixture of Spanish and English richly

punctuated with gesture. He would be honored, he added, to entertain us for the night. But after making him a small present of silver, in exchange for a dozen ears of green corn boiled in the shucks, we explained...that we must go on. I felt that we would be far more comfortable in a camp not shared by such impulsive children of nature.

Hardly a week later we learned that another exploring party had not been so fortunate as ourselves.... The Gardner-Gannett party, which we had been about to join, had been attacked by renegade Utes near the Sierra Abajo, only a short distance to the northwest. They had held off the attackers for thirty-six hours, then, with several of their mules killed, but with all men fortunately uninjured, they had cut their way out and escaped.

'I required another month to photograph my way across western Colorado, already snow-blanketed,' wrote Jackson, 'and it was not until October 13 that I was back in Denver. For once, after more than four months in the field, I welcomed the thought of a winter indoors.'

By then, the Jacksons had moved into their new home, a small rented residence on 18th Street, near Du Pont Circle, in Washington, D.C. On February 2, 1876 William and Emilie's first child was born, a son named Clarence. Jackson's next assignment from the Survey provided him with the opportunity to spend not just the winter, but the entire following season, including the summer, near his family.

The year 1876 marked the 100th anniversary of the Declaration of Independence, and the nation's Centennial Exposition was to be held in Philadelphia. During his most recent trip to the southwest, Jackson had spent nearly as much time sketching Indian settlements and land formations as he had making photographs of them.

The purpose was to provide me with the measurements and proportions needed to reproduce an extensive three-dimensional panorama for the Centennial....I spent the best part of six months shaping clay to exact scale models, forming the molds, casting the finished objects in plaster, tinting them to their colors in nature, and assembling the whole. When the fair opened, this display attracted more attention than the many photographs and all the rocks and relics of Dr. Hayden's career. It drew almost as many visitors as Dr. Alexander Graham Bell's improbable telephone.

The following year saw the publication of Jackson's 124-page *Descriptive Catalogue of Photographs of North American Indians*, an exhaustive, if less than scholarly, study listing more than 1,000 negatives depicting native-Americans. This compilation went well beyond Jackson's own work to cover all photographs then in the hands of various government agencies, including the Geological Survey's (the lack of individual photographic credit led historians in

later years to incorrectly credit all the Indian pictures to Jackson). In addition to the detailed listings, Jackson offered captions for selected photographs that seem meant to reinforce the public's narrow, self-serving view of the Indian. As Peter B. Hales correctly points out:

> The captions...could safely excoriate the bad Indian, admitting his existence, because these figures were relegated to history, killed off or converted to the new Indian policy of reservation, transformation, and assimilation. And page after page extolled the virtues of this policy, detailing the triumphs over recalcitrant hostiles, the religious conversions, the family farms, the tribal disappearances into the body of white settlement. And in this respect, it fit neatly with the archaeological work, where Indian civilizations could be safely resuscitated under the guise of history, an unreclaimable past.

Perhaps an avenging fate played a role in dealing a severe blow to Jackson's next season in the field, in 1877. In Washington, Jackson had met the Rev. Sheldon Jackson, Superintendent of the Presbyterian Board of Home Missions. Rev. Jackson was planning to visit his church's various outposts between Santa Fe and the Moqui pueblos and, with Dr. Hayden's blessing, the photographer arranged to go along. 'My short visit to the Moquis two years before had been so rich in subject matter,' Jackson wrote in *Time Exposure*, 'that I looked forward to an exceedingly productive trip.'

The minister planned to cover more ground than Jackson had on any previous photographic expeditions, so to keep weight down and expedite his work, Jackson decided to try a recent innovation: dry flexible film, newly available in rolls from London. By doing away with bulky wet plates and all the necessary processing paraphernalia, Jackson noted, 'with my 8 x 10 and all the film, I could, if necessary, have carried the entire load on my back.'

As it turned out, the whole season's work was lost, including, according to Jackson, 'a voluminous first report on the Chaco Canyon ruins – now a National Monument.' After the extended trip, and 'in spite of using great care in handling the film, always changing the rolls in total darkness, packing the exposed film in tight, waterproof cans, with the dry climate of the region as additional safeguard, there was no trace of an image when I developed the rolls in my own laboratory in Washington.' Too many months and too many miles had gone by, or, as Jackson surmised, 'it was simply a case of too long an interval between exposure and development.'

In 1877, photography was an embryonic technology still consisting of much guesswork and considerable luck. 'My experience... was quite the most costly setback of my career' Jackson wrote in *Time Exposure*. 'There was no going back, as I had done in Colorado in 1873.... I can never replace those lost pictures.'

The year 1878, a short season due to another late appropriation from Congress, was Jackson's last with the Geological Survey, and in terms of photographs one of his least productive. To photograph from Fremont Peak in the Wind River Mountains in Wyoming, however, a height that precluded pack mules, Jackson did finally manage to coat his own dry plates, with noteworthy results.

Thereafter, on a return trip to Yellowstone, Jackson, with some dismay at what he had helped to bring about, exclaimed: 'And now it was a park indeed, with rangers and tourists – and a cavalry detachment to guard them from the Indians!' Notes Hales in his biography, the Hayden party found their fabled Yellowstone '...not an escape from civilization, but an escape into civilization: accommodations had been built on the site and tourists were ensconced, riding the trails, staring at the fountains, taking the waters, bathing in the pools.' By then, souvenir hunters were taking home with them parts of the Park to display in their parlors, perhaps next to Jackson photographs purchased along the way.

Before long, Dr. Hayden lost control of the Geological Survey, and a new organization was put in its place that offered Jackson no role. He was out of a job, although Jackson subsequently would say he had already decided to resign. A daughter, Louise, had been born, and Emilie and the family needed a father who would not be required to spend, however willingly, the better part of every year away from home. And then there was money. At the age of thirty-five, Jackson's income had topped out at a salary of $175 a month from the government, plus a few private commissions that might add another $3,000 a year at most. He saw his future earning power under those conditions to be no better than that of any clerk in the bureaucracy. 'It was not a very high scale of living for a man who had reached the front rank in his field,' he wrote many years later in *Time Exposure*. Still, the experience had value of its own, as he also noted: 'I had gone through nine wonderful seasons with the Survey...and I had established myself as one of the foremost landscape photographers in the country. My career was assured.'

Jackson decided that he would relocate to Denver, Colorado, staging point for many of the Survey expeditions of previous years, and open his own photographic business there. He liked the cool, clear climate, the proximity of mountains, and the people who had chosen to live there. In the previous decade, Denver's population had increased seven-fold to 35,000, and Jackson predicted the growth would continue and that he would prosper along with it. 'I was right on both my guesses,' he wrote in *Time Exposure*. 'Denver's population tripled between 1880 and 1890, and so did my income.'

That the prosperity would have a price should go without saying. Henceforth, Jackson's working and creative life, one of relative freedom under the security of government sponsorship,

would be defined by the financial constraints of having to run a business. In Denver, Jackson would become as much entrepreneur as photographer.

Jackson's past experience told him that the railroads would be a primary market for his photography. 'It seemed to me,' he wrote, 'that they were missing a great opportunity to publicize and popularize their scenic routes.' On a trip to New York to research new photographic equipment, Jackson also sought out the magnate Jay Gould, who had controlling interests in the Missouri Pacific, Kansas Pacific, Central Pacific, Denver Pacific, and Denver & Rio Grande lines. The latter two, Jackson's '...immediate interest,' he noted, 'were almost his [Gould's] private property.' Fortunately for Jackson, Gould had remembered the photographer's Union Pacific work of a few years earlier. Evidently, Gould was also aware of Jackson's Survey work, especially photographs made in Colorado and Yellowstone, a fact that only serves to underscore the parallel concerns of Washington and the railroads. Gould promised to write letters of introduction for Jackson to railroad officials whose tentacles touched Denver, an act of 'kindness,' Jackson rightly felt, that would pay dividends for years to come.

Jackson purchased his four cameras and various lenses from the government for less than $200, about 20% of what he might otherwise have had to pay, and set up shop in Denver with Frank Smart, his first full-time employee. Smart, the son of a Washington photographer, had worked occasionally with Jackson on Survey projects, and was 'a thoroughly competent camera man.' Jackson

Symbol of democracy in America, the domed
Capitol in Washington, D.C.

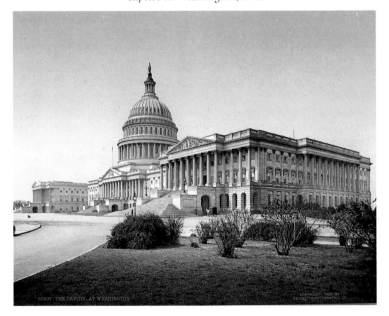

planned to bring Emilie and the family to Denver as soon as the new business was on its feet.

Smart's first assignment was to assist Jackson on a photographic excursion to Leadville, the so-called 'Sky City,' a celebrated silver mining town 10,000 feet above sea level. As Jackson wrote in *Time Exposure*:

> Scattered over the hill at the foot of Mosquito Pass were miner's shacks, derricks, ore dumps, and a few stunted pine trees. I photographed them all. At the end of each day the treasure seekers slopped through the mud of Harrison Avenue, to the Clarendon, or the Texas, and to half a hundred other saloons, brothels, and gambling dives, in search of such pleasures as they could pay for. I photographed them, too.

It would be a far different life in Denver for Jackson. Instead of exploring with a camera the mythic places of western lore and making history as well as pictures, he had to pick his destinations and take his photographs always with one eye on the bottom line. In addition to Smart, he hired another experienced camera operator, a printer, a mounter, and a receptionist for the studio, where portraits provided a financial foundation for Jackson's seemingly insatiable need to photograph the '...great open country,' he wrote, 'where I could do a good part of my work under the sky.'

Not until the spring of 1880 did Jackson send for Emilie and the children. 'The next dozen years,' he wrote, 'brought solid material success, although, with a growing family, I always felt hard up.' In 1881, Jackson went into partnership with a portrait photographer named Albert E. Rinehart, and at first the business was named Jackson & Rinehart. Rinehart eventually went off on his own, and Jackson arranged underwriting for certain major projects from Chain & Hardy, Denver booksellers, allowing him to act as a publisher and national distributor for his own and others' work. W. H. Jackson & Company became the W. H. Jackson Photographic and Publishing Company, which was finally incorporated in 1892, when a wealthy amateur photographer named Walter F. Crosby invested $10,000 in exchange for a one-third 'silent' interest in the business.

In 1881, often riding in style in the railway president's private car, Jackson traveled the main route of the Denver & Rio Grande, photographing for the railroad along the way. 'Thereafter,' he wrote, 'I spent part of every summer on the rails, for one road or another, and usually with a private car....' In the car Jackson would arrange to have a fully equipped darkroom set up – a far cry from his portable darktent and Hypo the mule. Occasionally, Jackson's family would even accompany him.

In 1883, after photographing the Grand Canyon, Jackson made his first trip to Mexico, on commission for the Mexican Central Railway. The following year he returned. Jackson's horizons continued to expand.

As time went on, I found my pictures for the Denver & Rio Grande paying big dividends. Other roads asked me to photograph their routes, and I could now take my pick from year to year. Hotels were also beginning to understand the value of advertising their scenic attractions; and between 1885 and 1892 I carried my camera into every corner of the land, as well as through Canada. In the summers I covered such sections as the Gaspe, the Yellowstone, Colorado, upper New York, and the White Mountains. After cold weather set in I found myself busy in Mexico or California or Louisiana or Florida. And since I enjoyed traveling even more, if possible, as I grew older, it was a thoroughly satisfactory life.

By then, there were no more American frontiers to conquer, no truly new lands to explore, no unknown vistas to discover and document. The American wilderness had indeed been tamed. The railroads had seen to that. William Henry Jackson now made his photographs not for the public good as he perceived it, but for private consumption – and, he hoped, for personal profit. In order to continue to photograph his beloved landscapes, he became the precursor of today's travel photographer, in effect a publicist for the wonders of the American West as experienced in the relative comfort of a railway car or the luxury of a Rocky Mountain spa.

Jackson was accompanied on his 1881 tour of the Denver & Rio Grande lines by his old friends, the painter Thomas Moran and the writer Ernest Ingersoll. One eventual result of this reunion was Ingersoll's illustrated book, *Crest of the Continent: A Record of A Summer's Ramble in the Rocky Mountains and Beyond*, first published in 1885, extolling the pleasures of traveling by rail through such magnificent country. Jackson's photographs also played a major role in the *Denver Times*' souvenir publication, *The City of Denver, Its Resources and Their Development*, a typical example of local boosterism. At about the same time, *Gems of Colorado Scenery* was published, also featuring Jackson's photographs, to be followed by *A Souvenir of the Beautiful Rio Grande...The Scenic Line* and *Wonder Places: The Most Perfect Pictures of Magnificent Scenes in the Rocky Mountains – The Master-Works of the World's Greatest Photographic Artist, W. H. Jackson, Selected from Thousands of Negatives as the Gems of the Collection*. Clearly the W. H. Jackson credit line, appearing as it did with scores of published photographs year after year, had achieved nationwide a certain cachet.

In his introduction for the latter book, Stanley Wood called Jackson the 'magician of the camera,' and compared his monumental photographic efforts to Pygmalion's carving the perfect woman. Such hyperbole aside, Jackson was, along with his contemporaries Carleton Watkins, Eadweard Muybridge, Timothy O'Sullivan, Charles

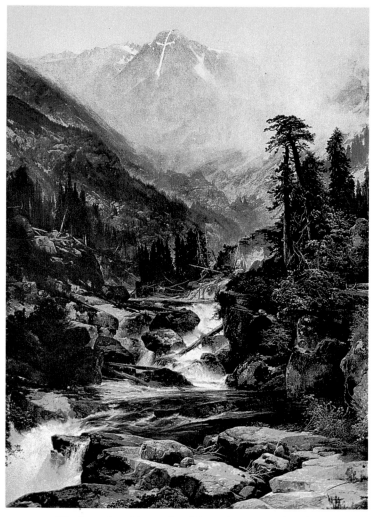

The legendary Mountain of the Holy Cross, Colorado.

Savage and A. J. Russell, pre-eminent in the field of landscape photography in America. In many respects, he was a pioneer. But other than his own particularly literal vision and his longevity, what set him apart from the others was the ease with which he seemed able to move in the world of commerce, if not always to his own benefit.

In 1892, his fiftieth year, Jackson became reacquainted with Joseph Gladding Pangborn, a former newspaperman and now the so-called 'special representative' of the Baltimore & Ohio Railroad. Pangborn, who handled advertising and publicity for the railroad, commissioned Jackson to make a number of 18 x 22 inch views of scenery accessible to the B&O lines – at the rate of $10 per picture. The mammoth-plate prints, now Jackson's specialty – his signature, in a sense – would be used in the upcoming World's Columbian Exposition in Chicago.

Pangborn also made a proposal to Jackson that at first sounded outrageous, as Jackson recalled in *Time Exposure*:

> ...Pangborn said: 'Jack, I've decided to take you around the world with me.' Then he lighted a large cigar and watched me from behind his smoke screen.... 'I think it sounds very interesting indeed,' I responded, rather insincerely, I suspect. Pangborn had so many gaudy notions that I found myself answering most of them with packaged phrases.
>
> 'Well, you'll be *sure* of it in just about five minutes,' he retorted. Then Major Pangborn sketched a world tour of fabulous proportions. He had conceived the idea of a transportation commission (with himself as head, of course) to visit foreign countries and study their railroad systems. Everything was to be conducted on a vast scale of gold braid and plumes, and it would require not less than three years of travel.

Pangborn became characteristically vague when pressed for details of financing and scheduling, however, and Jackson '...was sure I had heard the end of his round-the-world nonsense.'

That same year, the W. H. Jackson Photograph and Publishing Company, with the backing of its new silent partner, moved to greatly expanded quarters, the top two floors of the Industrial Building in Denver. 'We could hardly have picked a worse time to expand,' Jackson wrote in *Time Exposure*, 'but [Walter] Crosby and I were merely a couple of photographers, without the angular vision needed to see a severe depression just around the corner.'

Initially, Jackson was able to defer any financial problems by agreeing to provide photographs for the Chicago exposition's final report. He agreed to make 100 11 x 14 negatives for $10 apiece, then for another $1,000 sold a duplicate set to Harry Tammen, at the time, according to Jackson, proprietor of a Denver curio shop and publisher of *The Great Divide*, a journal that pitched the West as a modern paradise. 'Tammen, who later achieved a certain fame as the partner of Frederick G. Bonfils on the *Denver Post*,' wrote Jackson, 'made considerably more than that from the profits of *The White City*, as the collection of pictures was labeled when published; but I was perfectly satisfied with my share.'

Perhaps while standing in front of his own thirty-foot panorama, one of the hundred or more photographs included in the B&O exhibit at the fair, Jackson was accosted by Pangborn, who announced his world tour was going full steam ahead. And he still wanted Jackson as his official photographer. Before long, Pangborn had raised nearly $100,000, and what once seemed a hare-brained idea became an exciting reality. Having exhausted America's frontiers, Jackson perhaps envisioned the limitless horizons of a planetary adventure. In more practical terms, Jackson was promised, he believed, a salary of $5,000 a year, enough to provide for his

family in his absence. The Jackson company, much of whose business came from the continuing sales of existing stock, seemed in good enough condition to operate without him.

But on the eve of the World Transportation Commission's highly publicized departure, Jackson's promised salary evaporated, and he was offered only traveling and photographic expenses. Here were shades of the first Hayden Survey – but this time he had a wife and three children to support, and the studio could not be counted upon for that much profit. Not until the last minute did Jackson find what seemed like an ideal solution.

> I rushed to New York; and the answer to all my questions was that Mr. Payne, art editor of *Harper's Weekly*, quickly arranged to use not less than one page a week, at $100 a page. I was happy beyond possible expression. My problem was solved. In addition, my pictures and my name would be seen regularly every week by thousands. It meant free advertising, and being paid to boot.

On October 3, 1893, Jackson left for Europe aboard the liner *Bremen*. 'The tour lasted exactly seventeen months,' Jackson wrote in *Time Exposure*. 'We visited Europe, brushed northern Africa, almost encircled Australia, and penetrated deeply into many parts of Asia. Altogether we traveled close to a hundred thousand miles.'

Major Pangborn, now flaunting his new title of President of the World's Transportation Commission, proved to be more style than substance, and his much ballyhooed tour was shadowed by problems from the start. Although Jackson's portfolio swelled with new images, as any photographer's might upon encountering unfamiliar lands and sometimes exotic cultures for the first time, he would later flatly declare in *Time Exposure* that 'the World's Transportation Commission did no real work. For a time there was considerable pretense about detailed research along the way, and Major Pangborn dictated page after page of stern material to his secretary. But most of that wore off after a couple of months, and our tour became a handsome junket, with good will as our stock in trade.'

The small commission traveled by ship, rail, elephant and, through the Siberian winter, horse-drawn sledge. By and large, they were treated as visiting royalty, but the tour came to an abrupt end in Russia when Pangborn's money ran out and the original sponsors refused to re-invest in what was clearly a deception of the highest order. After a year and a half on the road, Jackson arrived back in New York with his wallet nearly empty. To make matters worse, *Harper's Weekly*, invoking its contractual agreements, retained all publication rights to the photographs Jackson made during the trip, and continued to use his images to illustrate the magazine's own editorial stance for several years thereafter, without further payment.

Upon his return to Denver, Jackson's worst fears were realized. In his absence, the business had foundered. W. H. Rhoads, the manager he had hired, had only been able to rearrange but not eliminate the Jackson Company's small mountain of debts.

> There were several circumstances – as much beyond my control as Rhoads's – which had caused us to lose ground. One was the increasing use of photographic illustration in all kinds of publications. As the process of half-tone engraving improved, not only did magazine pictures cut into the old 'view' market, but cheap (and increasingly excellent) reproductions, in color as well as in black-and-white, further lowered the demand for photo-prints. The latter had to be made one at a time, while photo-engravings could be turned out by the thousands. In addition, the hard-working photographer lacked copyright protections; his own pictures could be sold right under his nose.

On top of this was the phenomenon of almost any amateur photographer's now being able cheaply and easily to make souvenir images of his or her own travels. George Eastman's Kodak – 'You push the button, we do the rest' – had changed forever the commercial photographer's world.

'Under such adverse conditions,' Jackson wrote, 'even my considerable reputation in Denver couldn't bring in enough work, and it became quickly evident that I would have to find a new outlet. As it happened, I had already begun to investigate the possibilities of another field.'

> During my few hours in New York I had run into an old acquaintance of mine, E. H. Husher, a well-known photographer of California scenes, who had recently returned from Switzerland, where he had been sent by a group of Detroit men to study a new photo-lithographic process for reproducing pictures in color. He told me that American rights to the process had been bought by his associates and that the Photochrom Company had been organized to exploit it.... Husher, as superintendent, had recommended to his superior, William A. Livingstone, that the new company absorb the W. H. Jackson Company in order to acquire a stock of negatives. Furthermore, Husher had urged Mr. Livingstone to offer me a suitable position with the new company.

In 1898, Jackson and his wife and daughters moved to Detroit, leaving what was left of his business in the hands of his son Clarence, now grown and himself a capable photographer. The elder Jackson brought with him his favorite cameras and equipment, and a file of an estimated 10,000 black-and-white negatives, representing what he felt to be the most important pictures in his collection, many of which would be turned into screenless color-lithographic reproductions using the Photochrom process.

After a photographic trip to the Trans-Mississippi Exposition in Omaha in the summer of 1898, Jackson spent the fall familiarizing himself with the secret Swiss process and overseeing the color conversions of many of his negatives. Sizes of the final 'prints' ranged from 3 x 5 postal cards to 17 x 21 mammoth-plate reproductions to panoramas sized all the way up to 17 x 40 inches. At its peak, according to Jackson, the Detroit Publishing Company produced 7,000,000 prints yearly, including reproductions of famous oil paintings suitable for framing.

In 1899, in order to make contemporary pictures for the series, Jackson returned to his travels, and photographed along the routes of both the Chicago & Northwestern and the Delaware, Lackawanna & Western railroads. He also photographed coastal southern California, from San Diego to Santa Barbara, and then traveled to Boston to document that city's historic environs. 'Although I was in the field less than five months,' he wrote, 'I covered more than 20,000 miles.'

As he and many other contemporary photographers had throughout their careers, Jackson purchased negatives from local photographers – sometimes originals, often copies – to fill out his coverage of any given subject or area. These then became part of his collection. Previously they might be published under the W. H. Jackson Company imprint; now, along with images from his own substantial archive, they would be published under the copyright of, variously, the Photochrom Company, the Detroit Photographic Company or, most commonly, the Detroit Publishing Company, the name finally settled upon by the firm.

In the nineteenth century, the issue of individual authorship was not nearly so important as it is today, with the result that attribution in retrospect is difficult at best, and often impossible. Richard Rudisill, curator of photographic history at the Museum of New Mexico in Santa Fe, has determined that perhaps half of the photography published in a 1974 monograph of Jackson's work co-authored by the eminent American photographic historian Beaumont Newhall was actually made by others, including the Charles Roscoe Savage image used on the book jacket's cover. Indeed, Eric Paddock, curator of photography, Colorado Historical Society, points out that his institution has evidence of at least seventy-five camera operators over the years who worked for Jackson as assistants or whose work was either purchased or 'traded for' by him, including twenty-four during the Detroit years. In addition to Savage, the list would have to include, among others, such photographers as Alexander Gardner, A. J. Russell, Timothy O'Sullivan, Edwin Husher, Edward Curtis, Charles Bell, A. Zeno Shindler, Walter Chamberlain, Alfred Evans Rinehart, I. W. Taber, Arundel Hull, and Adam Clark Vroman.

In 1901, for example, as host of a special traveling exhibit of Detroit Publishing Company prints, Jackson toured the Southwest. In Los Angeles, according to biographer Peter B. Hales, Jackson stopped at the studio of fellow photographer Adam Clark Vroman and obtained a large number of Pueblo Indian photographs, many of which were published by the Detroit company and later assumed to be Jackson's.

Still, when time and conditions allowed, Jackson continued to make his own photographs. As he wrote in *Time Exposure.*, 'The "California Special"...drew great crowds at every stop.... I, in addition to giving informal talks and answering questions, made good use of the opportunity to take pictures along the line.' According to a handwritten notebook fragment now located in the New York Research Library, during one 51-day span he himself 'made negatives' on 31 days. Travel accounted for another 11 days, and on only nine of those 51 days did he make no photographs whatever. 'Made an average of about 7 exp[osures] per day for the 31 working days,' he noted.

Another notebook reveals that on a tour of the Washington, D.C./Richmond, Virginia area, he photographed a number of landmark monuments and famous buildings for use as Photochroms. To facilitate more accurate color, he wrote about one interior: 'walls buff yellow, lower half columns darker, ceiling lite yellow gloss.' Below the written words he sketched various sculptural forms and indicated colors in detail.

In 1903, when Edwin Husher retired to California, Jackson took over as plant manager of the Detroit company, thereby effecting his retirement from active photography at the age of 60. Jackson would live another 39 years, during which time he witnessed the demise by bankruptcy of his company in 1924, when its high-quality labor-intensive process finally succumbed to far easier and less expensive photo-reproduction techniques. Before his death at the age of 99 in 1942, his life having spanned almost the entire history of photography, Jackson arranged for his material legacy, a collection of some 40,000 negatives, most of them glass, to be transferred to the Edison Institute of the Ford Motor Company. Later this monumental archive, one man's visual history of the expansion years between the Civil War and the dawning of a new century, was split between the United States Library of Congress and the Colorado Historical Society.

Ironically, it was the bankruptcy proceeding of the Detroit Publishing Company that led to the preservation, in pristine condition, of thousands of never-distributed Photochrom prints in an old warehouse in Bozeman, Montana. It was from that cache that this book's selection was made.

JIM HUGHES

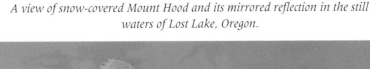

A view of snow-covered Mount Hood and its mirrored reflection in the still waters of Lost Lake, Oregon.

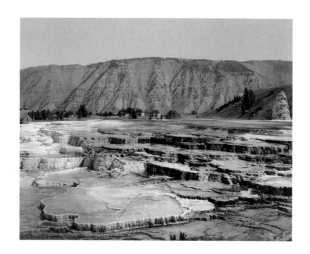

Fire and Brimstone
at Yellowstone

IN 1806 the Lewis and Clark expedition returned from its exploration of the fabled Rocky Mountains and the American northwest by way of the Yellowstone River. The following year John Colter, a member of the original party, now alone and carrying only a rifle and a thirty-pound pack, trekked back into the wilderness, following the river to its source in what is now Wyoming. There he was said to have stumbled upon hotspring cauldrons, spouting geysers and a sulfuric landscape so spectacular – and indescribable – that for decades skeptics derisively referred to his discovery as 'Colter's Hell.'

It was left to William Henry Jackson, official photographer of F. V. Hayden's 1871 U.S. Geological Survey, to bring back visual proof of the wonders of Yellowstone in the form of large, detailed, irrefutable black-and-white photographs.

At its next session in 1872, the United States Congress was moved to establish Yellowstone as the country's first National Park. Although he returned time and time again over the next twenty years, Jackson continued to be frustrated by the technical limitations of a medium which precluded his being able to record Yellowstone's astonishing colors, without which, he felt, all depictions were incomplete.

The development of the Photochrom process for continuous-tone, full-color reproductions of black-and-white photographs changed all that. And in 1898, when he joined the Detroit Publishing Company which held exclusive U.S. rights to the secret process, Jackson (always the pioneer) was finally able to realize his dream of fully capturing the awesome beauty of the remarkable place called Yellowstone.

ABOVE *Colorful mineral deposits at Hyman Terrace, Yellowstone.*

RIGHT *Old Faithful is the most famous of the geysers in Yellowstone National Park, located in the states of Wyoming, Utah and Montana. There are more geysers in Yellowstone than in the rest of the world combined.*

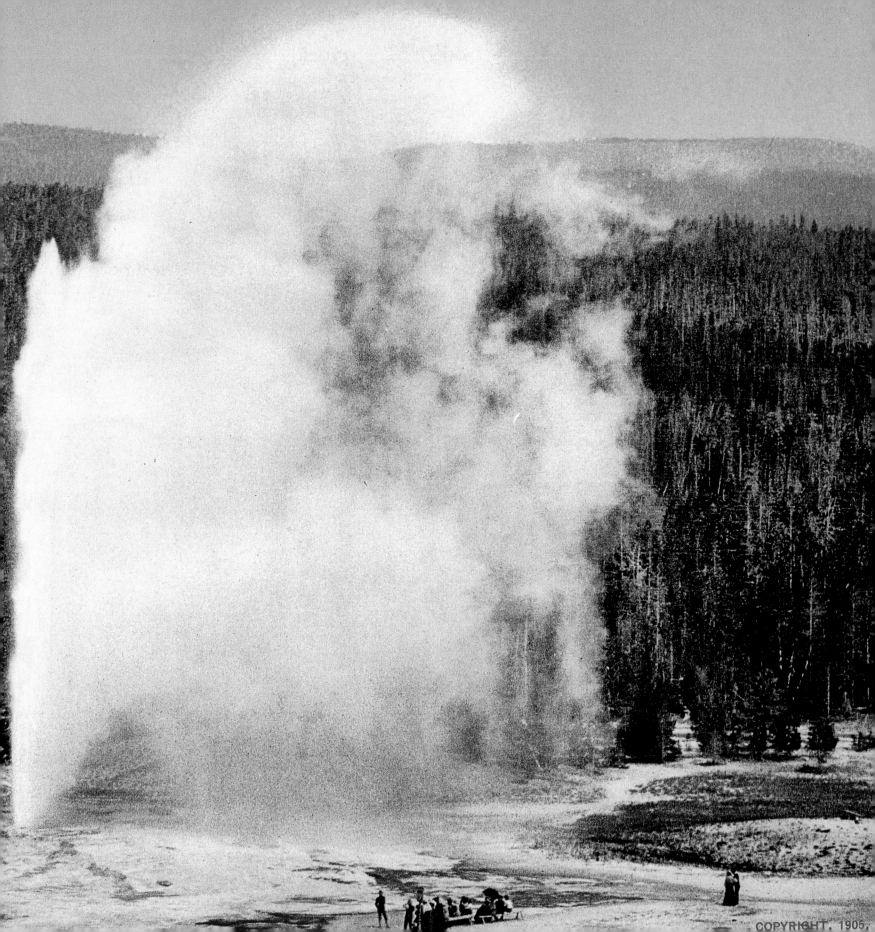

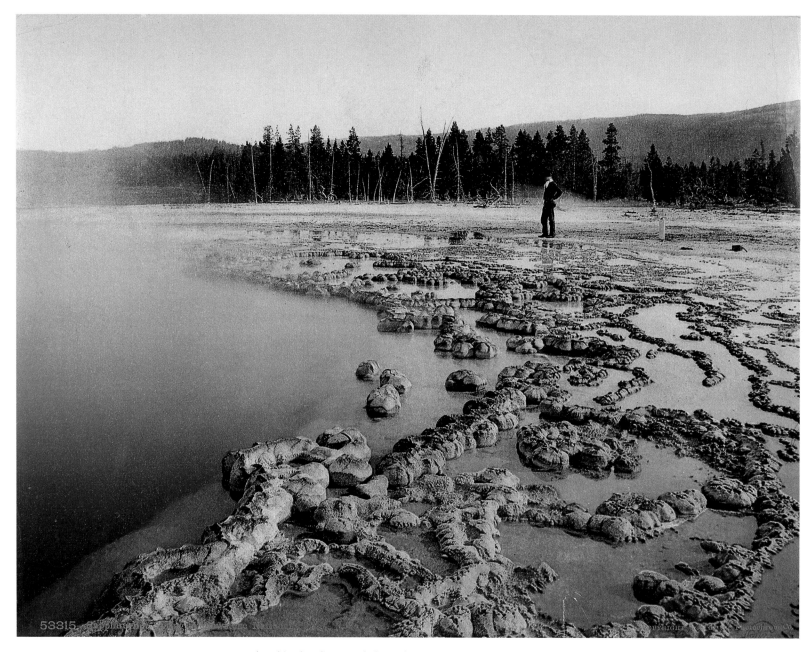

Placed in the photograph for scale, a man stands at the edge of the
steaming Sapphire Hot Spring, Yellowstone.

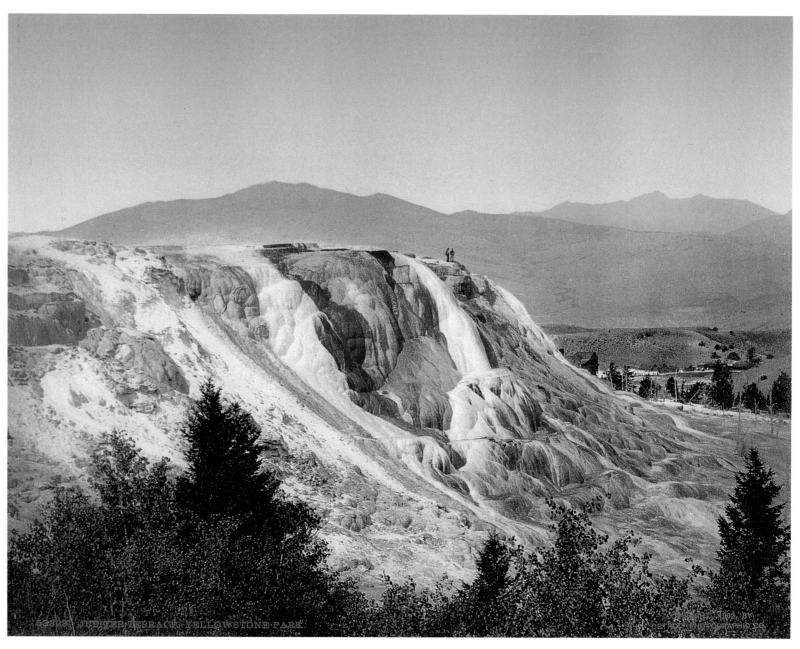

*A veritable waterfall of golden minerals formed
the Jupiter Terrace, Yellowstone.*

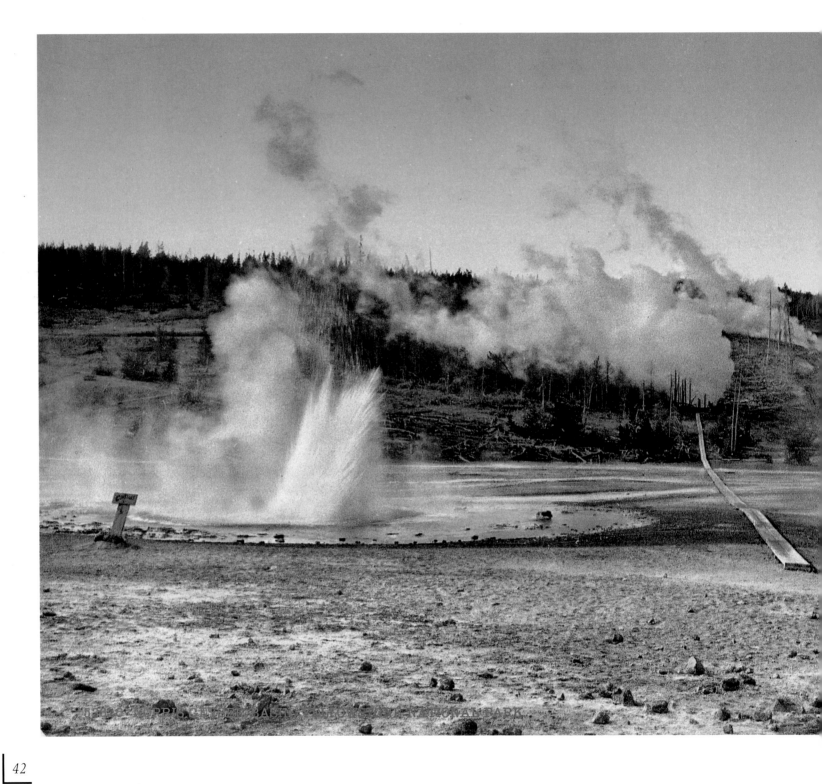

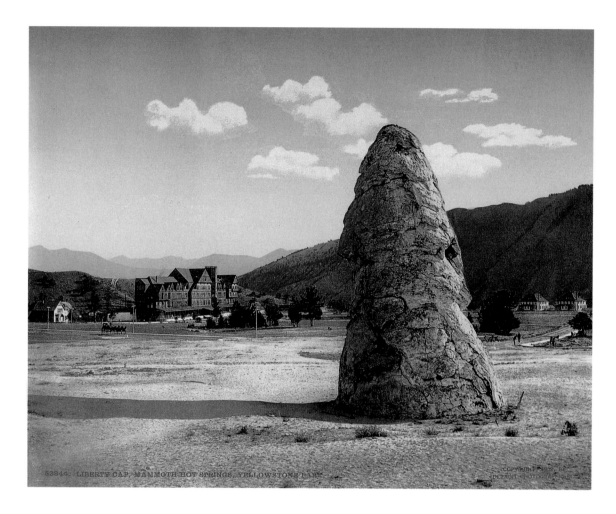

ABOVE *The view of Liberty Cap at Mammoth Hot Springs clearly depicts the encroachment of civilization in the once pristine wilderness at Yellowstone.*

LEFT *At the end of the nineteenth century, tourists were provided direct access to the wonders of Yellowstone, as evidenced by the wooden footpath bisecting the erupting Norris Geyser Basin.*

RIGHT *The ornately decorated lobby of the properly rustic Old Faithful Inn, a popular turn-of-the-century attraction at Yellowstone National Park.*

BELOW *A stagecoach full of tourists negotiates a road built alongside the Gardiner River, Yellowstone.*

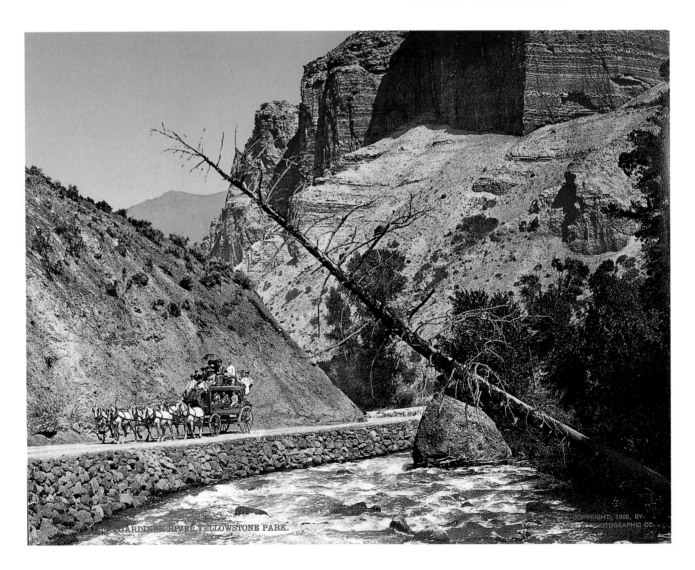

GARDINER RIVER, YELLOWSTONE PARK.

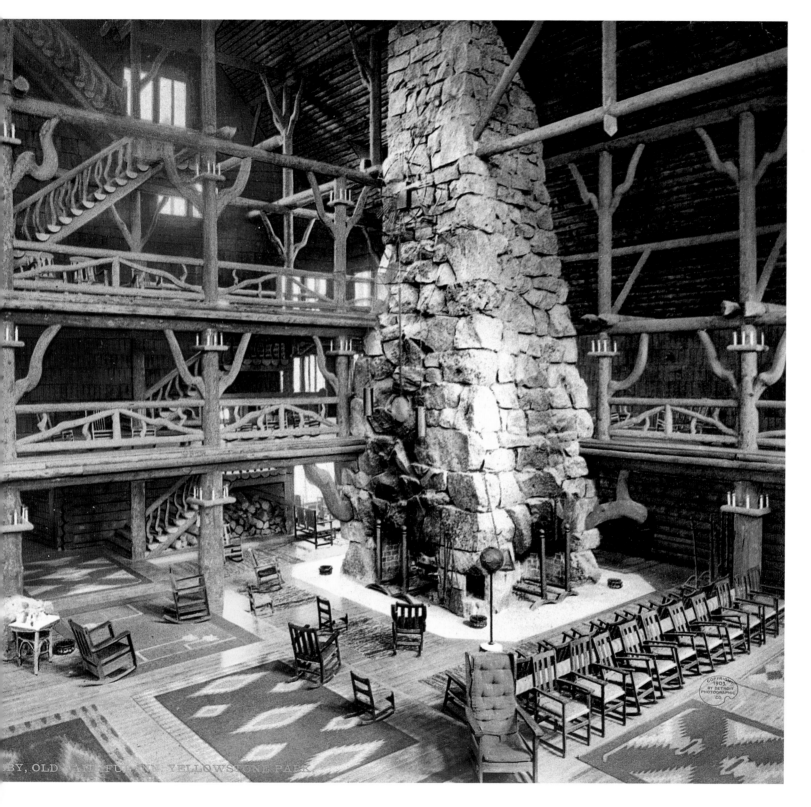

45

The Wild West as Scenery

IT MAY HAVE been the plow that broke the plains, but it was the iron horse that penetrated the wilderness and ultimately tamed the American West. Spectacular views, often in otherwise inhospitable environments, only became accessible to the public with the laying, at great human cost, of many thousands of miles of gleaming steel tracks over mountain, stream and gorge. Following his early exploration work, most of it on horseback, Jackson was engaged for a number of years by the railroads to publicize the pleasures of civilized adventure afforded by cross-country rail travel. Judging by the pictures, one of Jackson's primary objectives was to illustrate, whenever possible, the potential that existed for a positive, if ultimately mythical, nurturing relationship between man and nature.

The second half of the nineteenth century saw the burgeoning American rail system become the primary overland means of transporting goods and people from coast to coast and border to border, a dominance retained well into the twentieth century. (Not until the emergence of the automobile and its inevitable network of interstate highways did rail travel become secondary.) By the 1890s, the railroads had so opened the Great Plains to farming that the last remaining unsettled frontier finally could be said to have been breached. Ray Allen Billington, an eminent historian of the American frontier, paints a chilling picture of the result in his book *Westward Expansion*: 'Unlike those who preceded them, the [pioneer] farmers made no compromise with nature; their task was not to adapt but to conquer. They viewed the forests or grasslands of the continent as obstacles to be subdued; millions of acres of virgin timber were stripped away by their axes, millions of acres of prairie sod were turned under by their plows. They hated the Indians with a fervor...and wanted only to see the natives exterminated.... Their objective was to transform the western wilds into replicas of eastern communities, with no trace of the natural environment remaining.'

But it was this very environment whose beauty the essentially romantic Jackson wished to preserve and celebrate, and the Detroit Publishing Company's Photochrom series of American scenes represented a powerful opportunity to do so. Call this visual frontier his final one.

ABOVE *As the sun sets over the Lake Mountains, three men cast for fish from the shore of Utah Lake, near Provo, Utah.*

RIGHT *Dwarfed by dramatic mountains, a man fishes picturesque Twin Lake in Big Cottonwood Canyon, Utah.*

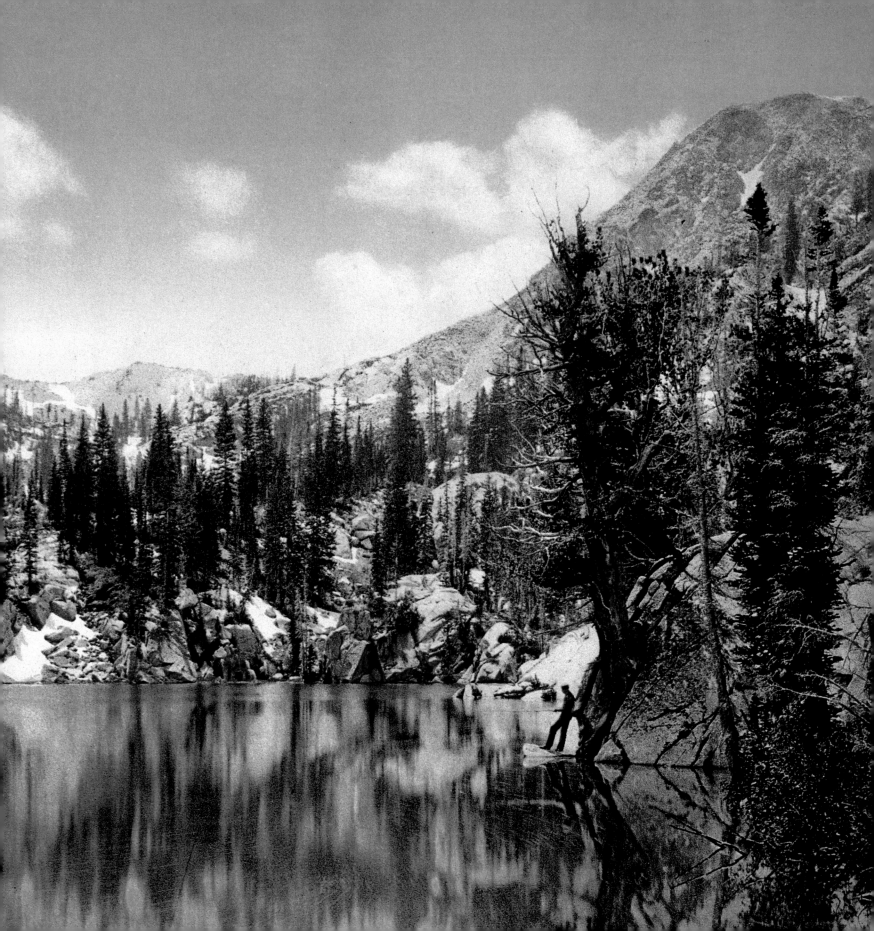

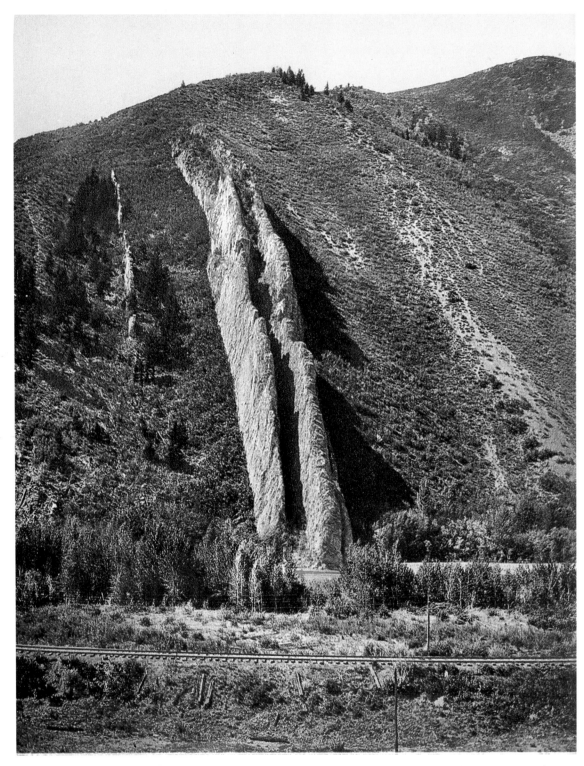

Looking across the railroad tracks to The Devil's Slide, a natural rock formation in Weber Canyon, Utah.

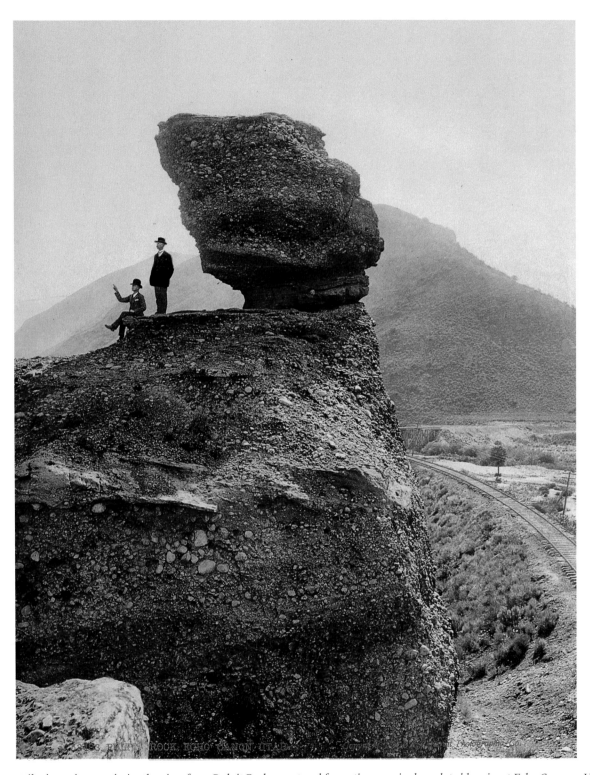

Two nattily dressed men admire the view from Pulpit Rock, a natural formation seemingly sculpted by air, at Echo Canyon, Utah.

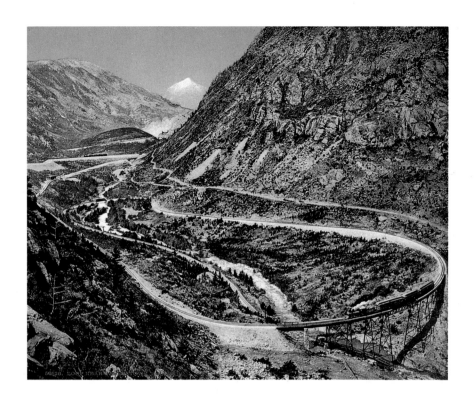

LEFT *The need to cross rivers and negotiate mountainous terrain afforded railroads the opportunity to offer riders some exhilarating experiences along the way, as evidenced by the Loop near Georgetown, Colorado.*

RIGHT *In Hagerman Pass, Colorado, wooden structures called snow sheds helped protect trains against winter drifts and avalanches while turbine-like plows were used to keep tracks clear.*

BELOW *Steam locomotive passes beneath St. Peter's Dome in Colorado.*

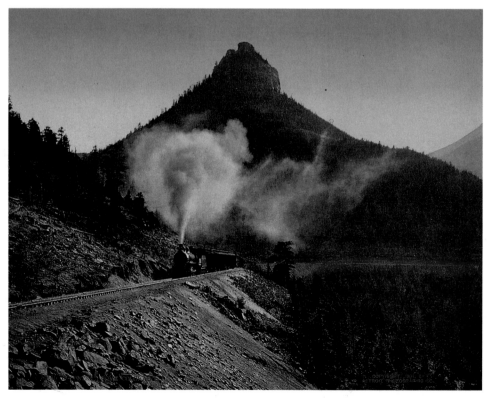

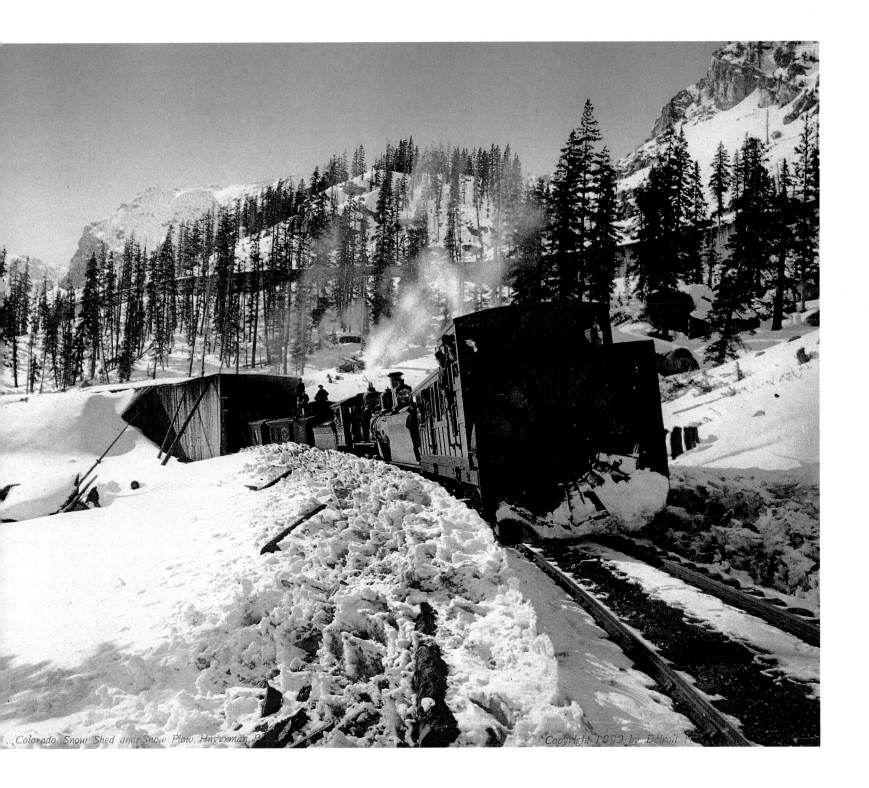

Colorado Snow Shed and Snow Plow, Hagerman P. Copyright 1899 by Detroit P.

Rocky Mountain Riches

THE AVAILABILTY OF vast expanses of virtually free land and its exploitation by an agrarian economy was only one of many reasons for the relentless occupation of the American West. It was the siren call of gold and silver that caused the young easterner Jackson to set out on his first journey west in 1866, crossing prairie lands and mountain ranges as a bullwhacker for a wagon train. Gold fever was a common malady in the fabled West, as word of strikes could spread like wildfire and populate whole areas almost overnight. The California Gold Rush of 1849 was credited with increasing the city of San Francisco's population from 800 to 30,000 in the astonishingly short span of two years. The subsequent miners' migration spread not from the east but from the west, out of California, into the mountain highlands of Nevada, Utah and Colorado, north to Idaho, Wyoming, Montana and the Black Hills of South Dakota, and south to the deserts of Arizona and New Mexico. The 'Pike's Peak or Bust' rush of 1859 drew an estimated 100,000 pilgrims to Colorado in search of unspeakable wealth said to be there for the taking, lying in streambeds or just beneath the crusty Rocky Mountain soil. The reality

proved more difficult, as the real mineral riches were buried deep inside the earth, and required increasingly sophisticated techniques to mine them. Some prospectors got rich; most did not, but stayed on with their families as settlers. Mining became big business, drawing more settlers to camps that became towns that became cities, in a boom that lasted until the 1890s.

In the Great Plains trough to the east of the mountains and deserts, cattle ranching underwent a similar development. By the end of the Civil War, 5,000,000 longhorns, most of them unclaimed, were estimated to be roaming free on Texas rangeland. With wartime restrictions lifted and a shortage of livestock in the north, enterprising Texas ranchers realized that cattle that could be sold for $40-$50 per head in the upper Mississippi Valley represented huge profits for small investments. Thus began the so-called Long-Drive, with herds of varying sizes being rounded up and driven over hundreds of miles of relatively open grazing land by small and hardy bands of cowboys on horseback, lasso in hand and sixgun in belt. The first successful trail, the Chisholm, was blazed through Indian territory to a

ABOVE *A rare photograph of an Old West cattle roundup in a Colorado corral, probably following a long drive across the Great Plains from Texas.*

RIGHT *Thousands of Texas longhorns were driven each year to the edge of the Rocky Mountains, where they were readied for market by rail to the rest of the country. Here, cowboys stop to pose during roundup on the Cimarron River.*

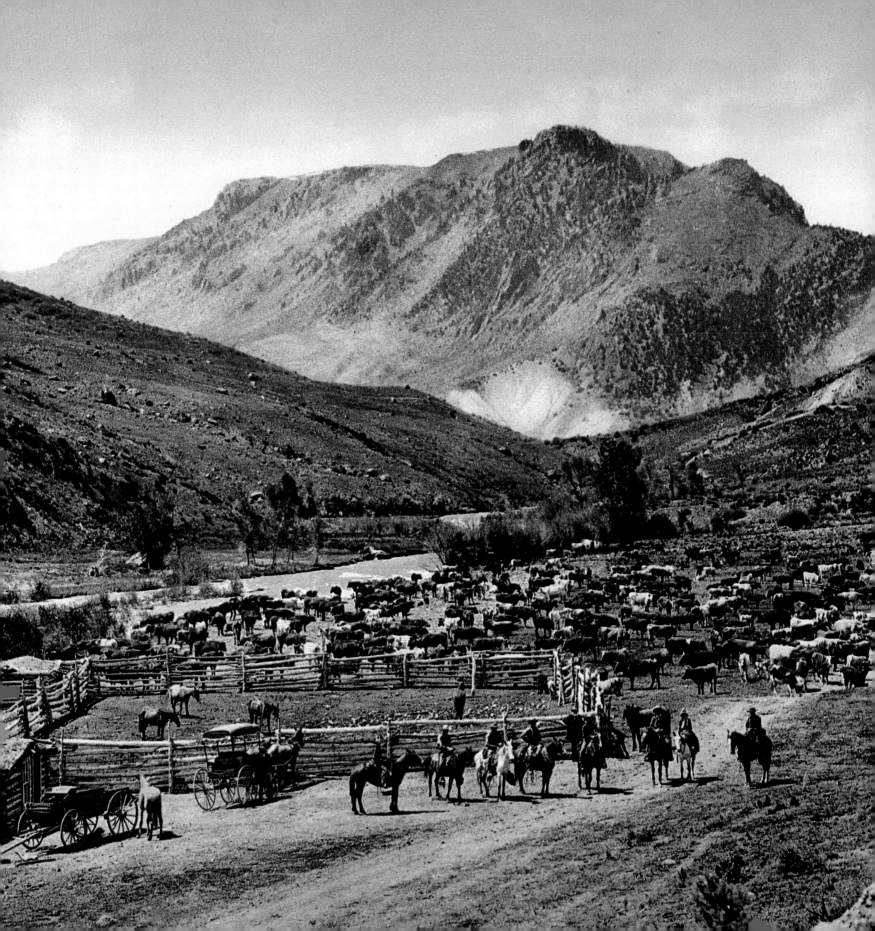

Kansas Pacific railhead in Abilene, Kansas. As settlement encroached, trails moved westward, to Ellsworth, and then to Dodge City, Kansas. Small villages were transformed into bustling and sometimes lawless Cow Towns by stockyards, hotels and saloons. A longer route, the wonderfully named Goodnight-Loving trail, was mapped farther west, and ended in Cheyenne, Wyoming, where the Union-Pacific Railroad provided access both east and west. Ultimately, ranching itself moved north, and cattle herds were established along rail routes. Word of riches to be made from cattle ranching caused another exodus from the east. As with gold fever, only a few who came succeeded. But many of the rest became available for settlement, as farming, with the aid of new technology from the industrialized east, took its inevitable dominant hold on the arable land.

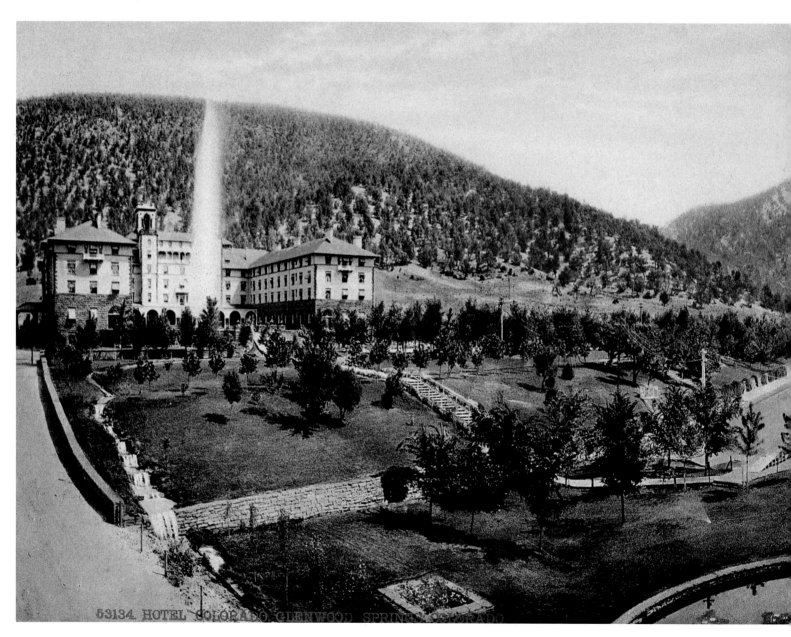

53134. HOTEL COLORADO GLENWOOD SPRINGS COLORADO

ABOVE *This view from Point Sublime shows the spreading city of Colorado Springs in the distance, and electric lines and railroad tracks in the foreground.*

LEFT *By the end of the nineteenth century, the wilderness had been in great measure domesticated. Witness the luxurious surroundings in the midst of a once uninhabited landscape at Hotel Colorado in Glenwood Springs, Colorado.*

*The frozen waters of the Toltec
Gorge, Colorado, in winter.*

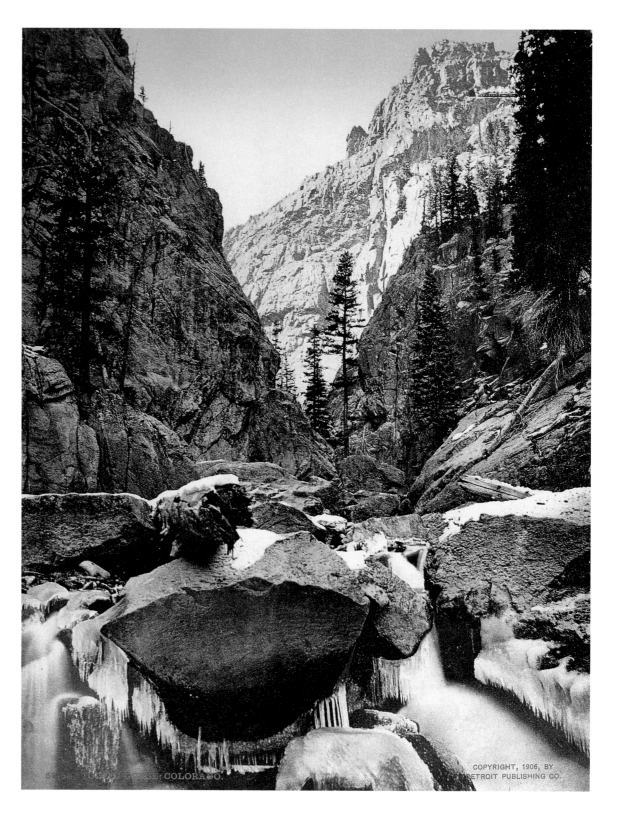

COPYRIGHT, 1906, BY
DETROIT PUBLISHING CO.

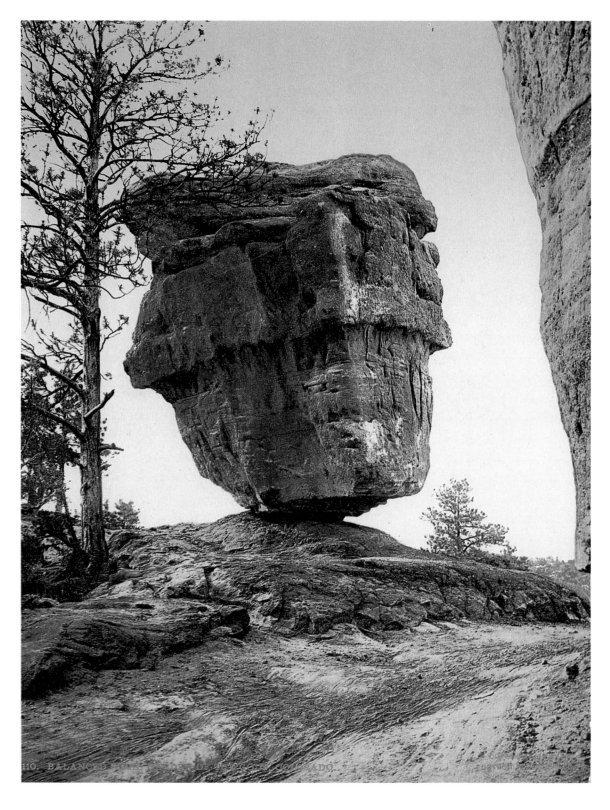

Nature worked its ancient arts in mysterious ways: here, the famous Balanced Rock, Garden of the Gods, Colorado.

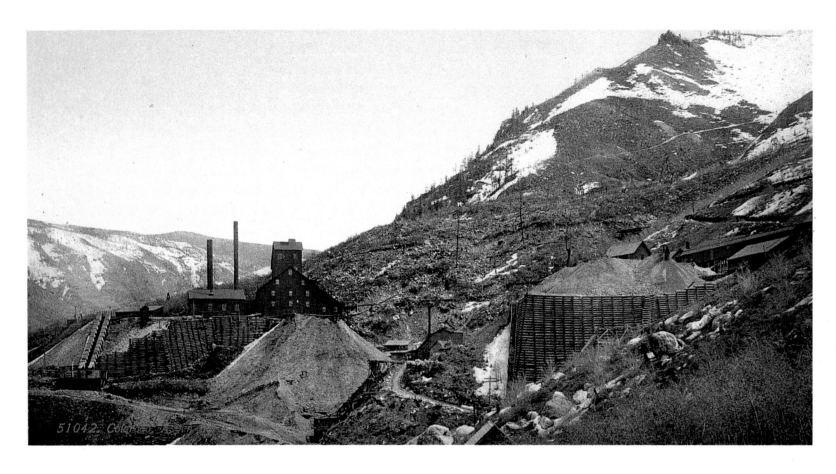

51042. Colorado

By the end of the nineteenth century, mountainsides were frequently scarred by the industrial reality of silver mining. ABOVE *The Aspen Silver Mines complex at Aspen, Colorado.* RIGHT *Colorado's Battle Mountain Mines at Cripple Creek.*

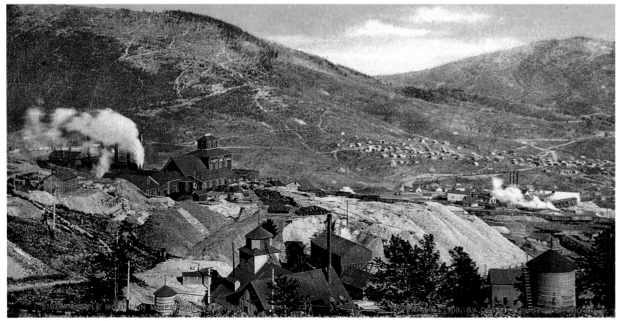

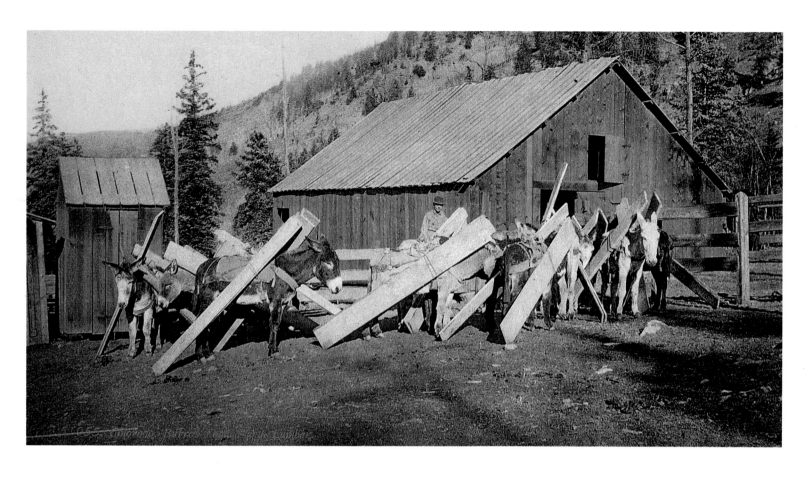

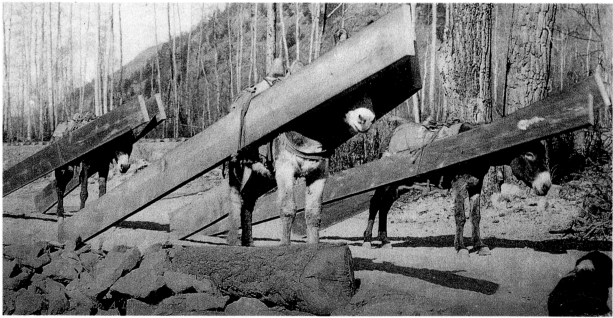

Hauling lumber in Colorado mountain country was hard work, even for burros.

RIGHT *Stacked ingots of silver bullion were the valuable product of the increasingly sophisticated business of mining the earth's natural resources.*

BELOW *'Cabins' dug into the mountainside provide shelter for the mining engineers who by the turn of the century had all but replaced early prospectors.*

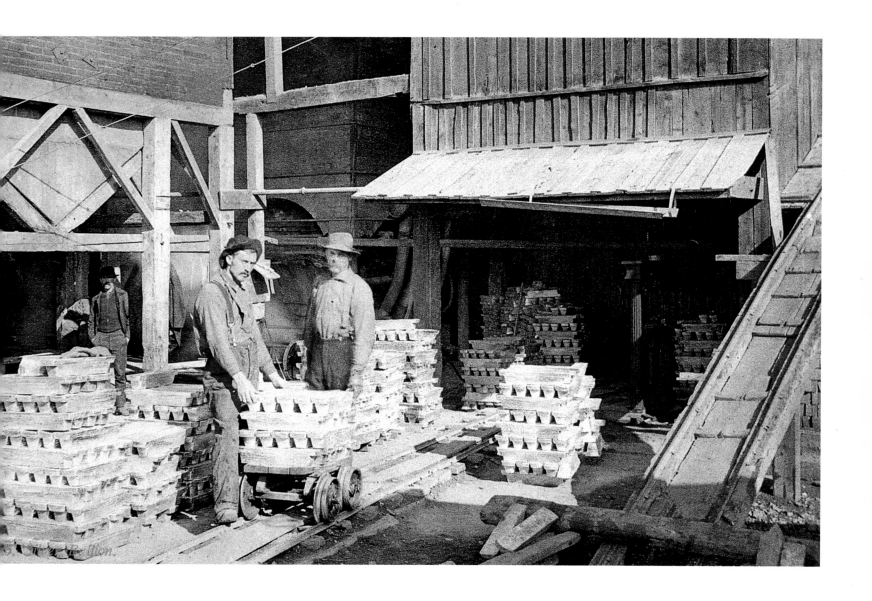

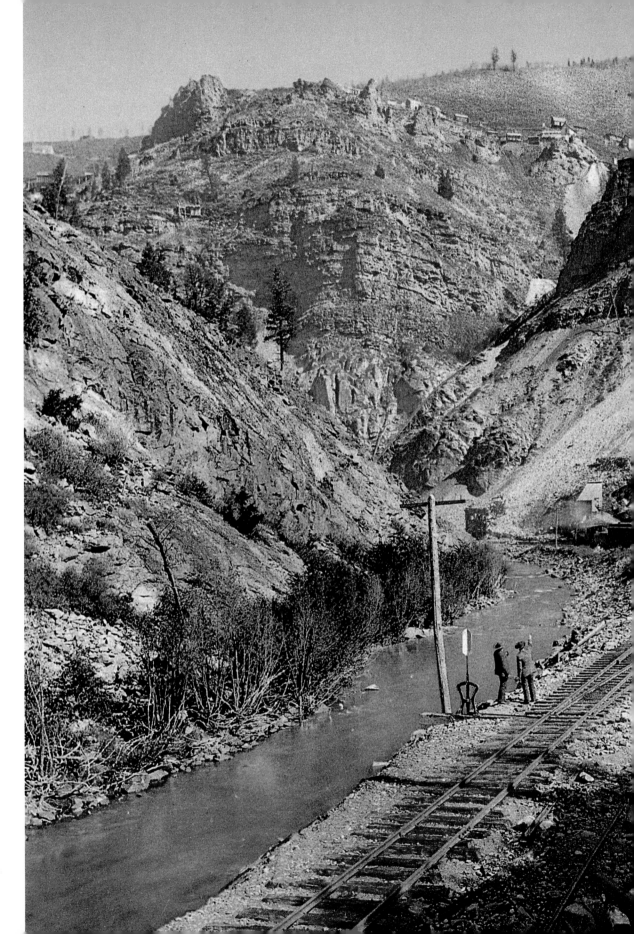

Silver mines line the steep sides of the Eagle River Canyon in Colorado, bringing with them the need for surrounding settlements.

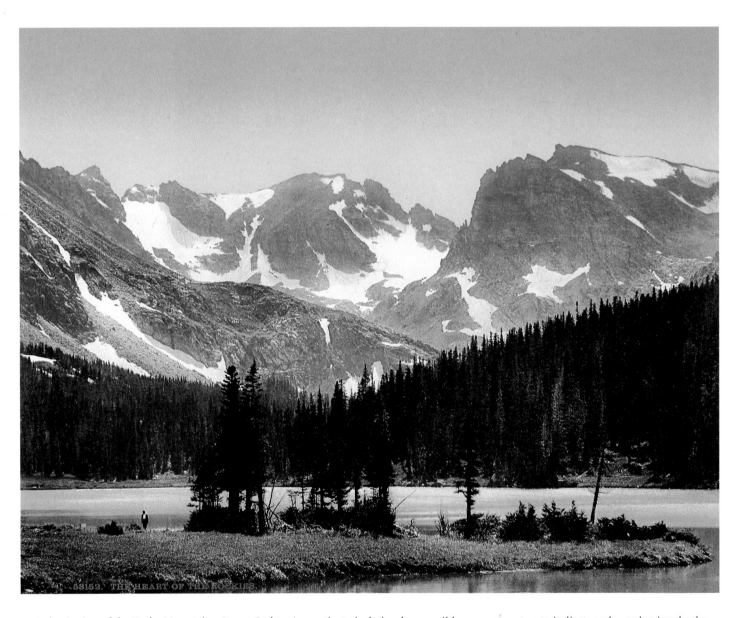

A classic view of the Rocky Mountains. It was Jackson's practice to include when possible a person or two to indicate scale, and to invoke the symbiotic relationship between man and nature he felt was not only possible, but desirable.

OPPOSITE *The remnants of a previous civilization: the Cliff Palace dwellings at Mesa Verde, Colorado.*

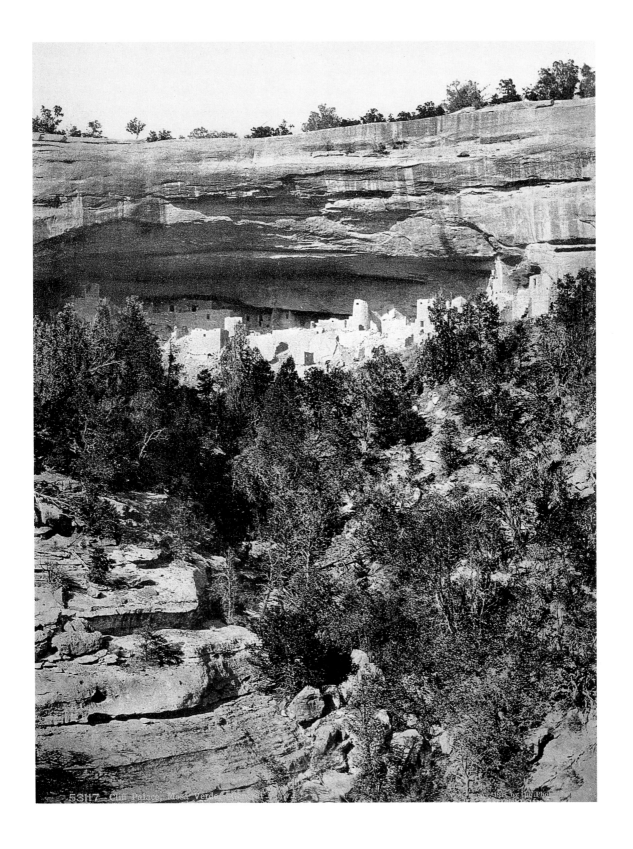

53117—Cliff Palace, Mesa Verde (General)

The Promised Land
in Utah

UTAH DID NOT become a state until 1896, shortly after the church of Jesus Christ of Latter-Day Saints, whose members constituted the great majority of the territory's population, officially agreed to prohibit polygamy, a practice banned in the rest of the United States since 1862. The Great Salt Lake Basin was settled by Brigham Young and his beleaguered Mormon followers in 1847, who turned the arid and inhospitable desert into a veritable paradise by dint of discipline, enterprise and cooperative effort. Although he later expressed misgivings about their religious beliefs and unconventional lifestyle, William Henry Jackson, physically exhausted and virtually penniless, was himself given refuge by a Mormon family in 1866 during his first journey west across the Rockies, a respite of reflection and artistic renewal that marked a turning point in his life.

By the turn of the century, the area's primarily agricultural economy was in the process of giving way to one more dependent on the commercial mining of the state's vast and varied mineral deposits. Tourism, attracted in particular by the phenomenon of a 1,750 square mile body of salt water – landlocked more than 4,000 feet above sea level, and endowed with supposed curative powers – had become another major industry. Salt Lake City, with its unique architectural landmarks and spectacular views, was the first destination of choice.

ABOVE *The Garfield Boating Pavilion in Utah's Great Salt Lake
here takes on a transparent, almost spiritual aura.*

RIGHT *The dramatic Eagle Gate, whose soaring spirit
overlooks Salt Lake City, Utah.*

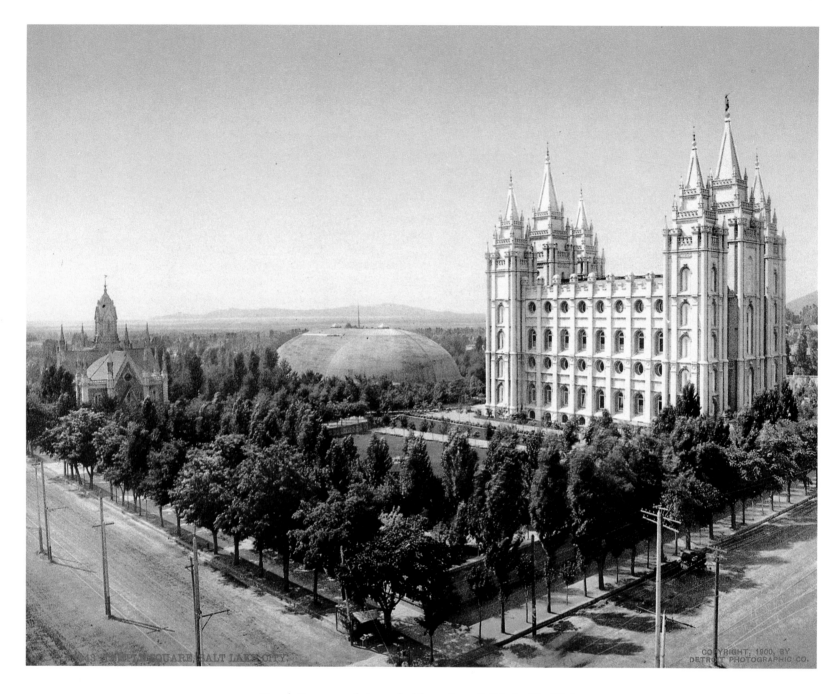

Temple Square as photographed from above, Salt Lake City, Utah.

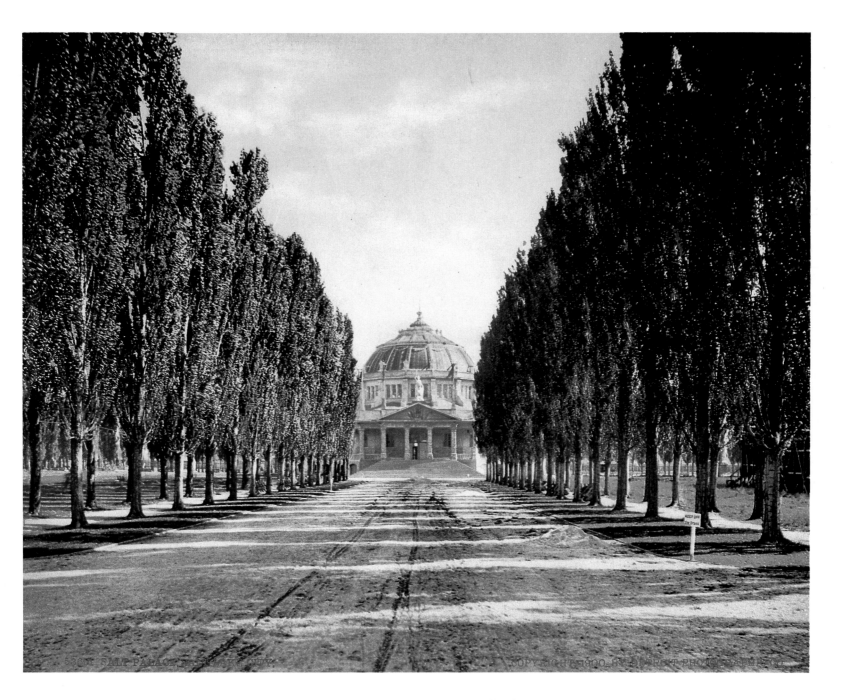

For Mormons, all roads led to the Salt Palace, Salt Lake City, Utah.

The famous Saltair Pavilion turned the Great Salt Lake into a spiritual experience for residents and visitors alike.

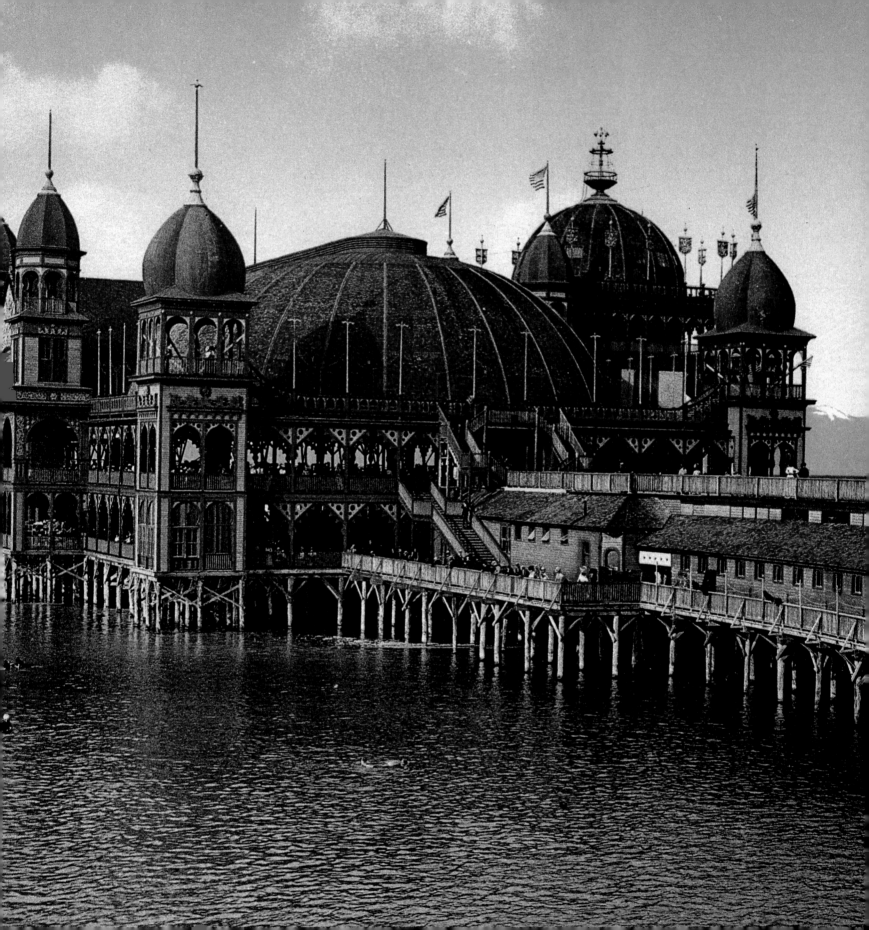

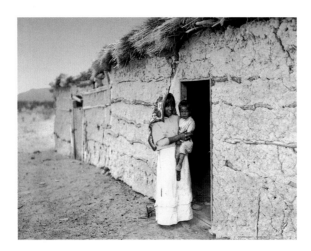

The First Americans

FOR GOOD OR BAD, images of native-American Indians stirred the public imagination and were a staple of early postcard publishers. The so-called 'Indian Policy' pursued by the government in Washington after the Civil War had as its goal the taming of the American West, making it safe for tourism, land exploitation and settlement. This shameful episode in American history resulted in much bloodshed as the nomadic Indians, their symbiotic relationship with nature severed by the reservations they were increasingly forced to live on, resisted the inevitability of the advancing western frontier until brought to their knees by the superior force of a relentless, and some might say heartless, civilization.

The Detroit Publishing Company focused its efforts on the American southwest, an area that carried fond memories of discovery and accomplishment for William Henry Jackson, who at the end of his active career was a partner in the company and the guiding force behind amassing its historically important photo collection. Picturesque rituals and symbolic dress combined with good photographic technique – no doubt the result of Jackson's own high standards – added an air of authenticity to the company's offerings, as did the subtle and lifelike coloring of the Photochrom process.

The Indian story is endlessly fascinating, and well told in the Detroit pictures. For example, the Moki tribe, also known as Hopis, worshipped some three hundred deities, and would perform an elaborately choreographed rite for each of them. In late summer, in order to curry favor with the rain god, the Mokis would celebrate a nine-day snake dance: snake priests would gather and wash their presumably dangerous reptilean subjects while antelope priests chanted and pranced. Even hairdos told a story: two large whorles, signifying the purity of squashblossoms, indicated a maiden looking for a mate, while after marriage a Moki woman would wear her hair in loose, shoulder-length rolls.

The unresolved tragedy of the Indian story is that the pictures depict a way of life that by the end of the nineteenth century had already become virtually extinct; only in posed photographs carefully crafted for public consumption – performance now in place of ceremony – did their long and proud history seem able to survive.

ABOVE *Papago Indian woman with baby stands in doorway to mud house.*

RIGHT *Sevara, a Ute Chieftan, poses with three generations of his family.*

53408 UTE

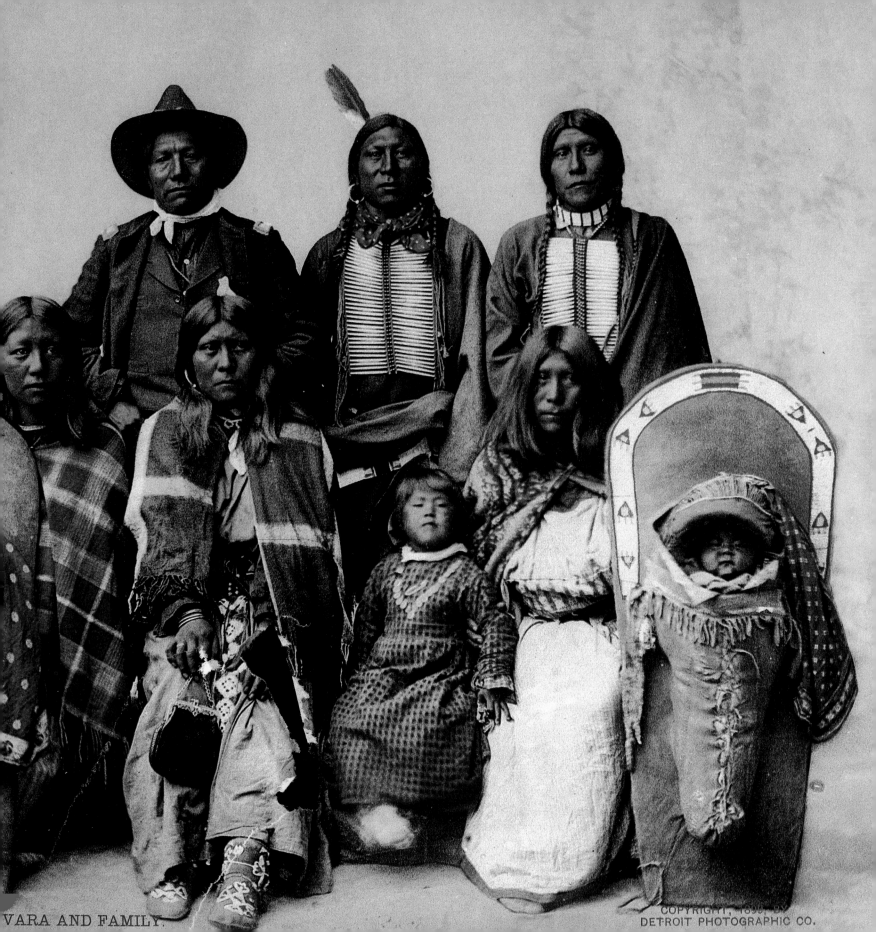

VARA AND FAMILY.

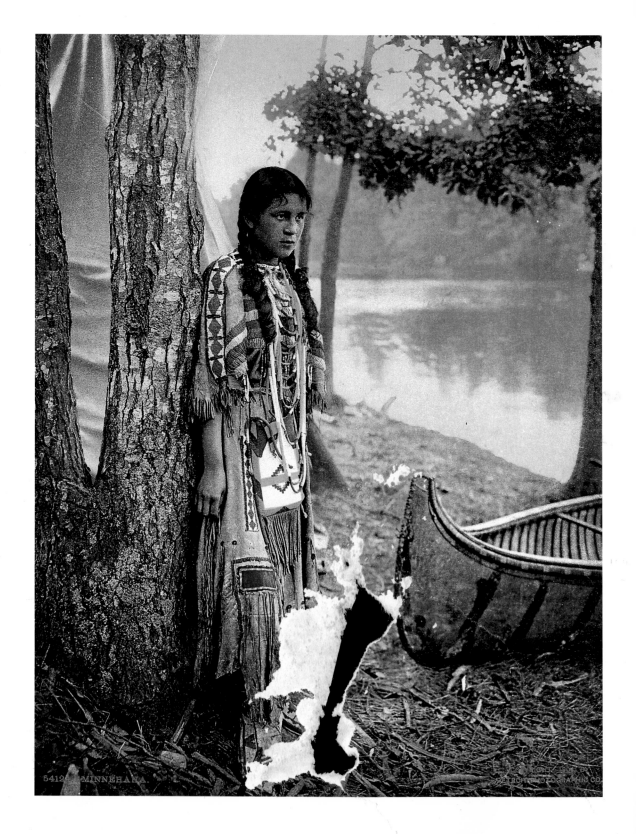

The fictional 'Minnehaha' was the wife of 'Hiawatha' in Henry Wadsworth Longfellow's epic narrative poem about the Ojibway Indians.

A member of the Moki tribe cultivates crops in arid Arizona.

53819 THE MAN WITH THE HOE

COPYRIGHT, 1902, BY
DETROIT PHOTOGRAPHIC CO.

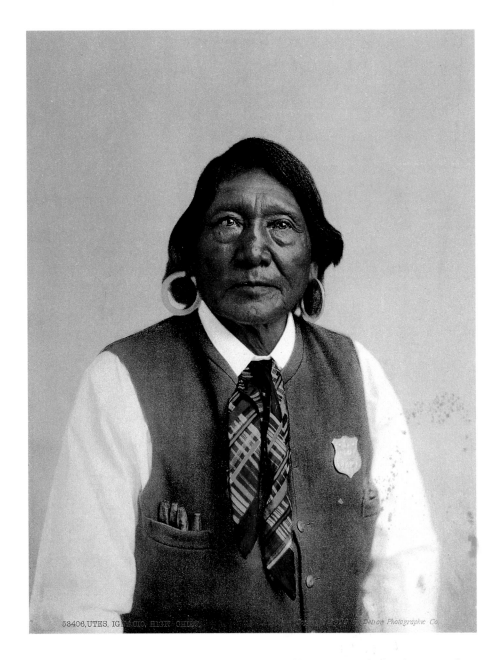

Ignacio, High Chief of the Utes, whose lands originally encompassed what is now Utah, Colorado, Arizona and New Mexico.

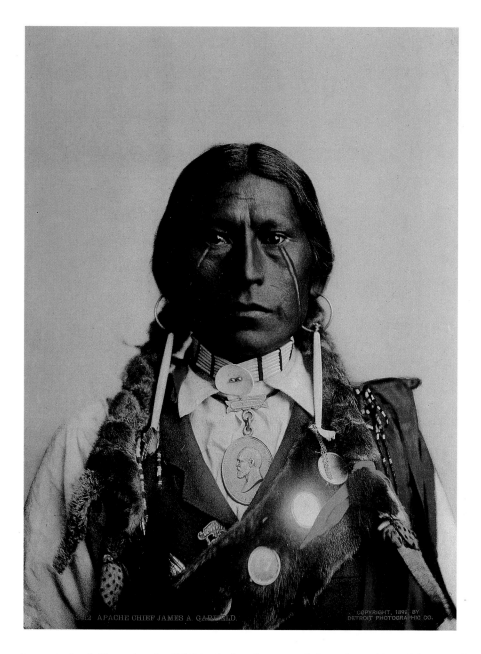

James A. Garfield, an Apache Chief, had taken the name of the 20th President of the United States, who died from an assassin's bullet in 1881. At one time, the Apaches were feared as the most warlike of the southwestern tribes.

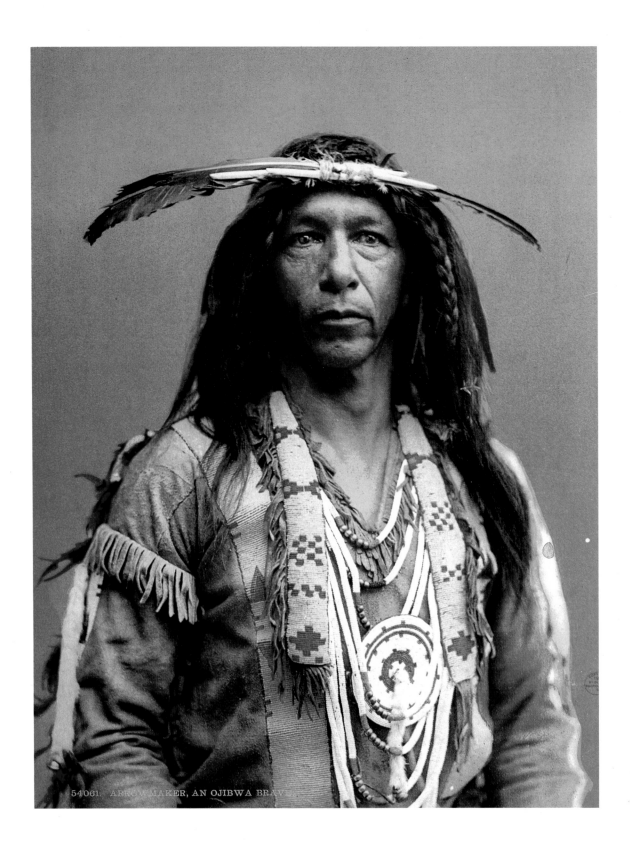

An unnamed Ojibwa brave, identified simply as an arrowmaker.

54061. ARROWMAKER, AN OJIBWA BRAVE.

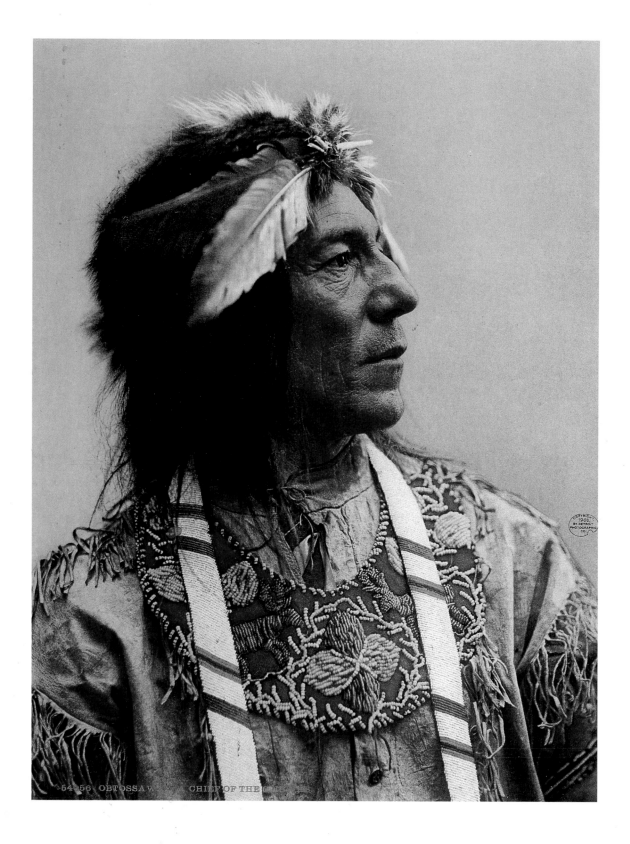

Obtossaway, a Chief of the Ojibwas,
shown in native dress.

-54-56 OBTOSSAW CHIEF OF THE

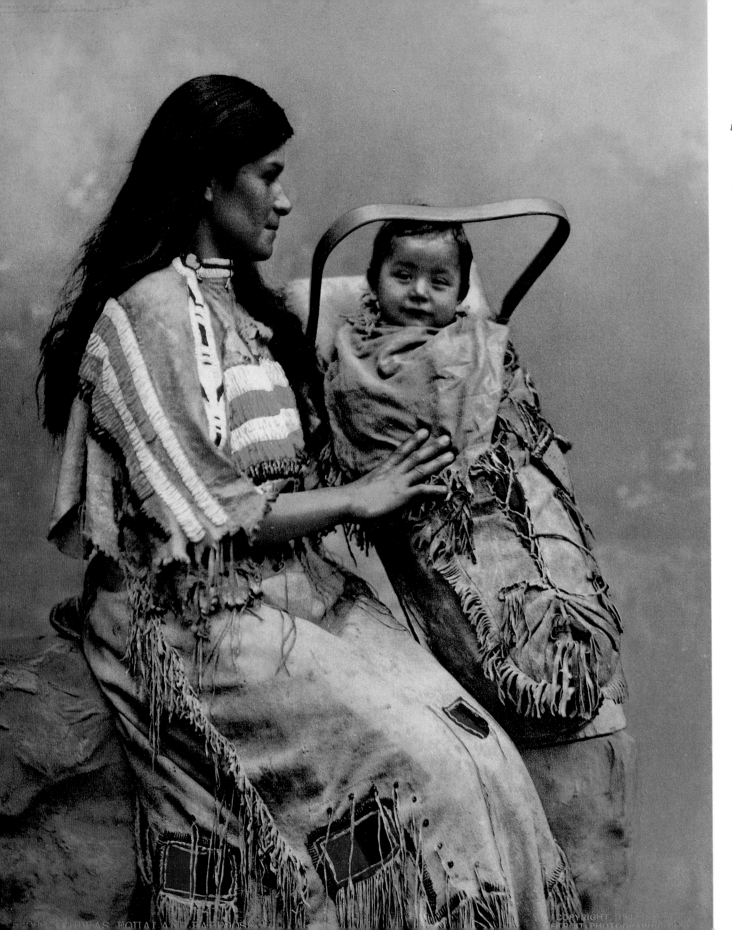

Equai, an Ojibwa,
holds her baby
'papoose,' swaddled
in leather on a native
backboard.

OPPOSITE
Taqui, a Moki Snake
Priest, posed in full
ceremonial dress.

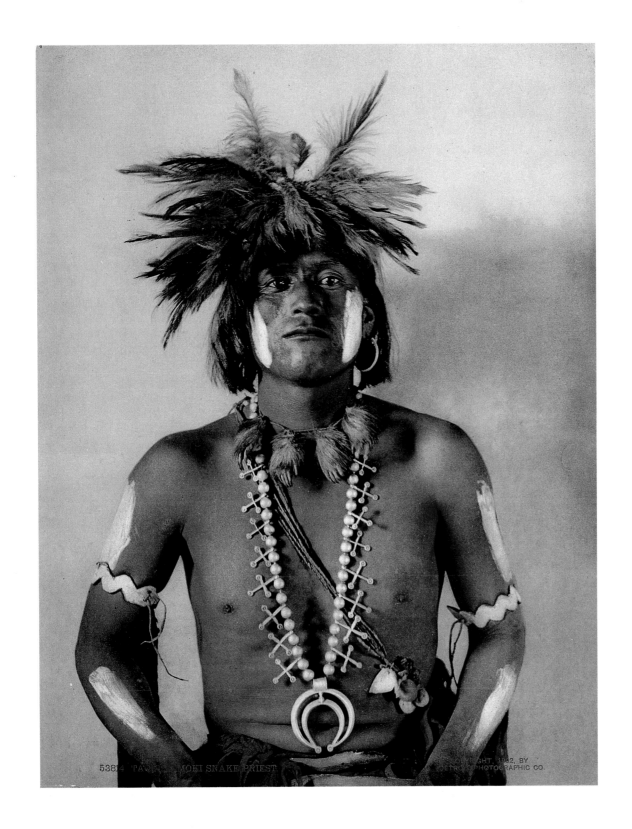

53814 TAWA MOKI SNAKE PRIEST. COPYRIGHT, 1902, BY DETROIT PHOTOGRAPHIC CO.

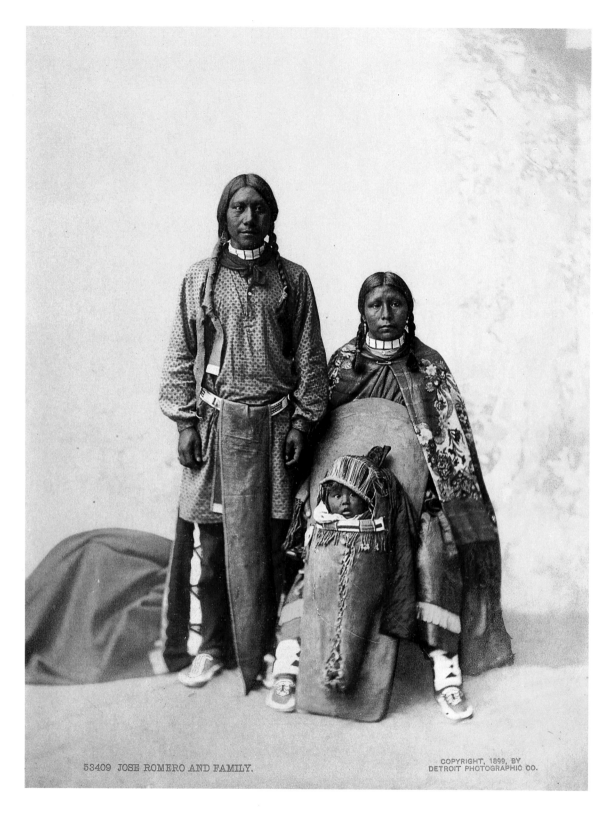

53409 JOSE ROMERO AND FAMILY.

COPYRIGHT, 1899, BY
DETROIT PHOTOGRAPHIC CO.

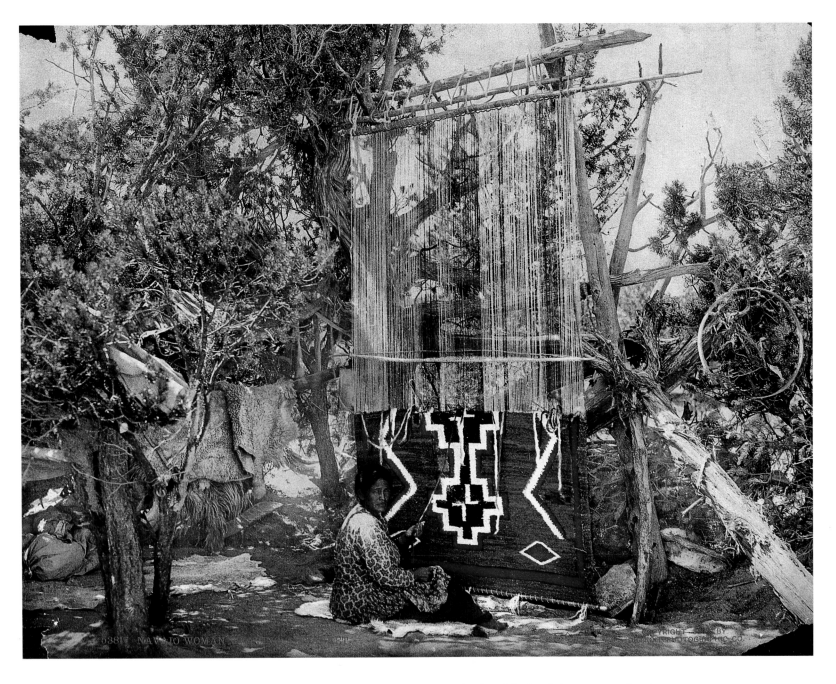

A Navaho woman fashions art from nature as she weaves an intricate blanket design on an outdoor loom.

OPPOSITE *Jose Romero with his wife and child.*

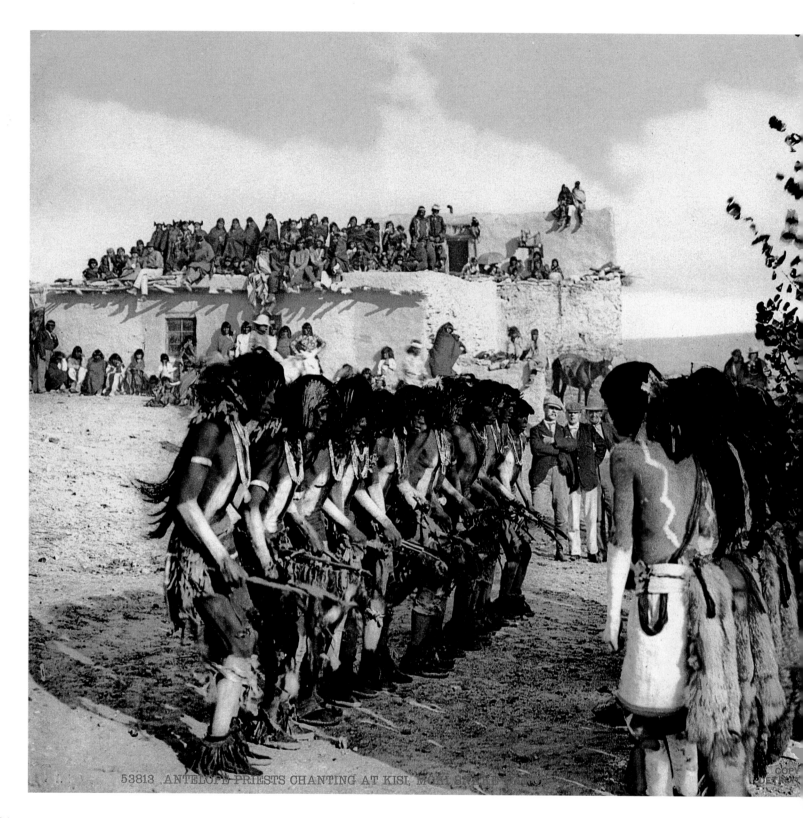

53813 ANTELOPE PRIESTS CHANTING AT KISI, MOKI SNAKE

LEFT *Antelope priests chant during an apparent re-enactment for tourists of a traditional Moki snake dance ceremony.*

RIGHT *Two women at the 'Matale,' Moki (or Moqui) Pueblos, Arizona.*

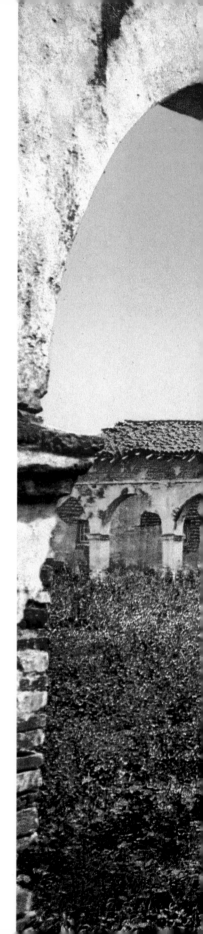

Vistas of the Pacific Coast

FROM SPANISH missions and working orange groves in southern California to breathtaking vistas and lush forests in Oregon and Washington, the Detroit Publishing Company's cameras spotlighted the visual delights of the Pacific coast that invariably held the rest of America in thrall. Those who visited bought Photochrom views as souvenirs for display back home, while those who were unable to take such time-consuming, arduous and expensive vacations were thus still able to partake of the experience vicariously.

California was originally explored and claimed by Spaniards in 1542, but it was not until the late eighteenth century that small colonies at San Diego and San Francisco were established to fend off a perceived threat to Spanish rule from Tsarist Russia. Up and down the coast, Franciscans set up missions where thousands of native-American Indians were converted, then put to work as field hands in the service of God and agriculture. Spanish

colonizers established a string of so-called *presidios* under a military government located at Monterey. In 1822, however, following its own hard-earned independence from Spain, the new republic of Mexico annexed California as a province. In June of 1846, Captain John C. Fremont declared himself president of the new republic of California. A month later, with the outbreak of the Mexican-American war, the American flag was raised and California was claimed as a U.S. territory. Fremont was displaced the following year, and in 1848, at the end of hostilities with Mexico, California was officially ceded to the United States. That same year, gold was discovered on John Sutter's ranch, signalling the start of the great California Gold Rush of 1849. Thus began a population explosion that by 1900 had reached 1.5 million, and continues apace today.

The Pacific coast states offered some of America's most spectacular scenery. One could ride an electric sightseeing tram to the top of mile-high

ABOVE *Brother Odoricus posed at an entrance to Mission Santa Barbara, the 'Queen of the Missions,' which was established in 1786 in Santa Barbara, California.*

RIGHT *The corridors of the interior courtyard of the old Mission at San Juan Capistrano, California, whose main church was said to be the most ambitious of the state's colonial buildings. Completed in 1806, it was partially destroyed by earthquake in 1812.*

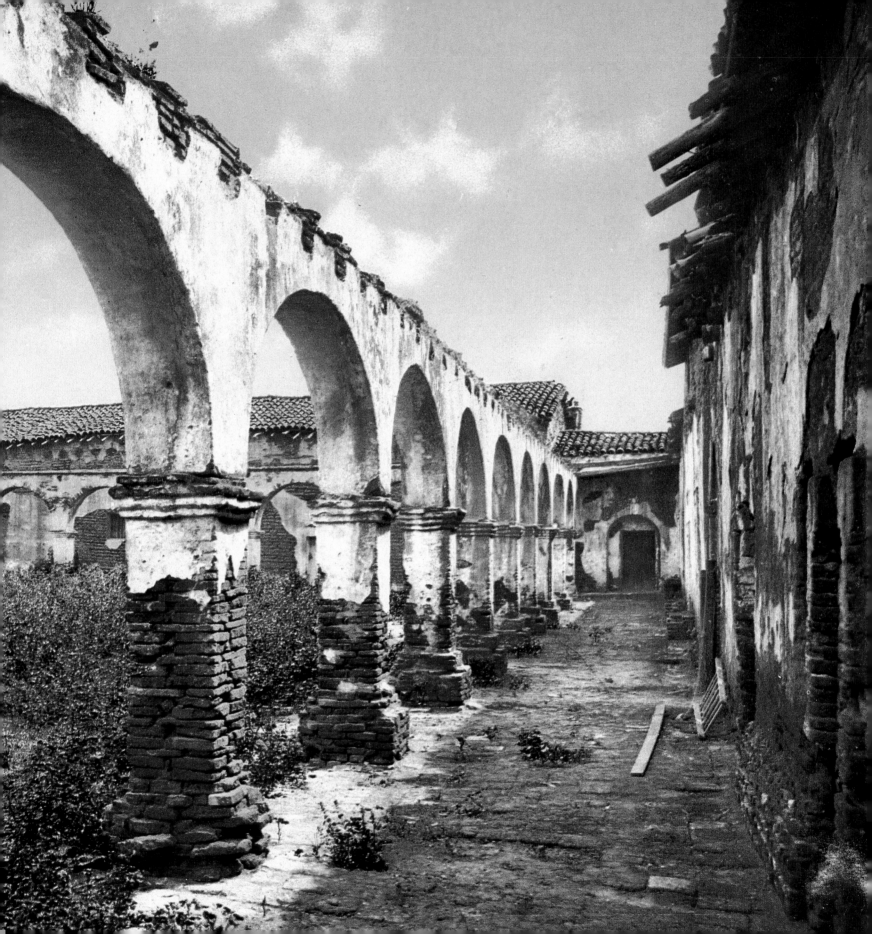

Mount Lowe, just north of Pasadena at the edge of California's San Gabriel range, to obtain a view of the Pacific ocean across a sparsely populated grid now known as greater Los Angeles, its verdant hills and canyons still pristine. To the north, from San Francisco's fabled Telegraph Hill, when the morning fog lifted one could look out over a sundrenched city to the Golden Gate itself (minus, of course, the famous suspension bridge built in 1937, but complete with the tall-masted ships of the day).

Due east of San Francisco lies Yosemite, the country's first nationally-protected area and now a National Park, where a nearly 800,000 acre wilderness of mountains and valleys have long offered the intrepid tourist irresistible pleasures that often defy gravity as well as description. Farther north, the Columbia River, 1,214 miles in length with headwaters in Canada, carved its sculptural presence first south then west, serving as a dramatic border between Washington and Oregon. Taken as a whole, the Pacific coast was as invigorating as it was varied.

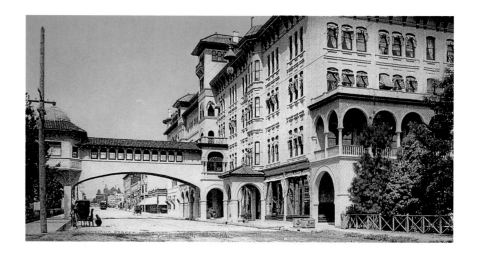

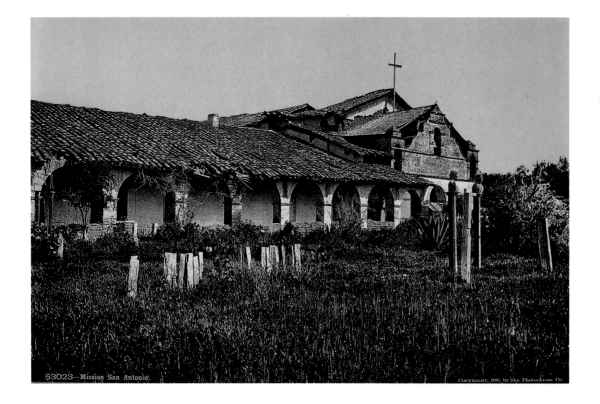

ABOVE *A view down Raymond Street beneath the glassed-in overpass to the Green Hotel in Pasadena, California.*

LEFT *The Mission San Antonio de Padua in Jolon, eight miles from Big Sur, California, was founded in 1771. At the turn of the century Jolon was a prosperous way station on a stagecoach line, but today it is a virtual ghost town.*

A laborer picks oranges from a heavily laden tree in southern California.

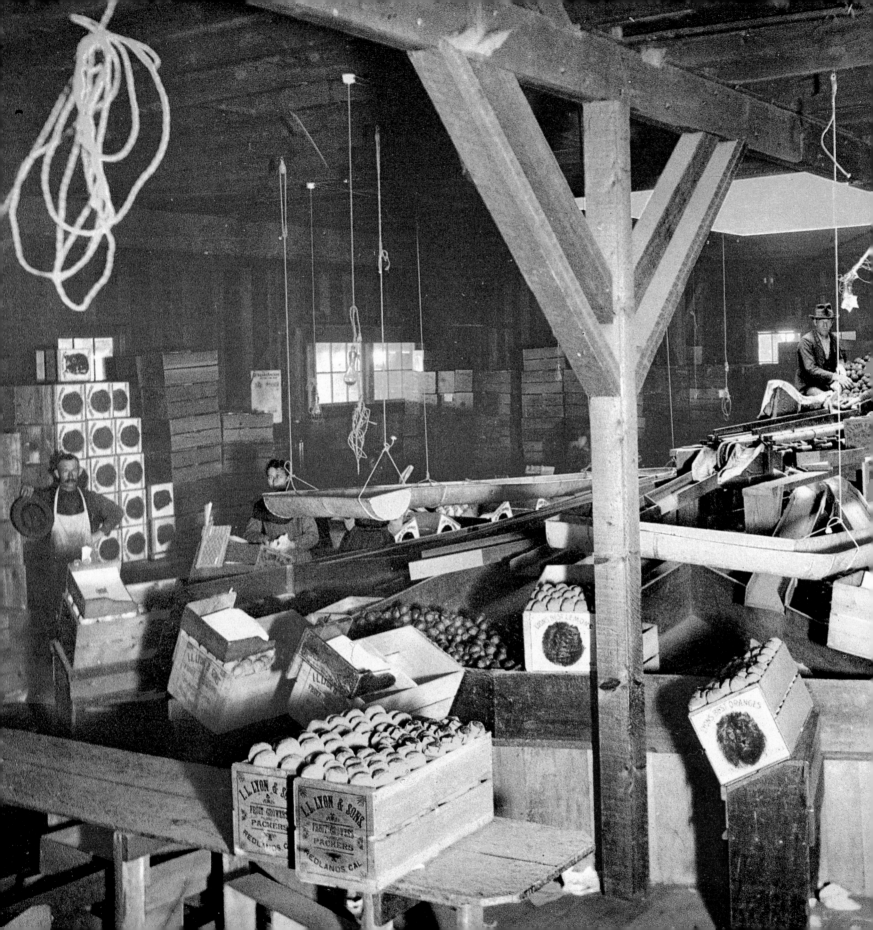

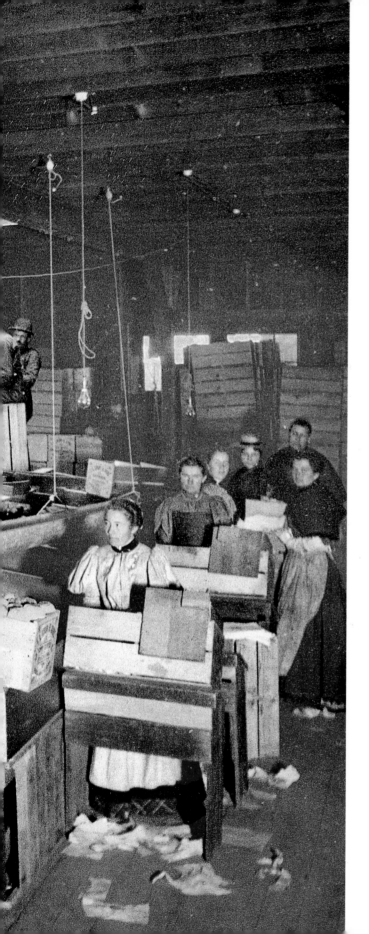

Fruit and vegetable growing was introduced into California by missionaries, utilizing natives converted to Catholicism as laborers. Here an orange grove and a pine-tree nursery thrive in close proximity.

LEFT *Men and women work together at an orange packing plant in Redlands, California.*

BELOW *Racks for drying grapes into raisins are spread out in a field to bake in the California sun.*

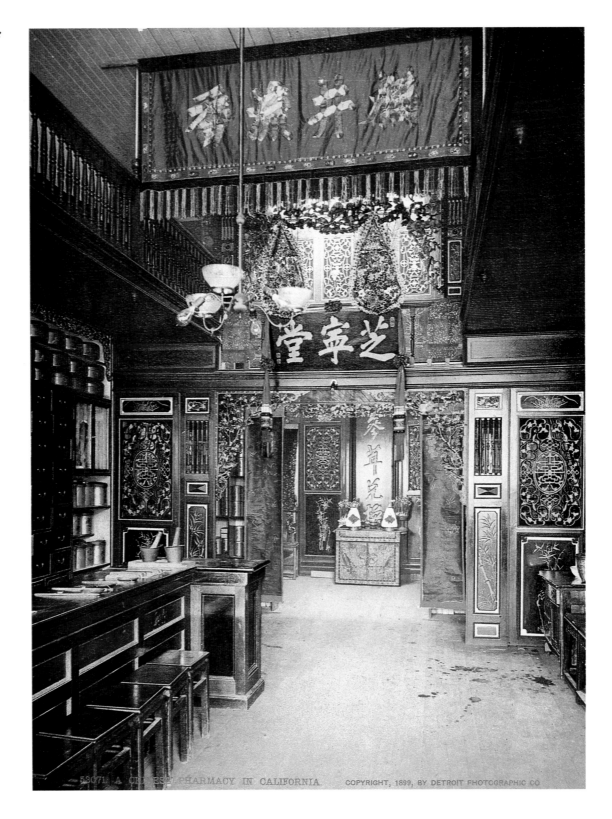

53071. A CHINESE PHARMACY IN CALIFORNIA. COPYRIGHT, 1899, BY DETROIT PHOTOGRAPHIC CO

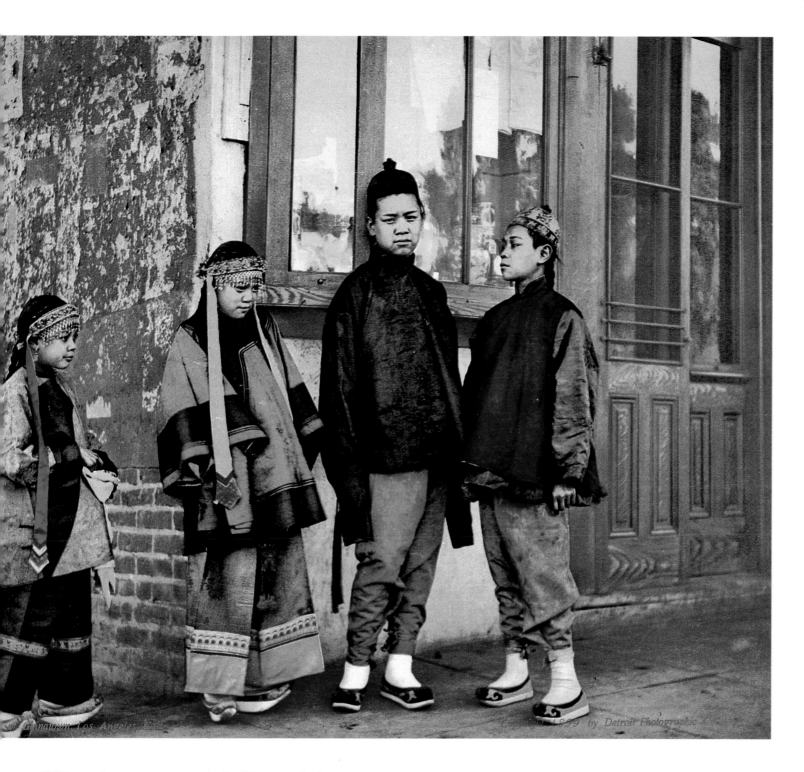

*Children gather on a street corner in the Chinatown district,
Los Angeles, California.*

53051. South View, Hotel del Coronado, California.

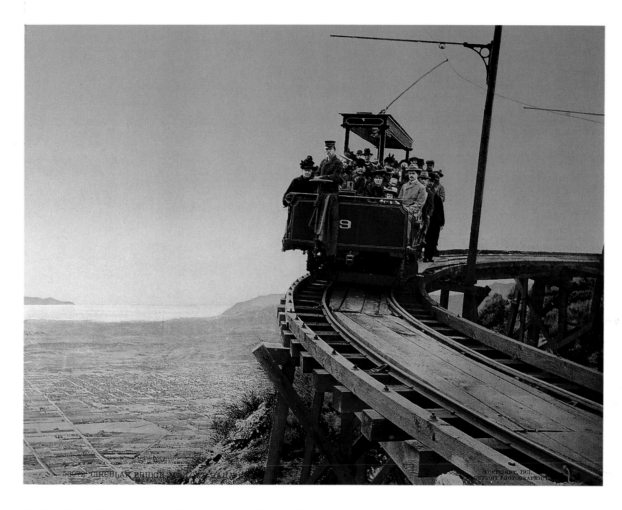

The Circular Bridge lookout on the Mt. Lowe Railway, offering adventurous tourists a magnificent vista west over what is now greater Los Angeles.

LEFT One of the most luxurious grand resorts on California's gold coast: the Hotel del Coronado, overlooking the blue Pacific Ocean at San Diego.

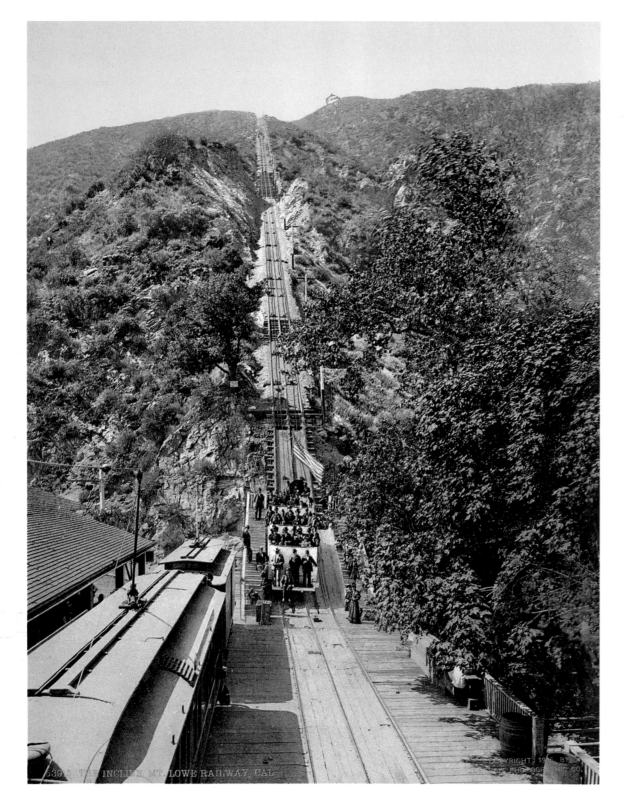

53915 THE INCLINE MT. LOWE RAILWAY, CAL.

The Incline for the Mt. Lowe Railway, which took passengers on scenic tours in the San Gabriel mountains north of Pasadena, California.

View from atop Mt. Lowe: the Echo Mountain House and the nearby Observatory.

A growing population made water a scarce commodity in southern California. The wonderfully named Sweetwater Dam outside of San Diego was an early engineering achievement.

RIGHT *The protected bay and beach at Avalon, Santa Catalina Island, California.*

BELOW *Called 'Farnsworth's Loop,' this well-traveled dirt turnaround atop a small mountain afforded tourists to Santa Catalina Island, off Long Beach, a spectacular 360 degree ocean view.*

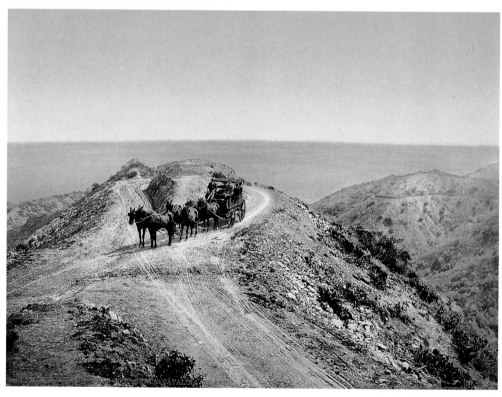

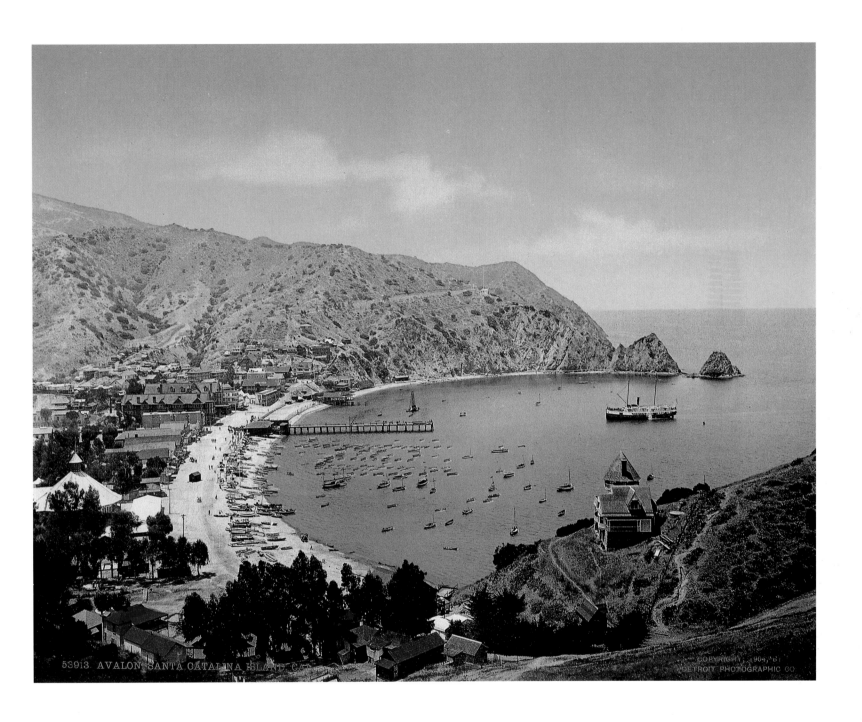

53913 AVALON SANTA CATALINA ISLAND CA

COPYRIGHT 1904 BY
DETROIT PHOTOGRAPHIC CO

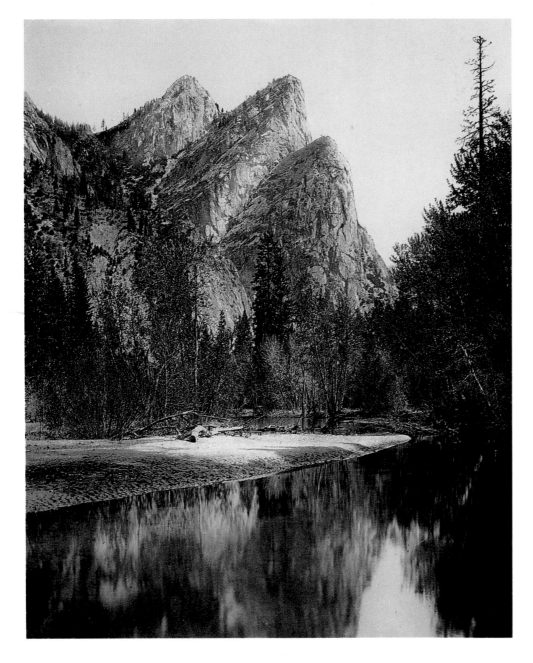

The Three Brothers peaks, as seen from the river bottom, Yosemite Valley, California.

RIGHT *A young girl tests the surf at the beach just south of the famous Cliff House, the gothic hotel precariously perched on the rocks at San Francisco, California.*

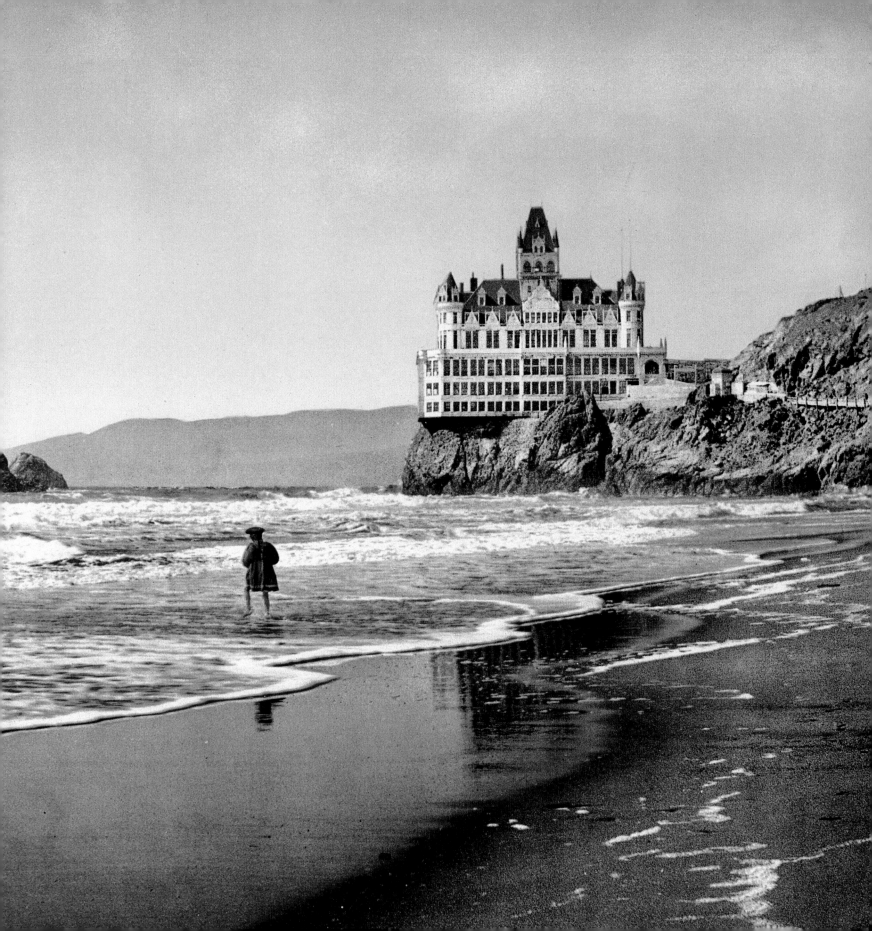

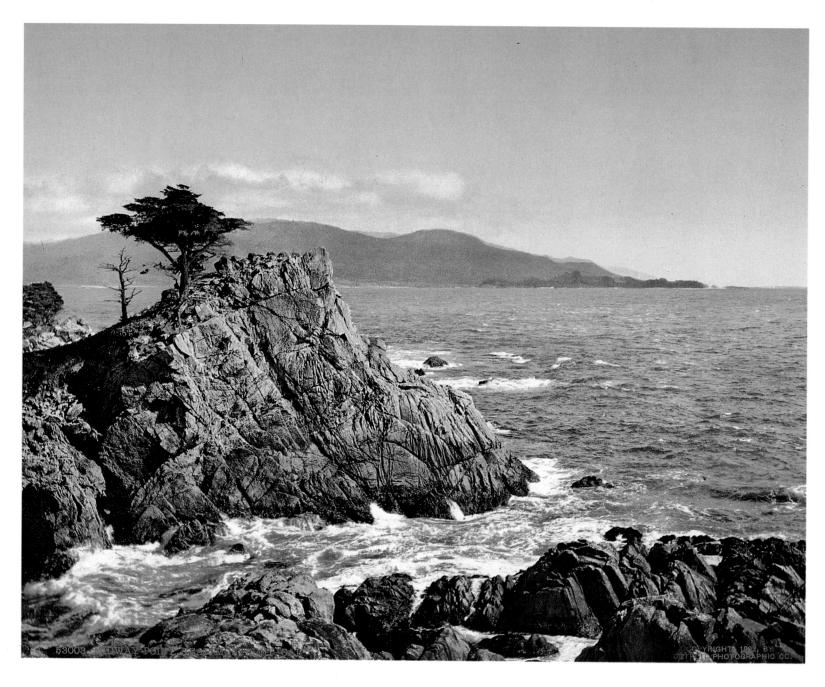

Midway Point, near what is now Point Lobos, between Monterey and the
Big Sur region, one of the most scenic ocean lookouts on the California coast.

OPPOSITE A lookout of another sort, but just as spectacular and more difficult to reach:
Glacier Point and the South Dome, Yosemite Valley, California.

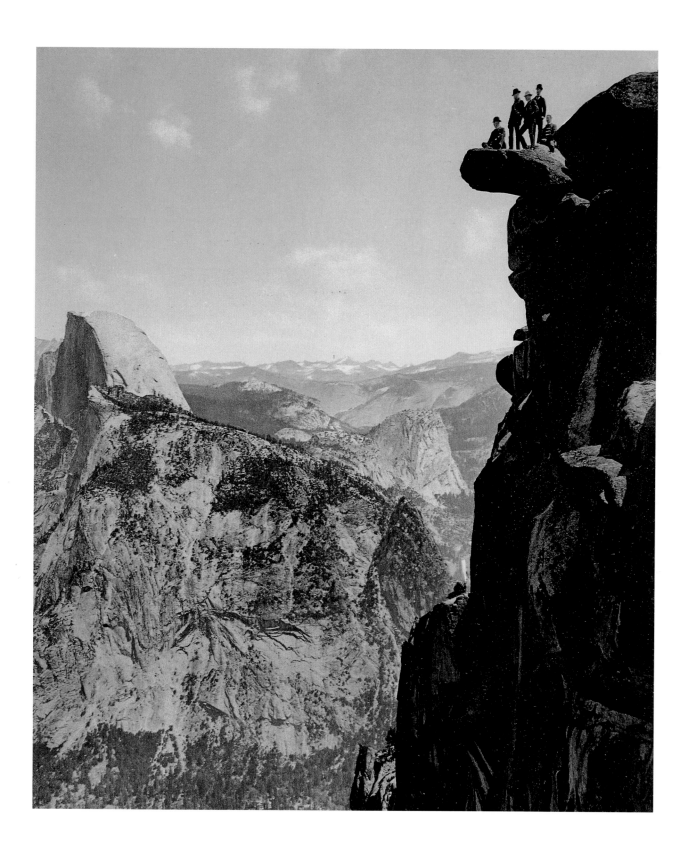

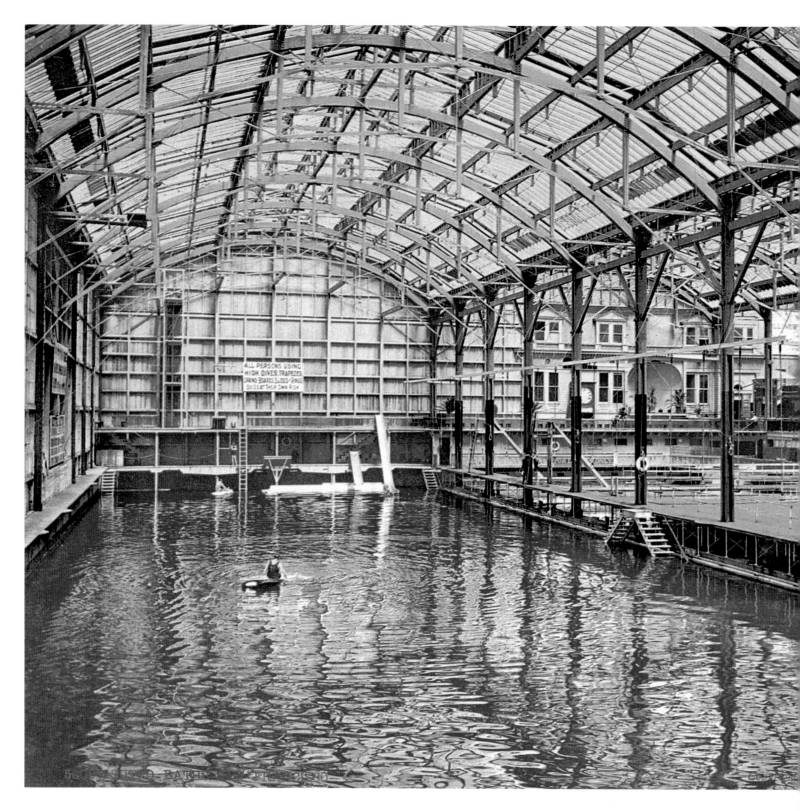

The Sutro Baths, a large, protected oceanside bathing facility in San Francisco, California.

In the distance, the golden Castle Crags, as seen from Castella, California.

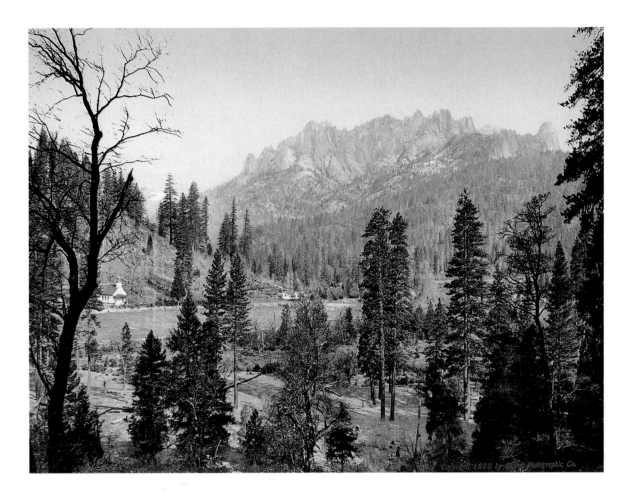

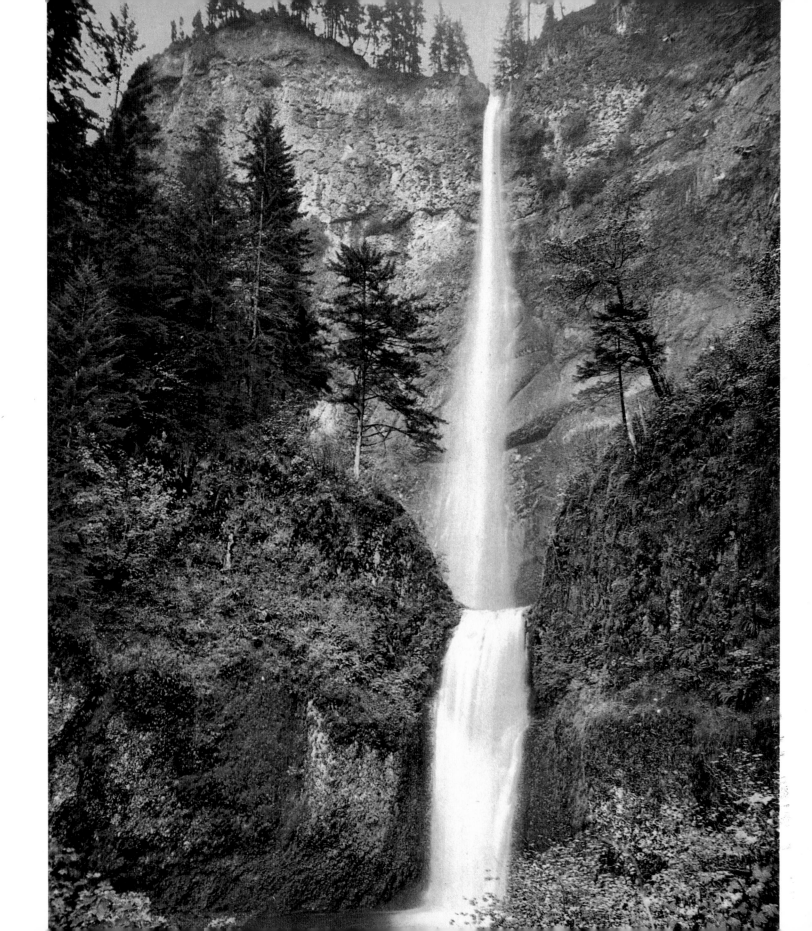

LEFT *The precipitous Multnomah Falls, near the Columbia River, Oregon.*

A lone boater rows the calm waters around Cape Horn on the Columbia River, for many miles the dividing line between Oregon and Washington.

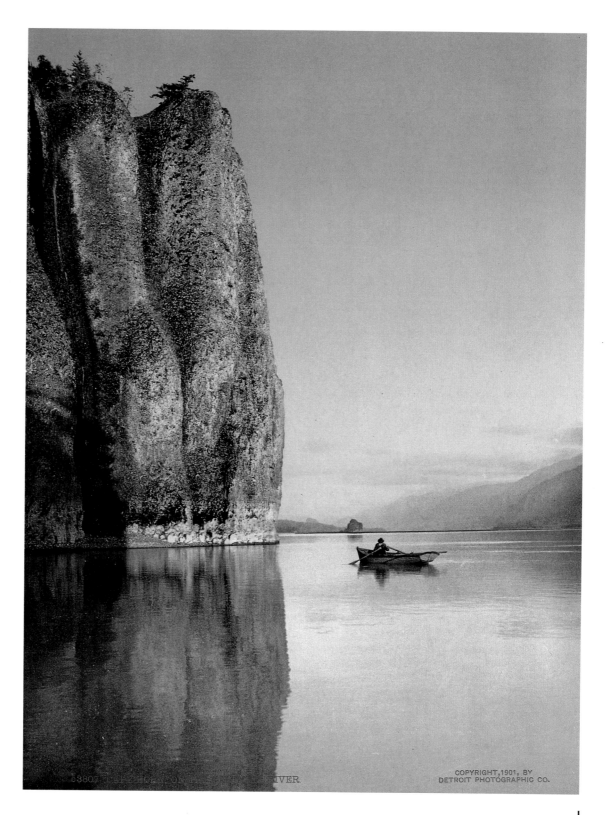

COPYRIGHT, 1901, BY
DETROIT PHOTOGRAPHIC CO.

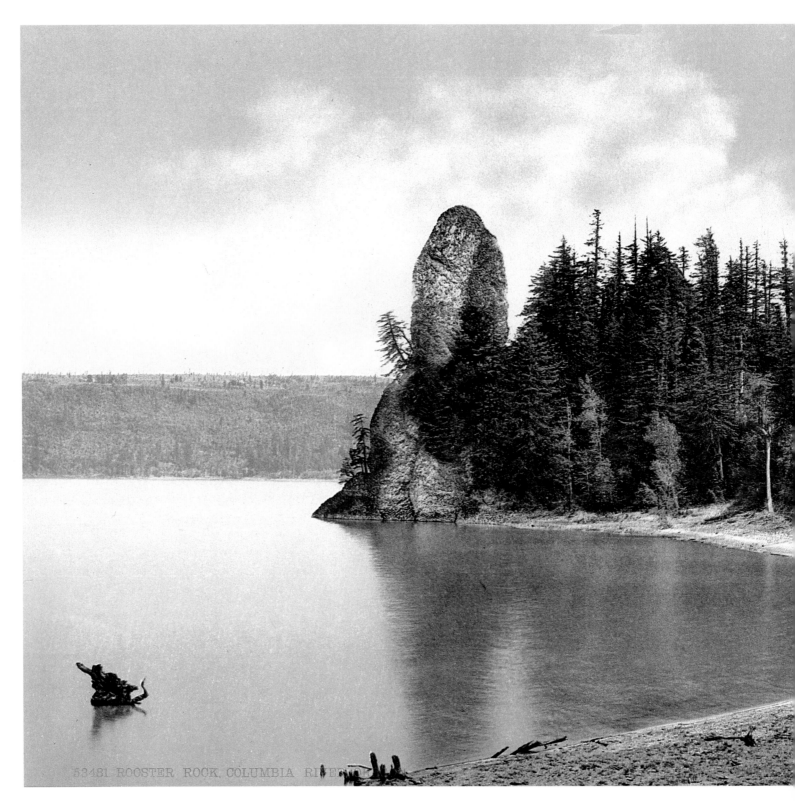

52481 ROOSTER ROCK, COLUMBIA RIVER

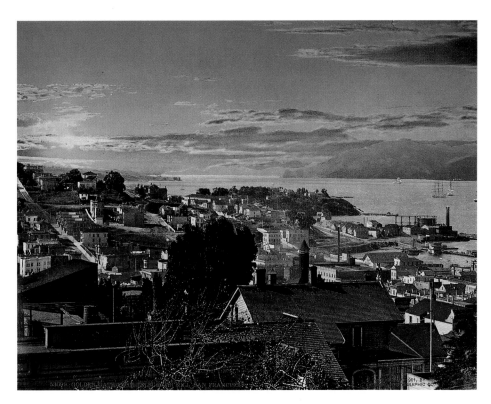

The Golden Gate and the Marin Headlands as seen from Telegraph Hill in San Francisco, California.

LEFT Boaters beach their craft near Rooster Rock on the Columbia River, Oregon.

RIGHT San Francisco was a busy seafaring town at the turn of the century, as evidenced by this view of the wharves.

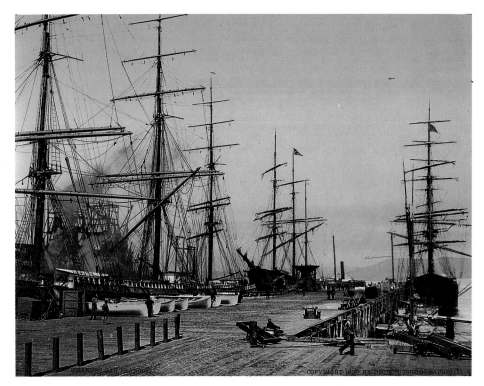

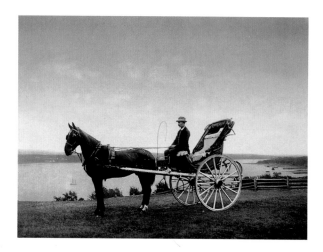

The Northern Light of Canada

THE CANADIAN PROVINCES were apparently considered by William Henry Jackson to be a natural extension of scenic America, as evidenced by the selection of Photochrom views from north of the border offered by the Detroit Publishing Company. Canada is vast in terms of both area and character, and no attempt was made to provide as comprehensive a picture of its diversity as had emerged for the United States. Jackson did make occasional trips to photograph in Canada, particularly in the more mountainous regions, and that fact is reflected by his surviving photographs. In the Selkirk Mountains, for example, a lone man challenges the glacial white cold at the edge of an abyss – a familiar Jacksonian theme from his pioneering days. In the main, however, his attention seems to be concentrated on the wonderful quality of the clear northern light, and how its photographic effects are enhanced by the addition of color to a seemingly endless landscape. By way of contrast, two cityscapes are offered at the end of the portfolio, from Montreal and Quebec, and their civilized density stands apart in this rugged land of wide open spaces.

ABOVE *A caleche, a buggy whose driver would sit on the splashboard, awaits its passengers in Quebec, Canada.*

RIGHT *Intrepid climber stands in the jaws of a crevasse at Illecillewaet Glacier in the Selkirk Mountains, British Columbia, Canada.*

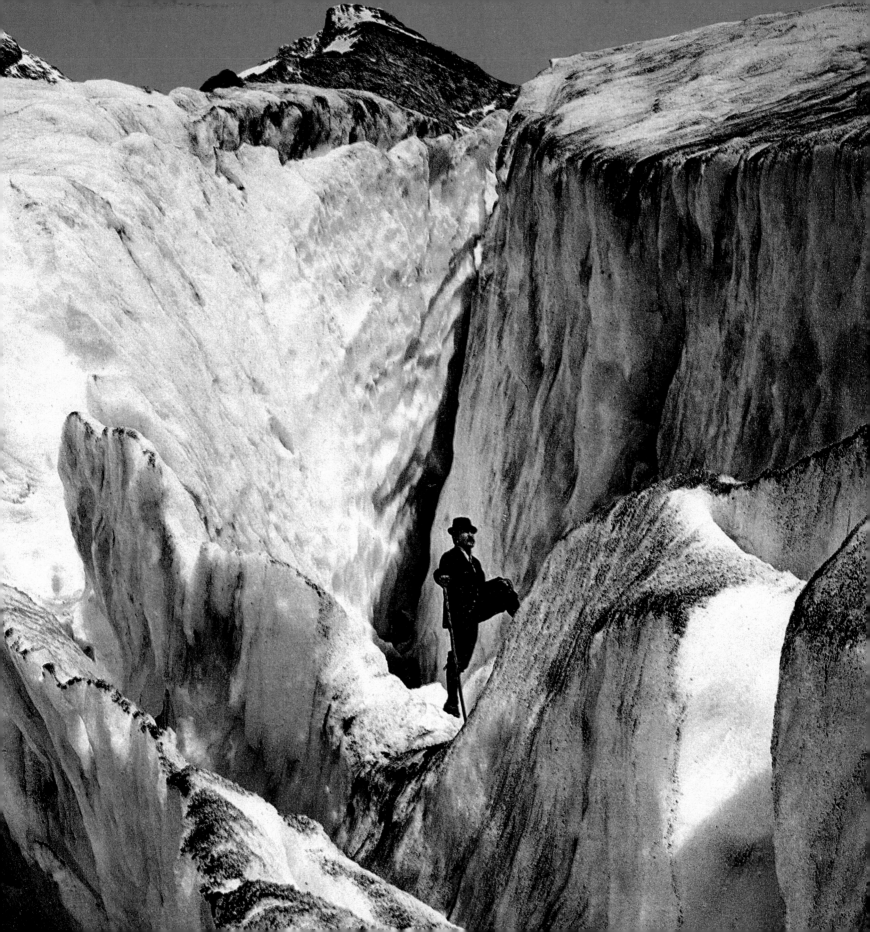

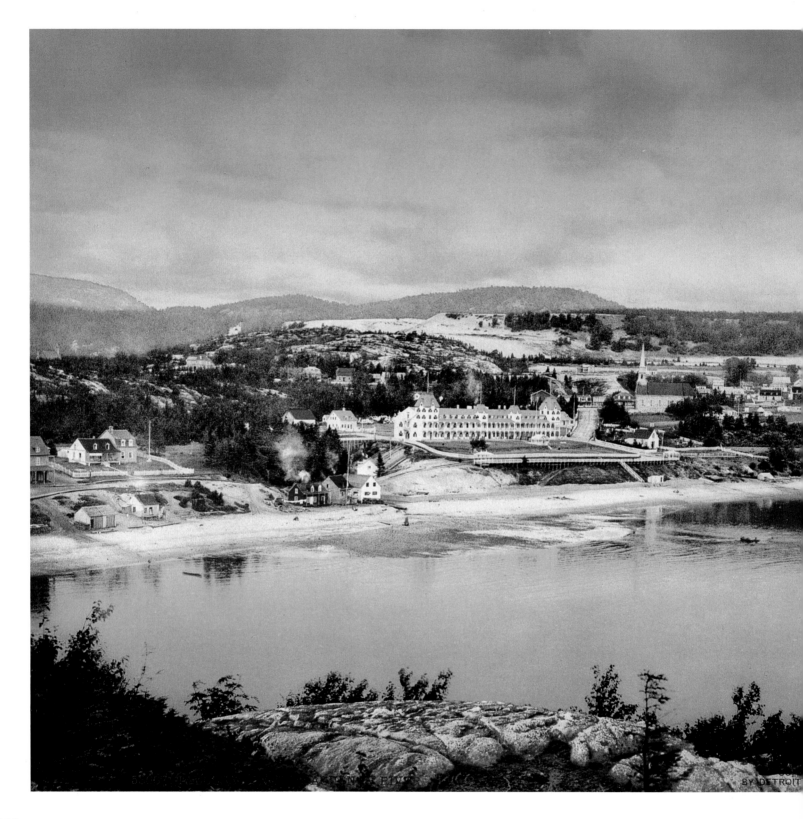

SAGUENAY RIVER, P.Q. BY DETROIT

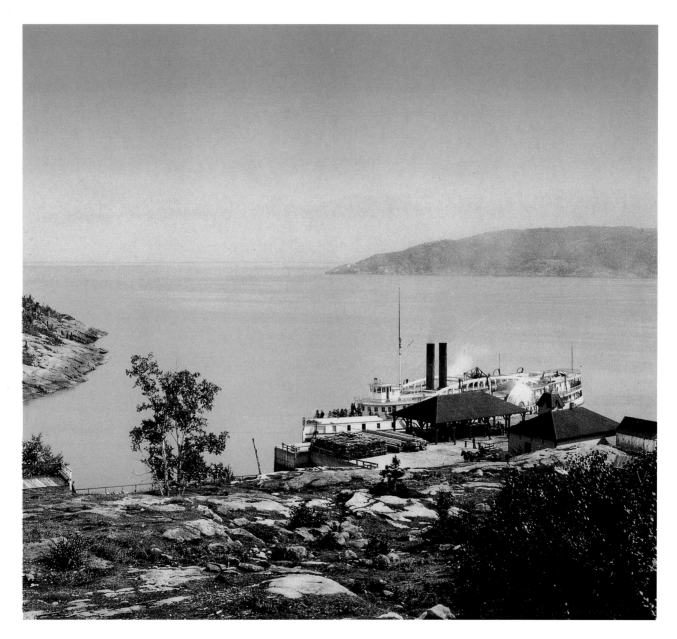

A sidewheeler takes on passengers at Tadousac Landing at juncture of the Saguenay River and the St. Lawrence River, north of Quebec, Canada.

LEFT *Picturesque Tadousac on the Saguenay River.*

*Alexandria Bay, Thousand Islands, from the New York side,
where the St. Lawrence marks the border between the United
States and Canada.*

*The Captain Visger with a full load of passengers steams
through Lost Channel in the Thousand Islands, at the juncture
of the St. Lawrence River with Lake Ontario.*

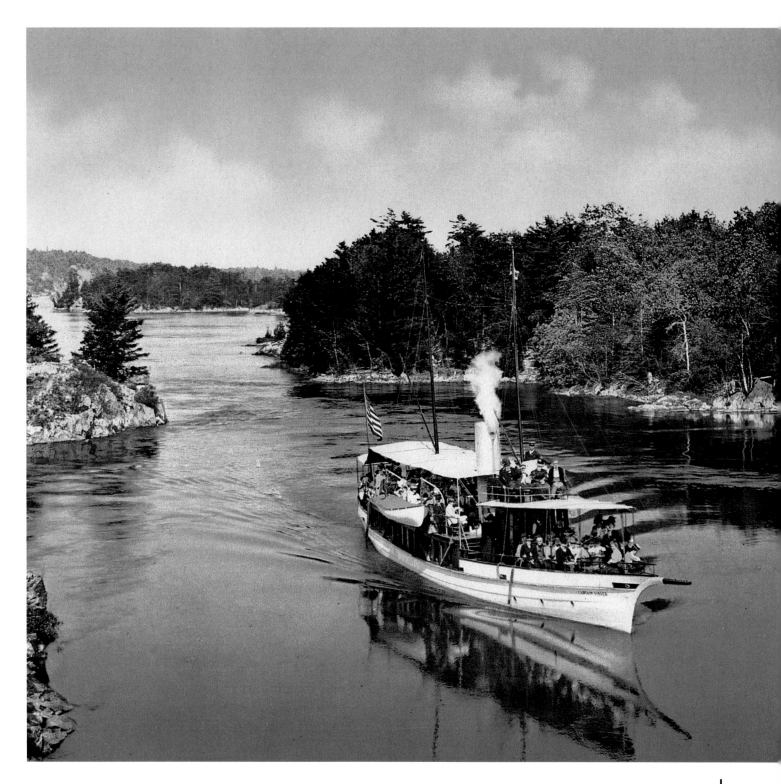

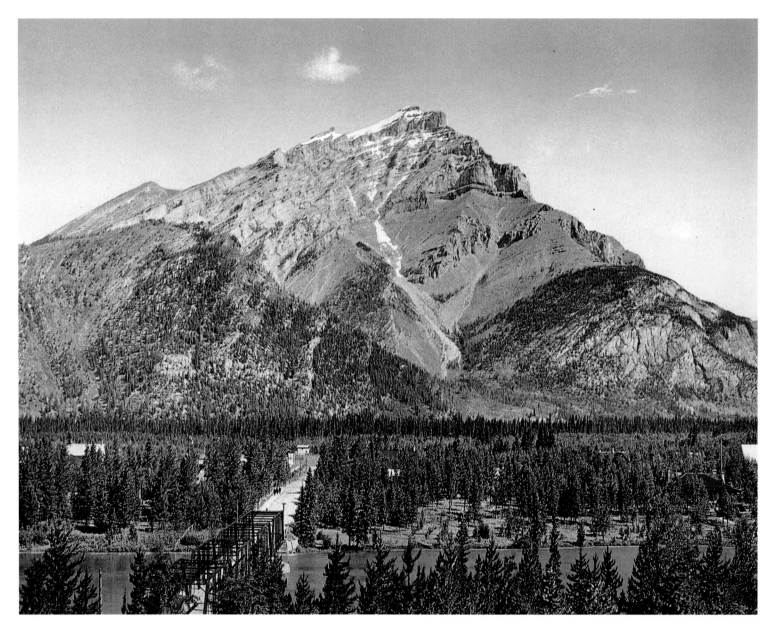

Monumental in the distance, the silver-hued Cascade Mountain lives up to its name in Alberta, Canada.

Horsedrawn wagon on Sous Le Cap, a wood-planked back street in Montreal, Canada.

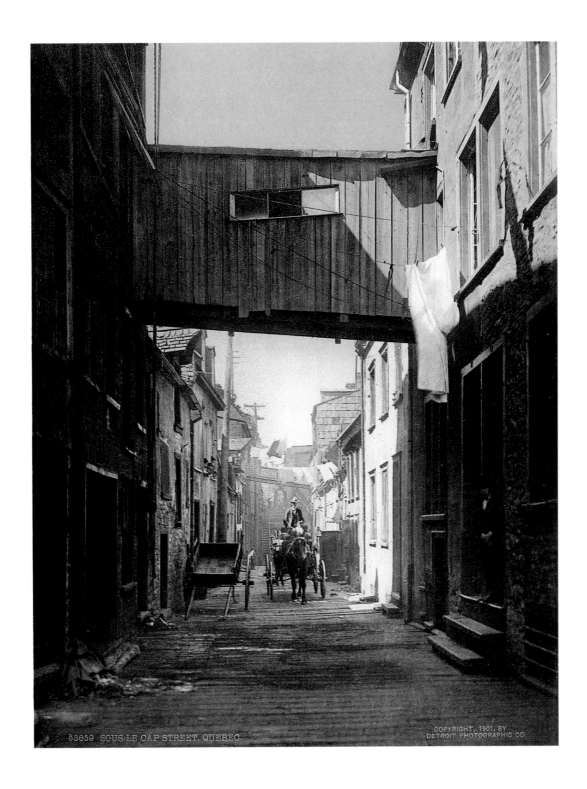

53659 SOUS LE CAP STREET, QUEBEC.

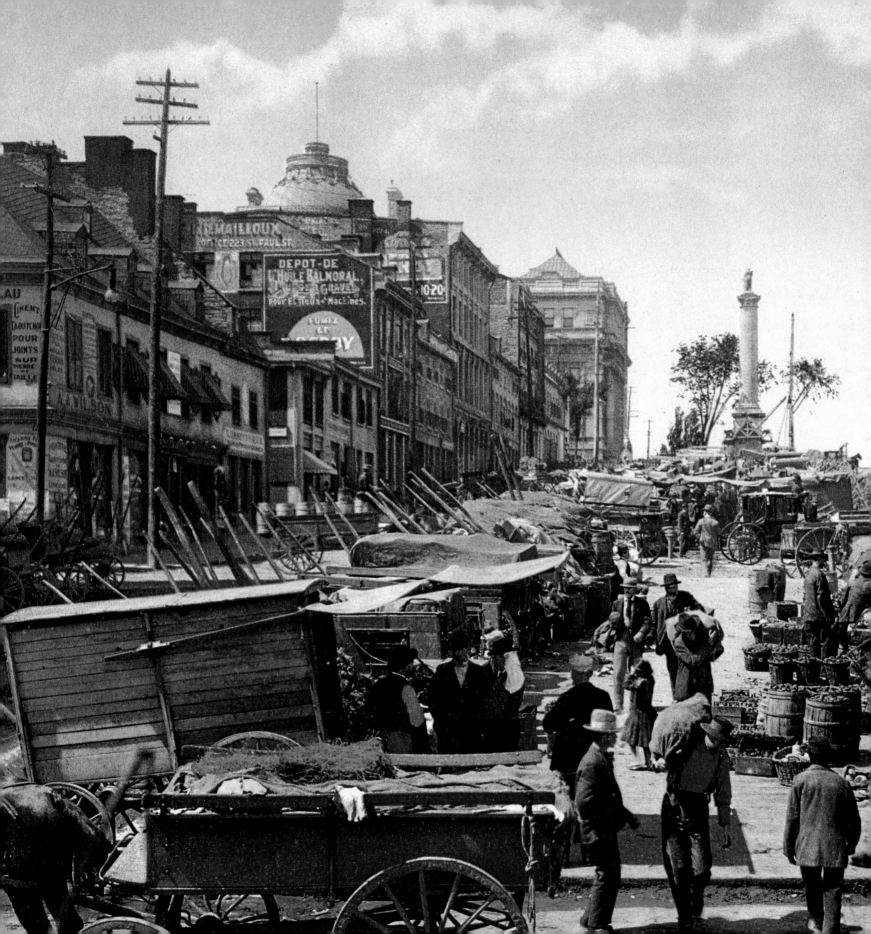

The open-air produce mart at Jacques Cartier Square, Montreal, Canada.

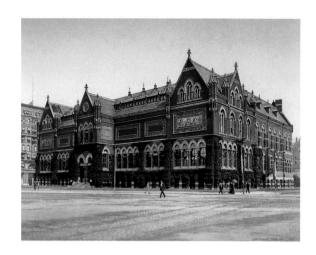

New England Memories

WILLIAM HENRY JACKSON was a northeasterner by birth and upbringing, but upon reaching maturity he, like many young men of his time, set out on a long journey to explore the mythic American West. Through the cameras by which he would earn his living, he focused his substantial artistic vision on what must have seemed a never-ending universe. Yet in a comparatively brief twenty-year period, the pioneer photographer ran out of virgin land to explore; driven by the economic engine of expansion, an irresistible wave of humanity had tamed and settled the West. During the last decade of the nineteenth century, driven by his own economic needs, Jackson returned to his roots to photograph an already civilized landscape that, in comparison to the West, had changed little since his youth.

Instead of his past practice of discovery and description, Jackson's later, more commercial object-ives seemed to be validation and promotion. The Detroit Publishing Company series of New England Photochroms serve to reaffirm the American ethic: hard work earns the leisure time to enjoy the world's riches. By today's standards, we might call Jackson a travel photographer *extraordinaire*: a seller of technicolor dreams to an audience accustomed to black-and-white. In New England, and for that matter the northeast in general, Jackson most often made (or purchased from another photographer who met his standards) photographs of landmarks that were already in the public consciousness. The rather prosaic home of writer Nathaniel Hawthorne in Concord, Massachusetts, for example, was included for its historical interest to the typical tourist rather than any intrinsic value the photograph might have as a work of art (which it most assuredly was not). On the other hand, the photograph of the upper falls of the Ammonoosuc River in the White Mountains of New Hampshire could stand on its own artistic merits in any collection, the delicate blue-green of the rapidly moving water forming a perfect, almost three-dimensional complement to the absolute stillness of the surrounding rocks and the man-made bridge that frame it all.

ABOVE *The ornate architecture of the Art Museum in Boston was itself felt to be a work of art.*

RIGHT *Busy Tremont Street winds its way past the famous Boston Common and through the old city of Boston. In the distance is Charles Bulfinch's 1795 architectural masterpiece, the gold domed Massachusetts State House.*

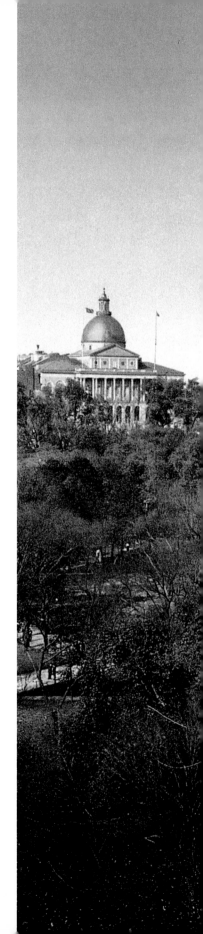

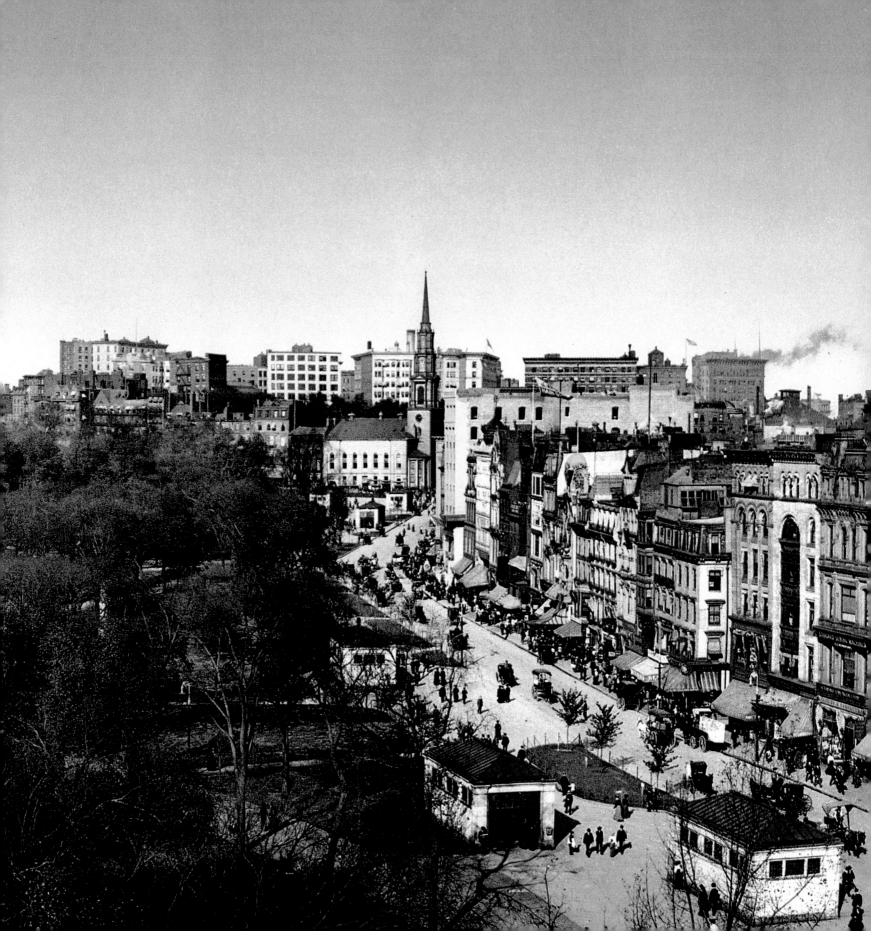

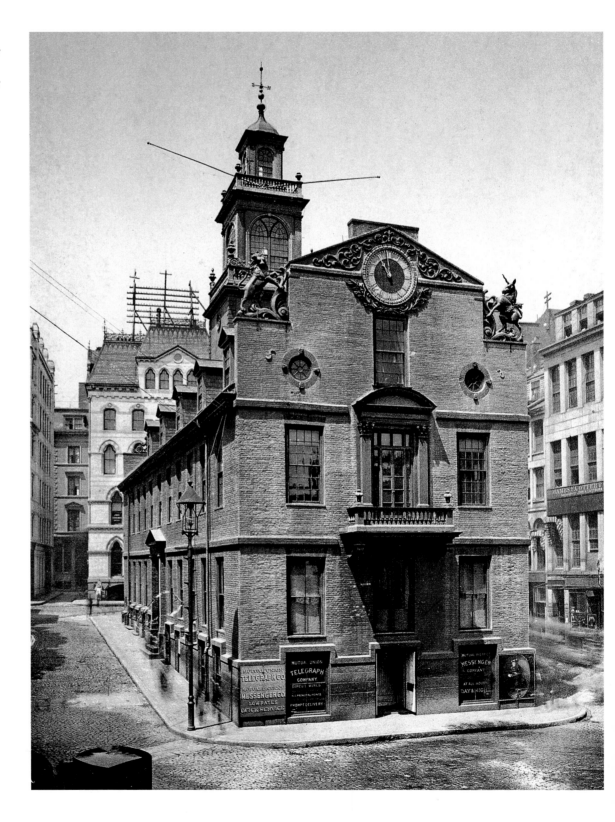

The Old State House in Boston, Massachusetts. At the turn of the century, advertisements for telegraph and messenger services flanked its street level entrance.

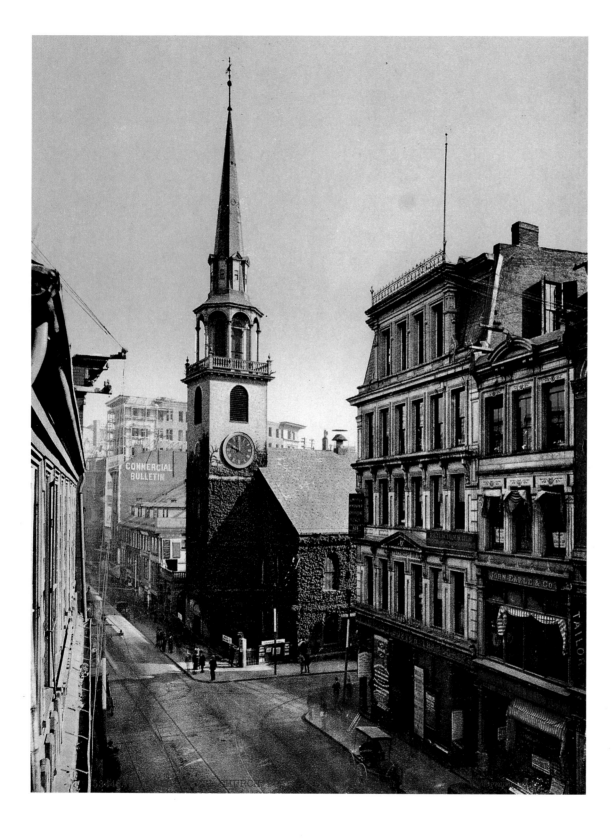

The historic Old South Church in Boston, Massachusetts.

Wearing their ubiquitous bowlers against the noonday sun, gentlemen of Boston relax
beneath a canopy of stately trees on the Beacon Street Mall.

'Wayside,' the home of writer Nathaniel Hawthorne in Concord, Massachusetts.

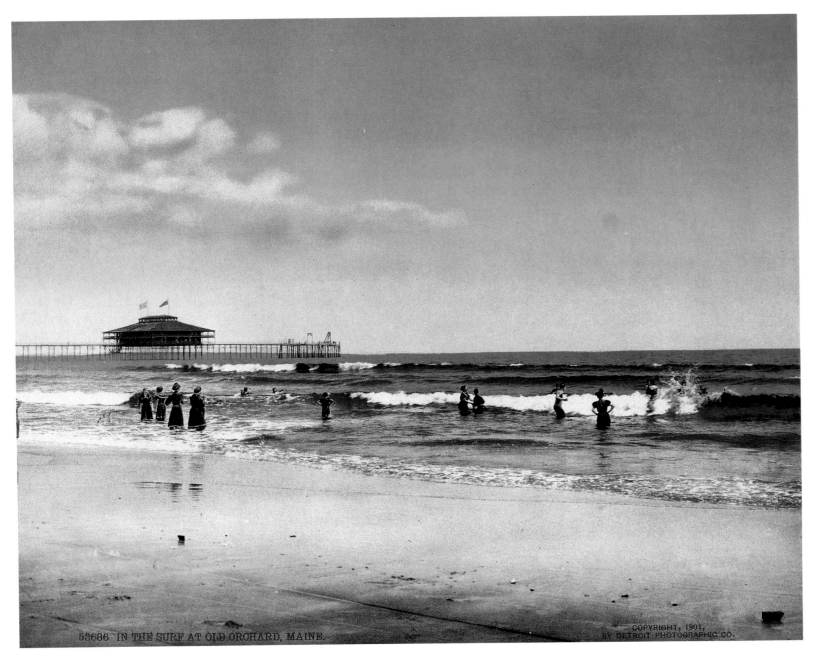

53686 IN THE SURF AT OLD ORCHARD, MAINE.

COPYRIGHT, 1901, BY DETROIT PHOTOGRAPHIC CO.

Bathers in Gay Nineties swimsuits challenge the cold surf at Old Orchard Beach, Maine.

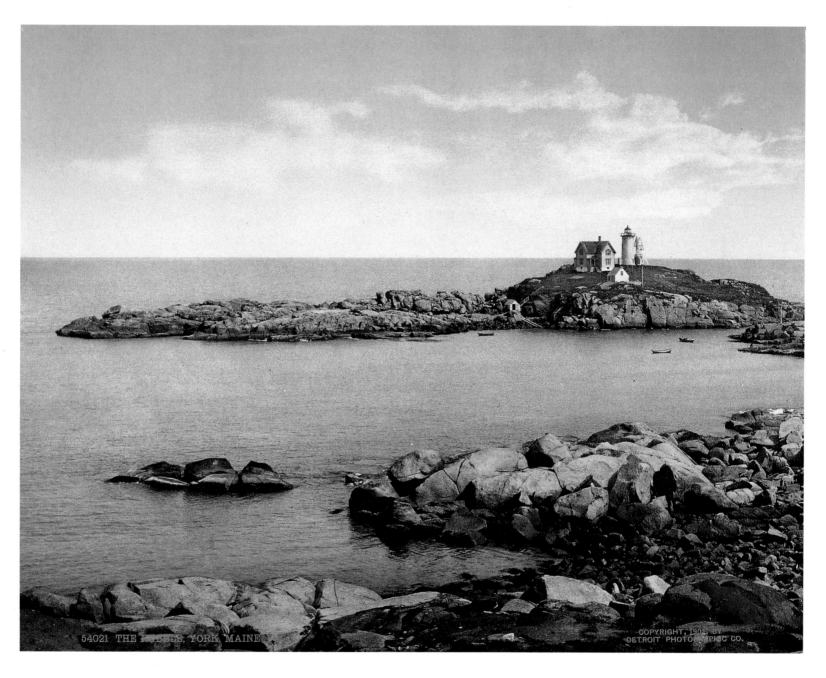

The lighthouse at the Cape Neddick Nubble, York, Maine.

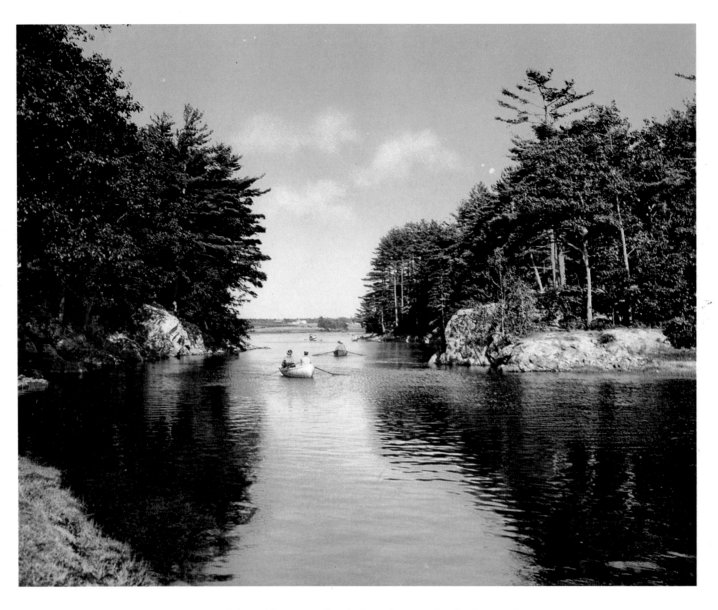

Romantic boat rides among the Picnic Rocks, Kennebunk River, Maine.

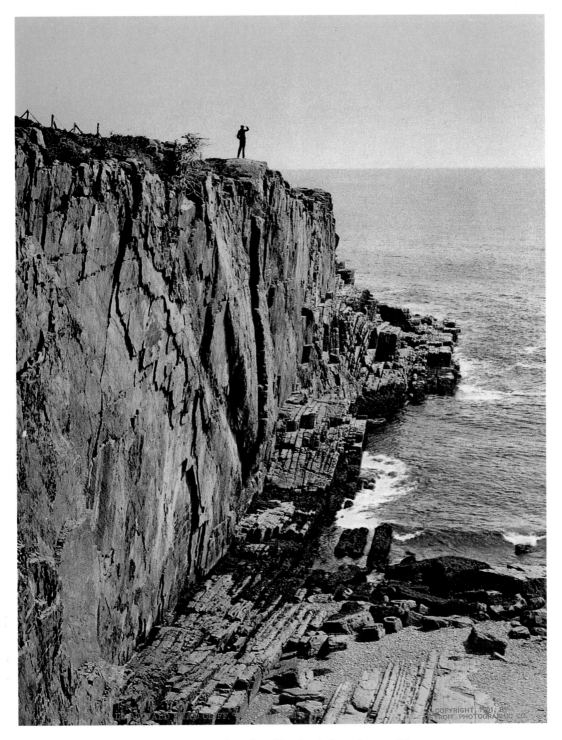

Man peers out into the cold Atlantic from the top of the
Sea Wall at Bald Head Cliff, York, Maine.

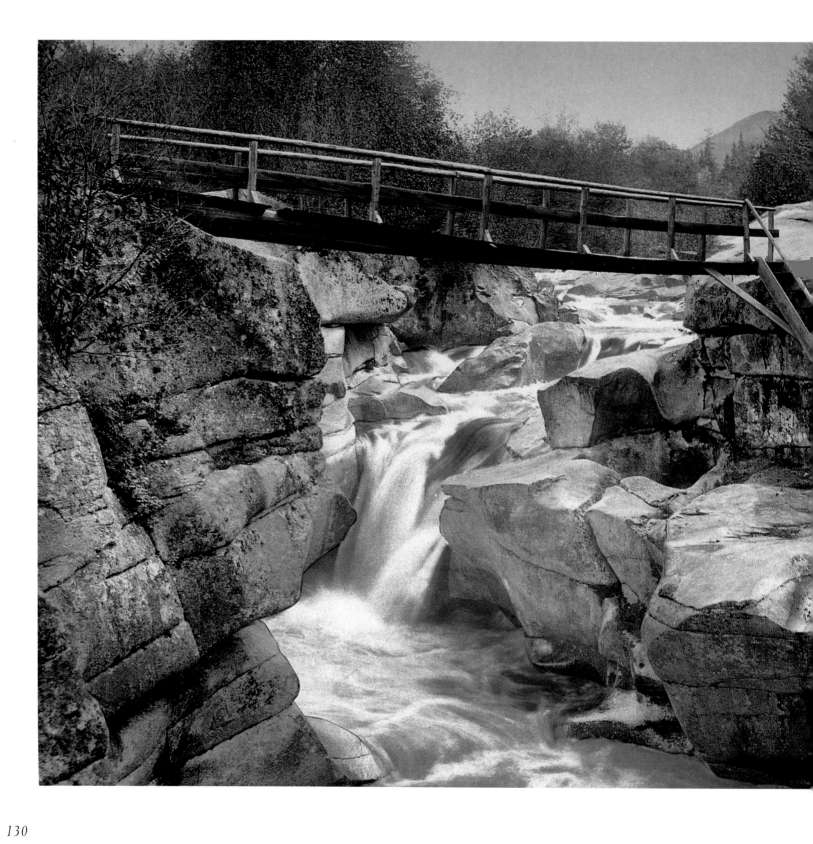

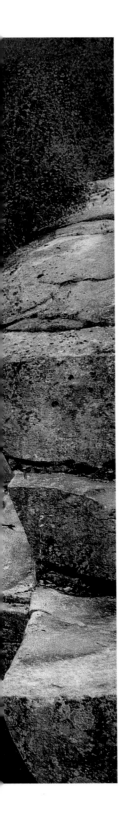

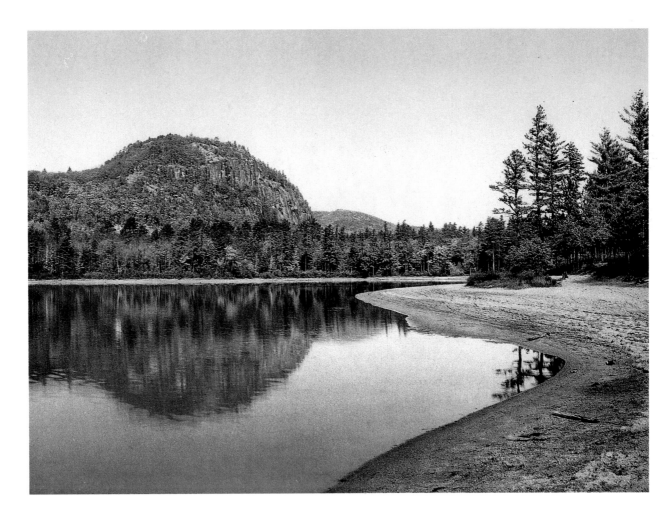

*View from the beach across the still
waters of Echo Lake, near North
Conway, New Hampshire.*

LEFT *The Upper Falls of the
Ammonoosuc River, in the White
Mountains of New Hampshire.*

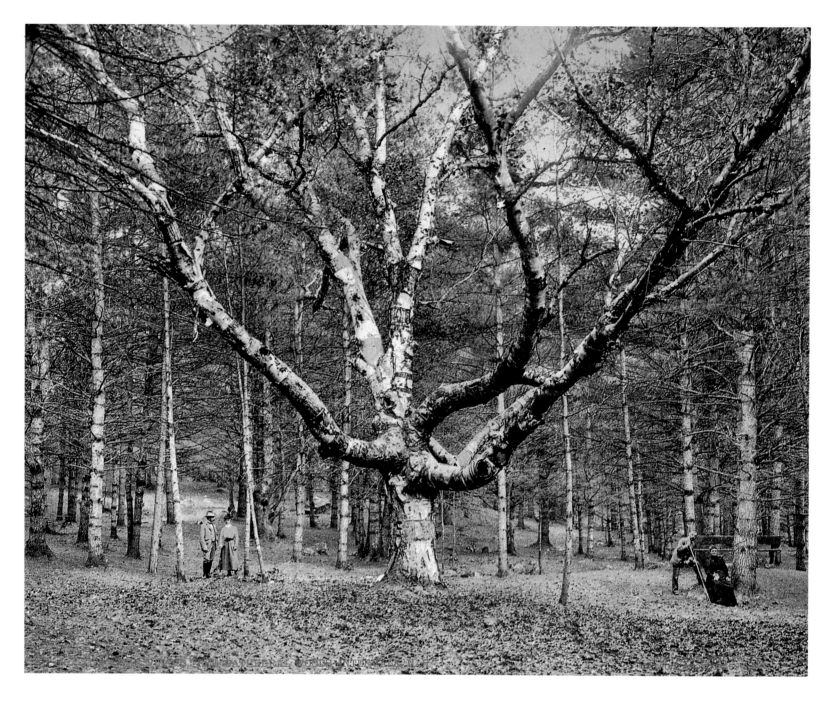

*Two couples, hikers in the Cathedral Woods, Intervale, New Hampshire,
pose beneath the gnarled old limbs of the Wizard Tree.*

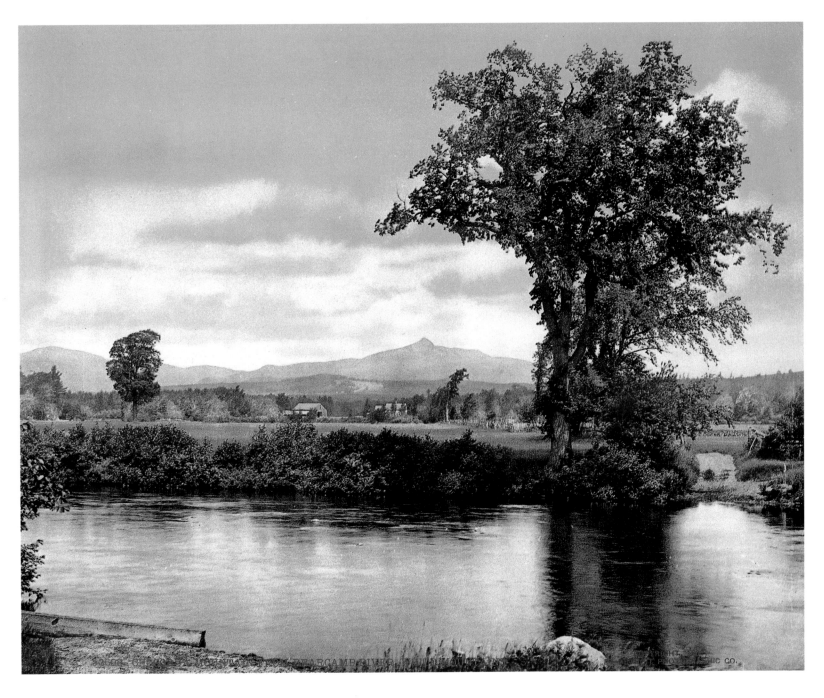

*Long view of the Chocorua Mountains from Bear Camp River
in the White Mountains of New Hampshire.*

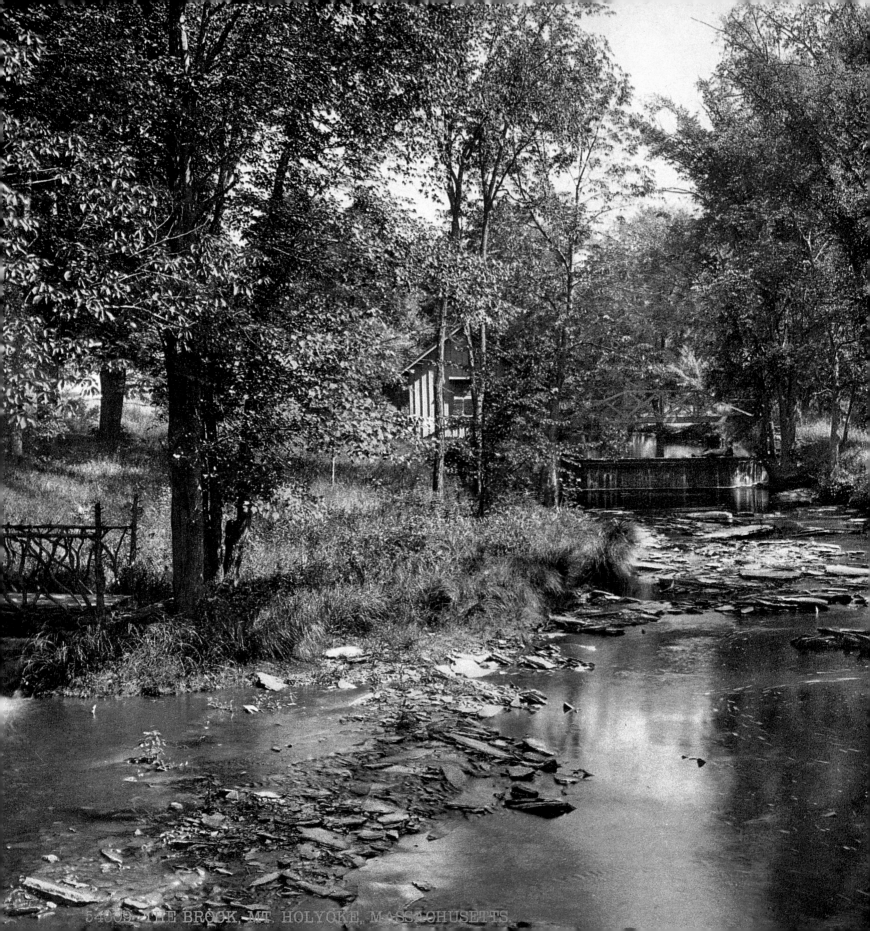

54000. THE BROOK, MT. HOLYOKE, MASSACHUSETTS.

At sunset, the Old Fairbanks House blends into the wooded landscape in Dedham, Massachusetts.

LEFT *A babbling New England brook in Mt. Holyoke, Massachusetts.*

A panoramic view from Bald Mountain of Franconia Notch in the White Mountains of New Hampshire.

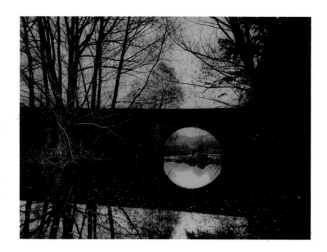

Sightseeing in the Northeast

DISCOUNTING New York City, which from its beginnings had been a unique entity requiring separate consideration, the northeast corridor of the U.S. extended from Philadelphia at the south, known as the cradle of American democracy, up the Atlantic coast through New Jersey and upstate New York to the Canadian border. Even at the turn of the century one did not need to travel far from a densely populated urban center to experience some of the most varied and beautiful scenery in America – often, one could simply take a relatively short daytrip by rail or river: south to the fabulous boardwalk of Atlantic City, for instance, or north to a rustic retreat at Chautauqua.

Of course, longer excursions were available, which was clearly one of the reasons railroads of the northeast had hired such a high-profile professional as William Henry Jackson, by then known as 'the world's most famous landscape photographer,' to extoll the virtues of their scenic routes and destinations. Dramatic and deeply seen photographs could reinforce the myth of the landscape as an experience with almost spiritual powers. The thunderous Niagara Falls had since the mid-1800s proven to be an increasingly irresistible lure, to daredevils in barrels as well as hordes of honeymooners, while a few hundred miles to the east – but still in New York – one could walk silently on a carpet of pine needles and commune with the ageless forests of the Adirondack Mountains. Indeed, New York state alone – the Finger Lakes, Watkins Glen, Ithaca Falls, Lake George, the Catskills – was a veritable traveler's paradise that offered nature's wonders in microcosm.

ABOVE *A view at sunset through the old stone Palmer Bridge in New York State reveals the mountains beyond.*

RIGHT *Visitors enjoy a respite at Glen Afton Spring near Pen Mar Park, Afton, New York.*

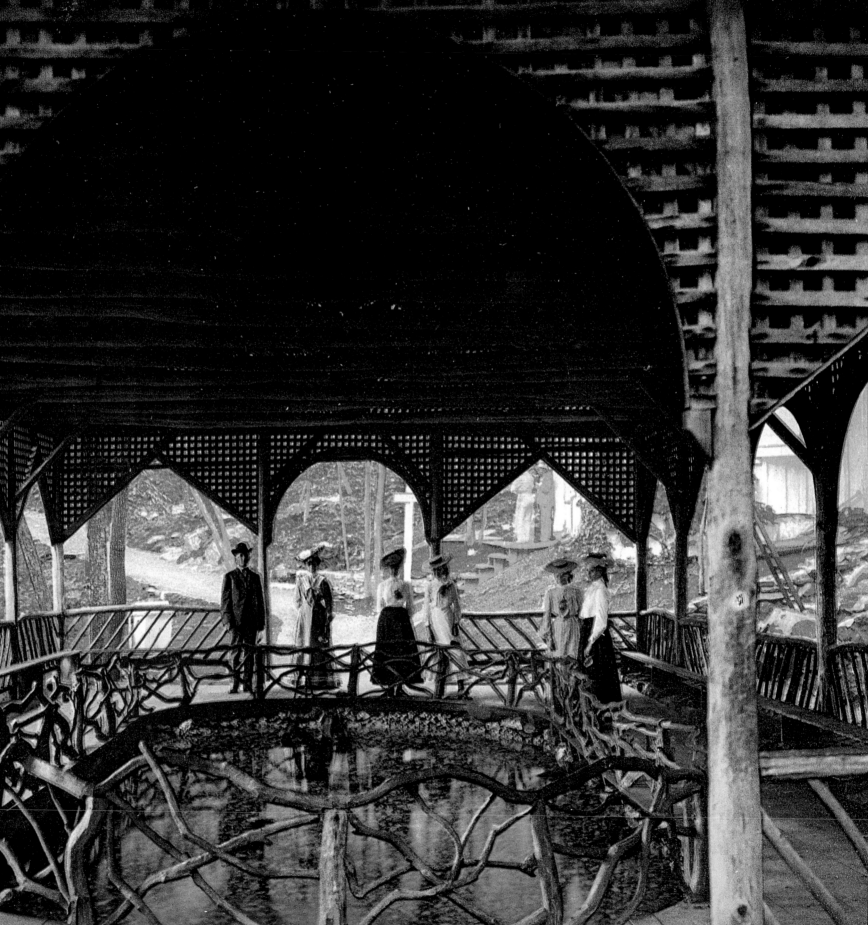

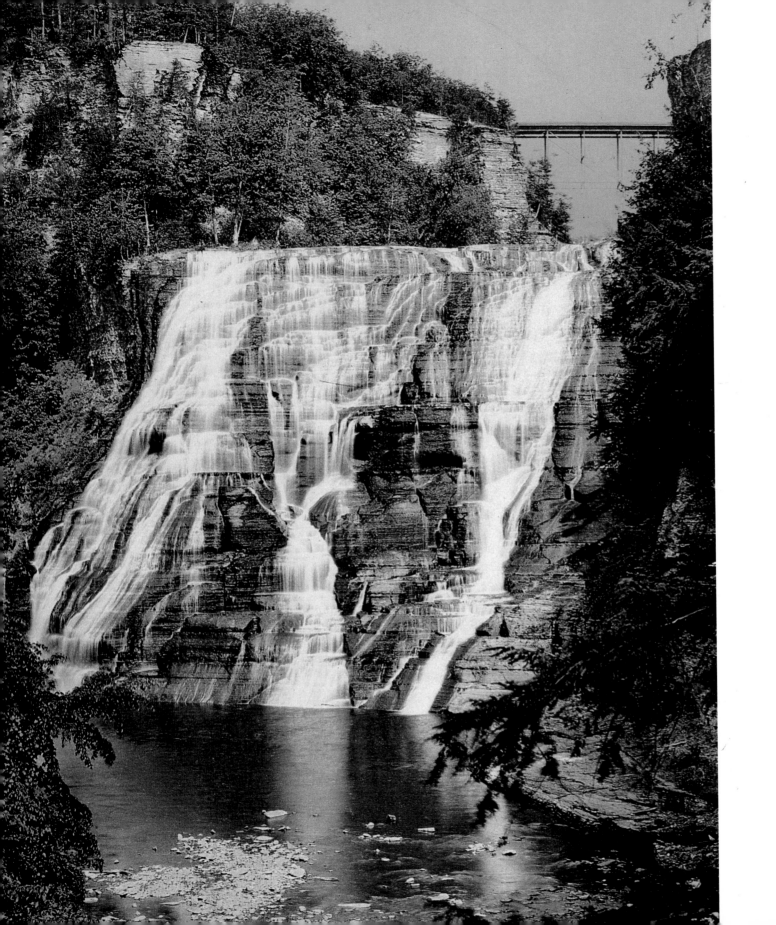

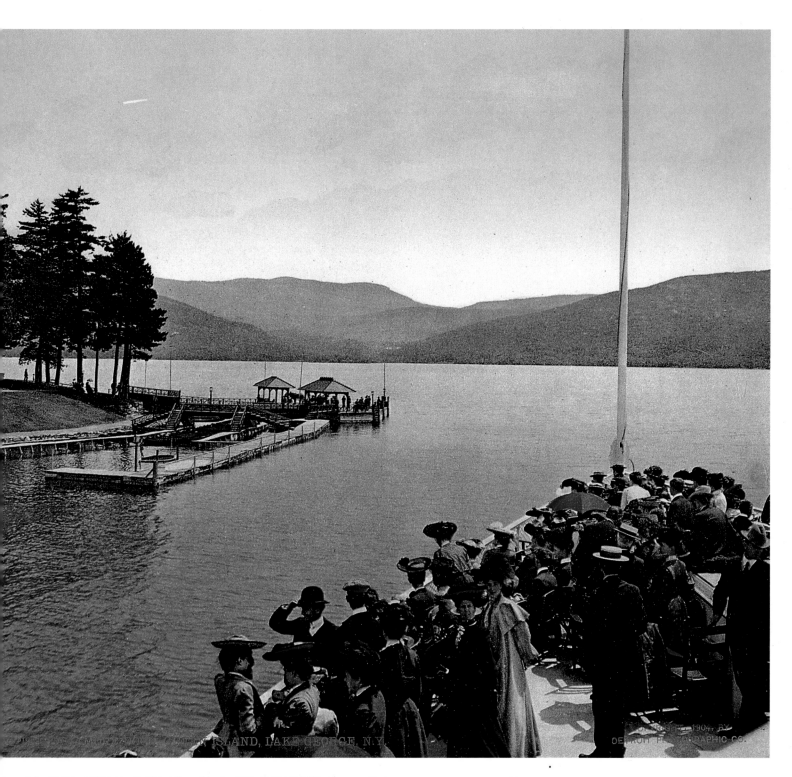

*Tourists crowd the bow of a sightseeing boat as it approaches the
Sagamore dock at Green Island, Lake George, New York.*

LEFT *The rocky steps of the Ithaca Falls, Ithaca, New York.*

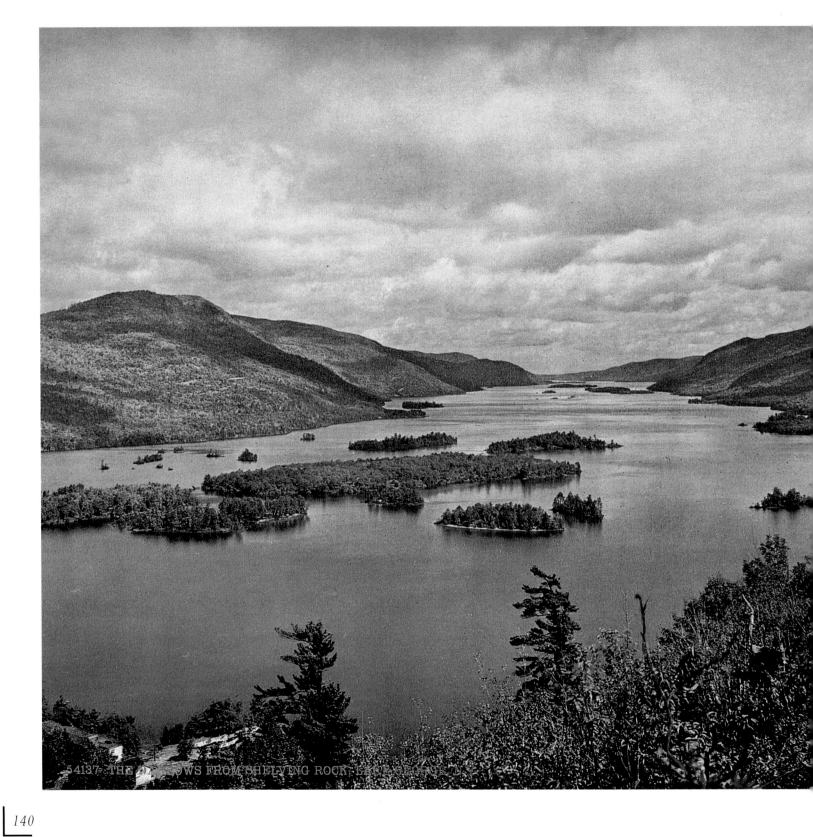

54137 THE NARROWS FROM SHELVING ROCK, LAKE GEORGE, N.Y.

*A lodge in Chautauqua, New York, photographed
through a rustic, hand-hewn bridge.*

LEFT *A long view of the Narrows from Shelving Rock,
Lake George, New York.*

The awesome power of the American Falls and the Rock of Ages, Niagara Falls, New York.

The Maid of the Mist approaches the base of the American Falls, Niagara, as photographed from the Canadian side.

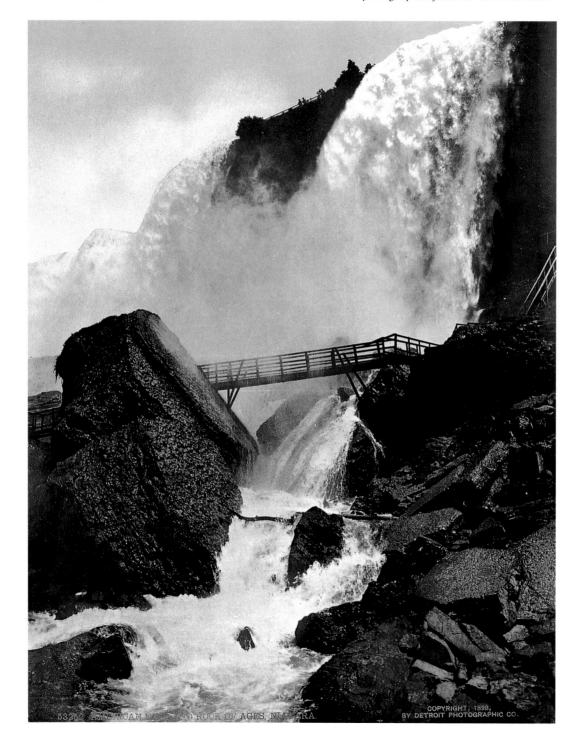

53252 AMERICAN FALLS AND ROCK OF AGES, NIAGARA.

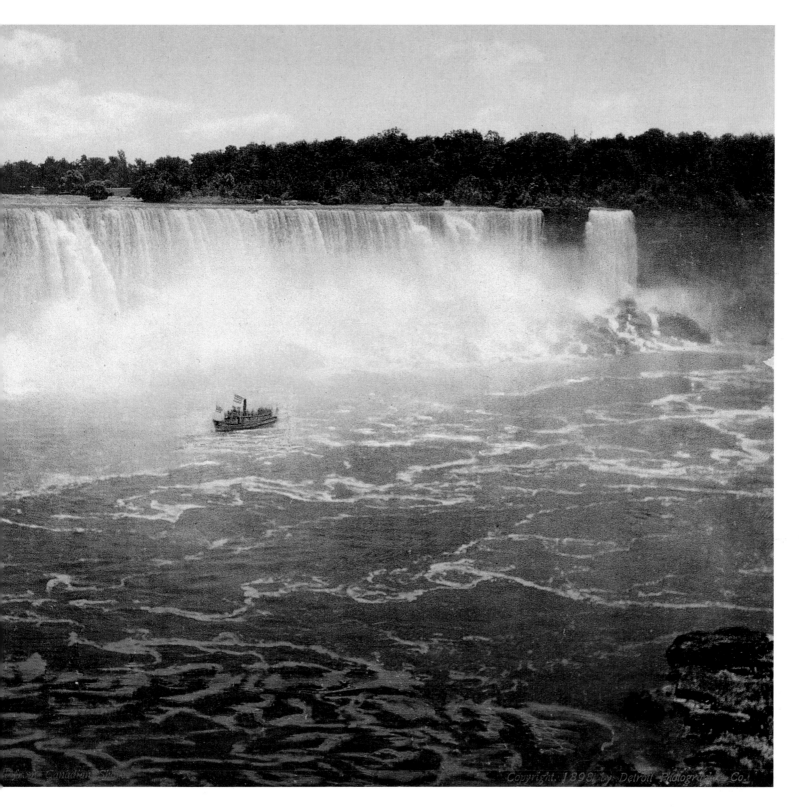

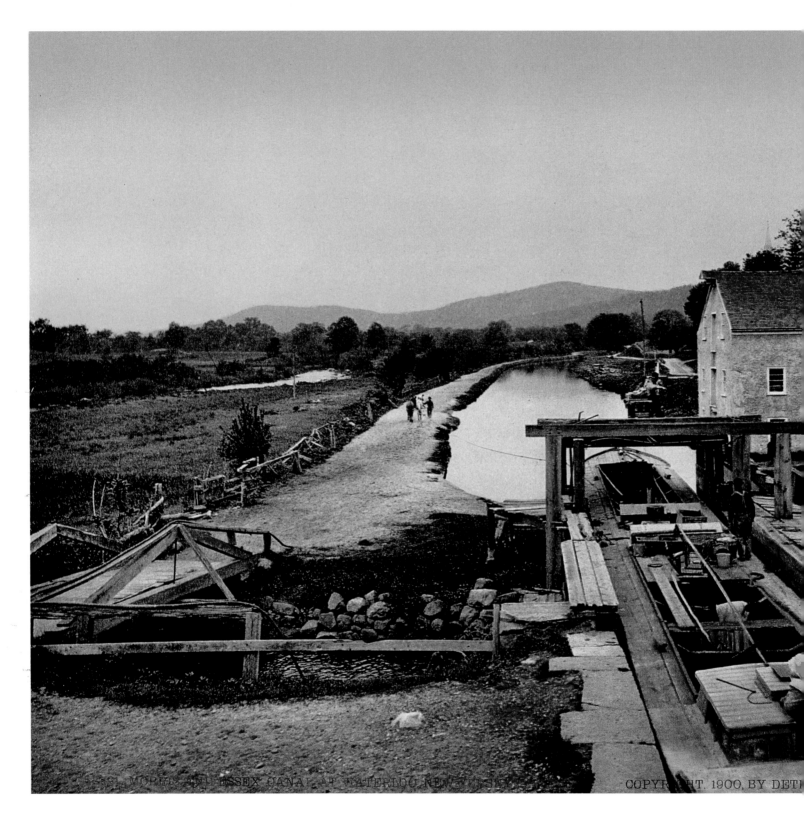

MORRIS AND ESSEX CANAL AT WATERLOO NEW JERSEY COPYRIGHT. 1900, BY DET

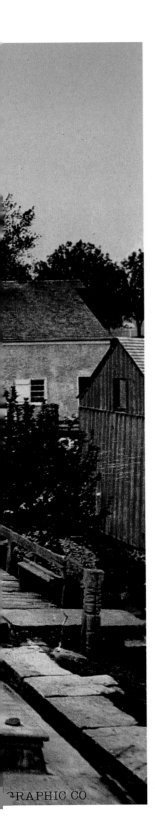

LEFT *Boat being pulled through a lock, Morris and Essex Canal, Waterloo, New Jersey.*

The Elevating Railway in New York's Catskill Mountains affords a magnificent view from the top.

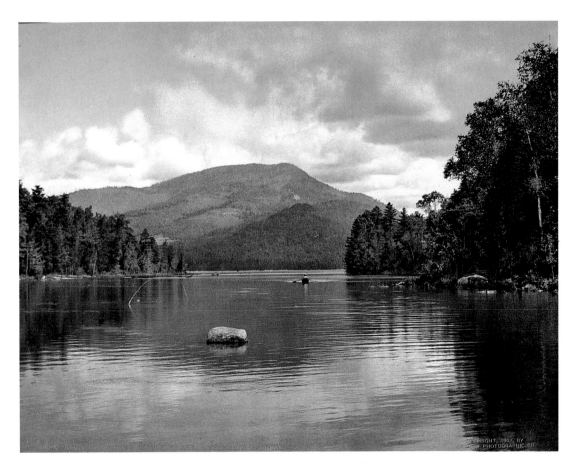

In the distance, across Eagle Lake, the aptly
named Blue Mountain, in the Adirondack
Mountain range, New York.

LEFT *Special wheeled carts were often used to
transport lake boats through the forests of the
Adirondack Mountains in New York.*

Vacationers strut their finery as they stroll along the famous Boardwalk at Atlantic City, New Jersey.

The 'Sandman,' a local artist of the time, sculpts messages in the sand at Atlantic City, New Jersey.

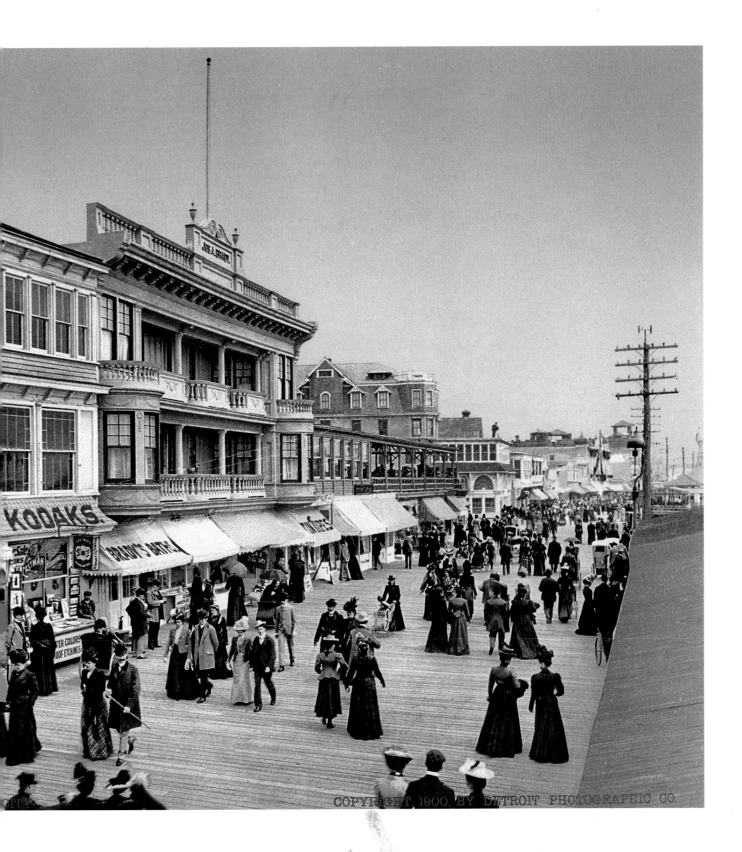

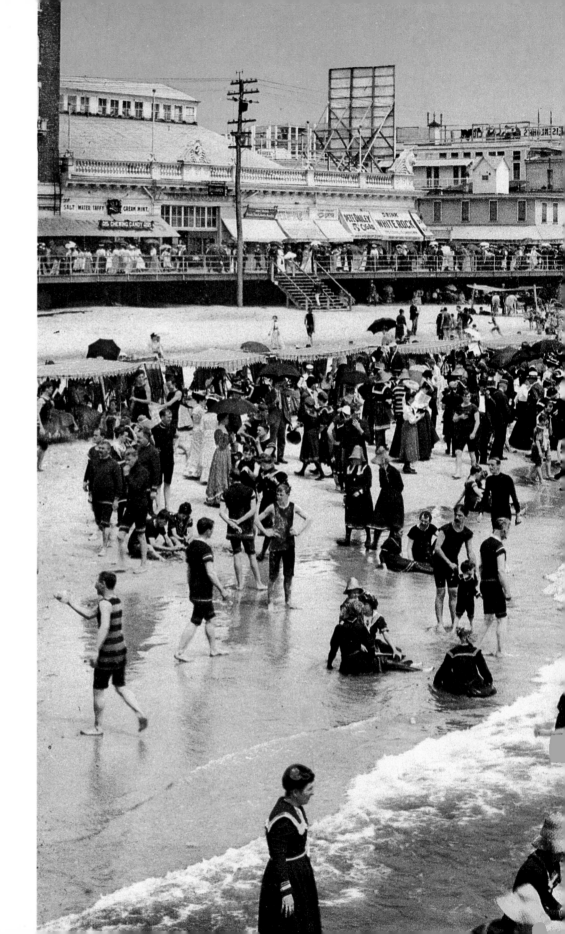

Bathers seeking respite from the summer heat throng the beach at Atlantic City, New Jersey.

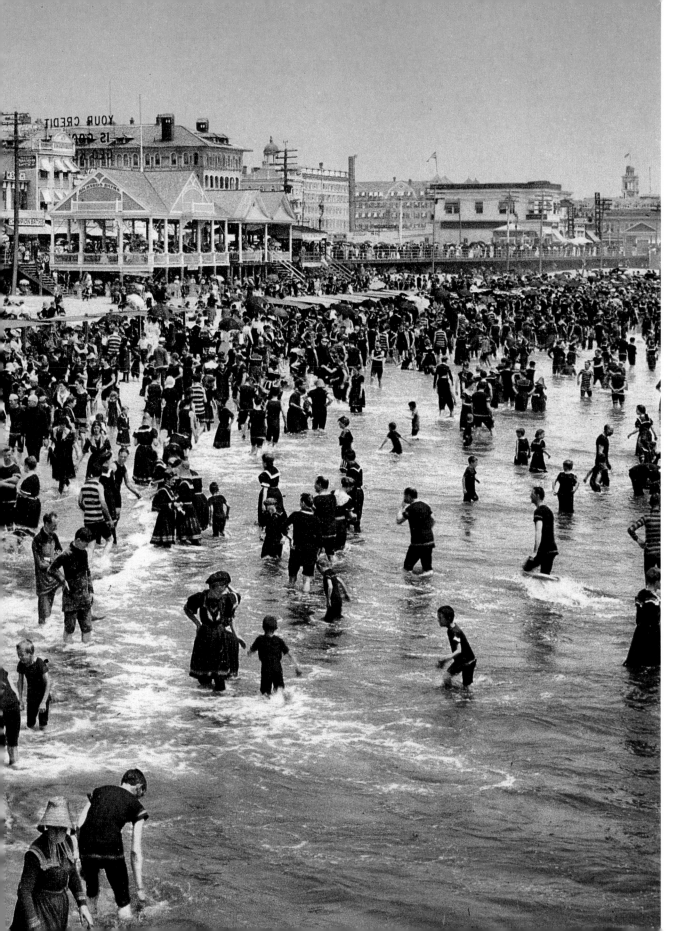

The Liberty Bell on display at Independence Hall, Philadelphia. Cast in London in 1752 to adorn the Pennsylvania State House, the one-ton bell cracked in 1835, as it tolled in mourning for the passing of U.S. Chief Justice John Marshall.

OPPOSITE *Carpenters' Hall, Philadelphia, Pennsylvania, which in 1774 housed the first Continental Congress, and became a historical museum in 1857.*

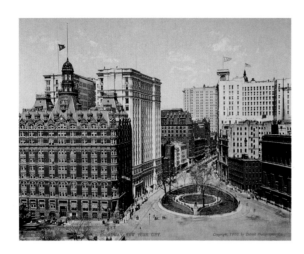

New York City Life

NEW YORK CITY grew to its present configuration in 1898 when the four outer boroughs – the Bronx, Brooklyn, Staten Island and Queens – were consolidated with the island of Manhattan under a central government. Already known as the melting pot of the world, with the opening of Ellis Island in 1892 the city of New York saw immigration reach 5,000 people a day by the turn of the century. Across the ocean they came, in 'an unending stream, a polyglot of races speaking a babel of languages,' declared one history of the period. A greater contrast with the natural beauty and grandeur of much of the rest of the country would be hard to imagine.

A long sliver of land bounded by the Hudson, Harlem, and East Rivers, Manhattan's expansion possibilities were primarily vertical – and in the eyes of the world Manhattan *was* New York. With the exception of an occasional foray into the summer playgrounds of Brooklyn, this was the New York that the Detroit Publishing Company chose to portray in its New York series of 'American Views' (called 'unsurpassed' by the definitive *Picture Postcards in the United States, 1893-1918*).

An easterner by birth, William Henry Jackson brought to the East's most populous city a set of photographic sensibilities honed on the open spaces and looming mountains of the American West, and his hand, at the editing table if not on the shutter, is readily evident in this wide-ranging selection. Shown is a city on the verge of entering a new age, but with one foot still in the old. Towering edifices pierce the sky, but streets are cobbled or remain unpaved. Trolleys and horse-drawn carriages abound, but there is nary an automobile in sight. High-angle perspectives show a place approaching nearly inhuman dimension, while street-level 'candids' depict a teeming life below. The city's future as the epitome of the best and worst life has to offer was cast in concrete.

ABOVE *Photographing one peak from the vantage point of another, an aesthetic developed by Jackson in the western Rockies, was applied to the high-rise urban mountains of New York City. Here, the sheer-sided buildings along lower Broadway as they stretch uptown from Bowling Green in Manhattan.*

RIGHT *From atop the ubiquitous elevated rail line, looking south down the Bowery past the Bowery Savings Bank and the notorious Gaiety vaudeville theater.*

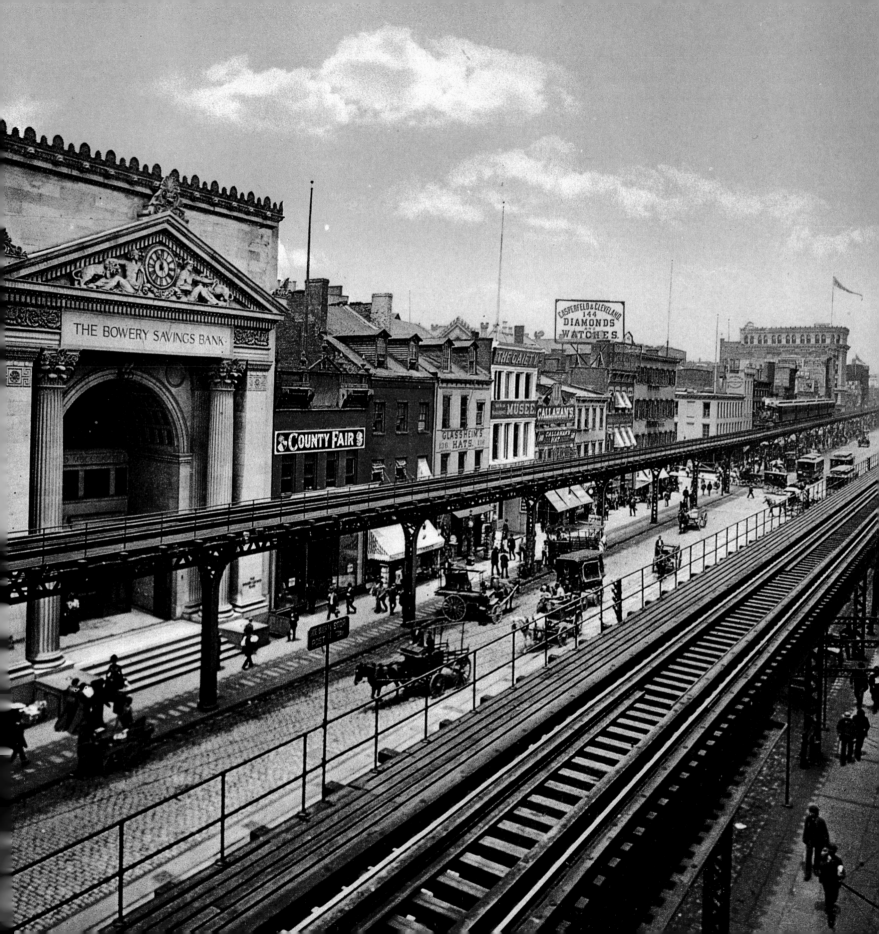

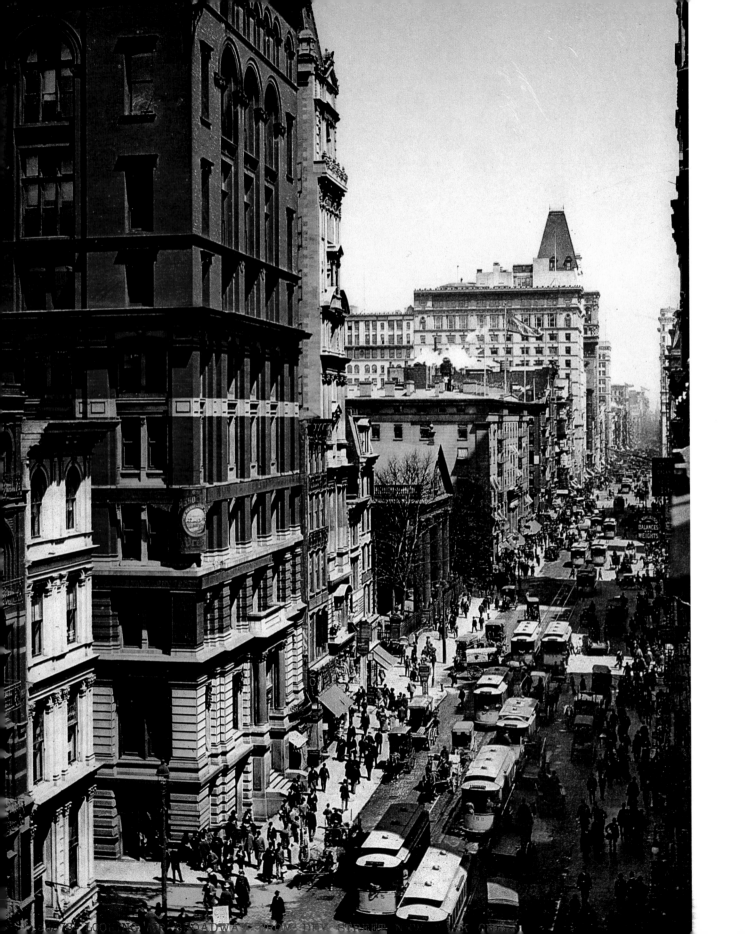
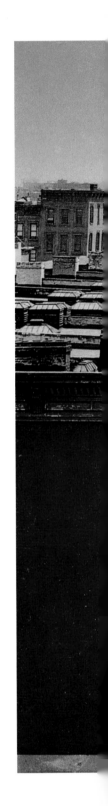

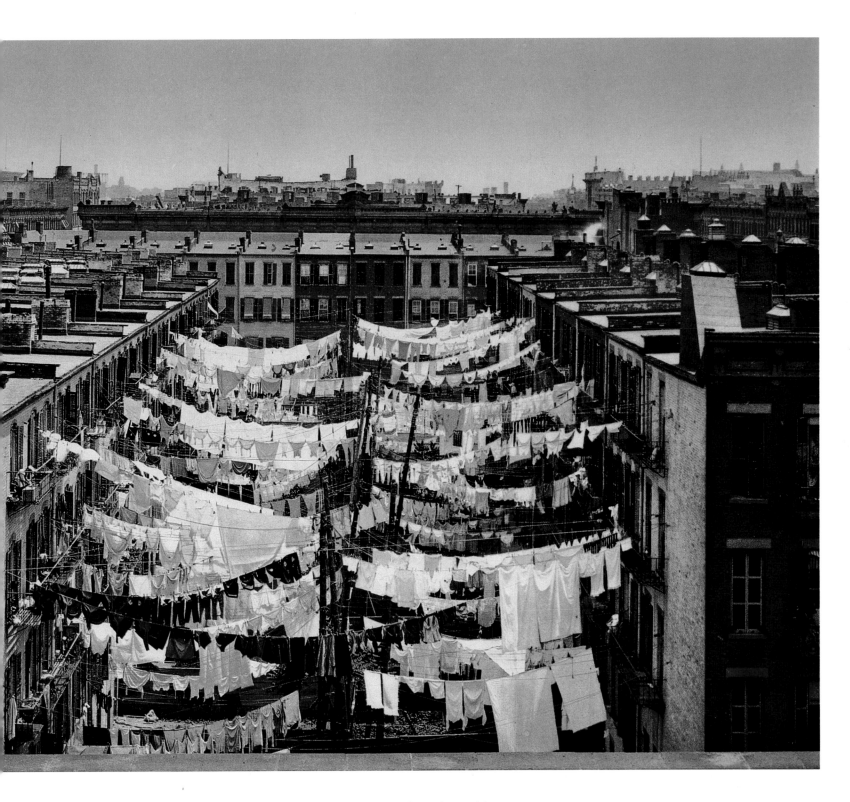

LEFT *A long view up Broadway from Dey Street reveals the congestion New Yorkers endured even before the advent of the automobile.*

ABOVE *The traditional Monday washing strung from each apartment across the backyards of a typical tenement block in New York City.*

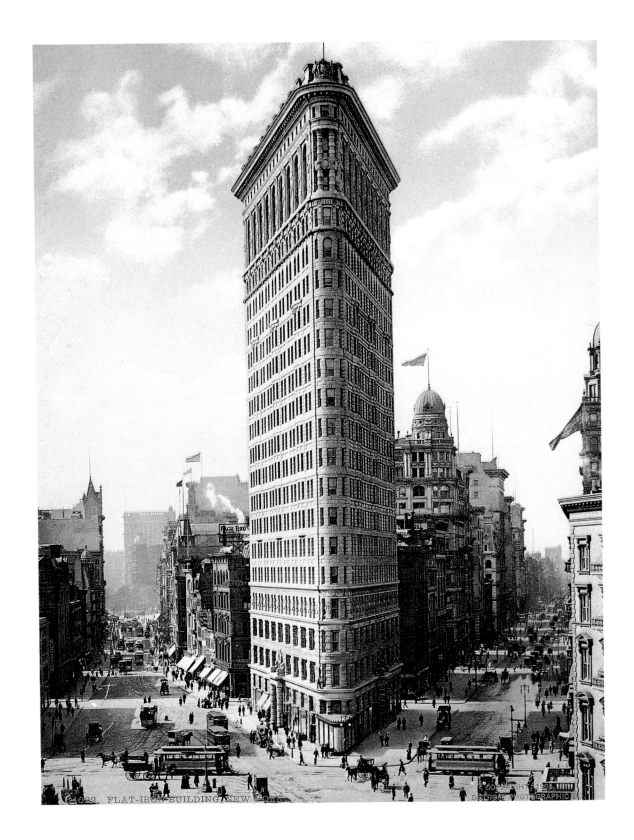

Radically shaped to fit the triangle where Fifth Avenue crossed Broadway at 23rd Street, the Flatiron Building, finally finished in 1902, was New York City's first so-called skyscraper.

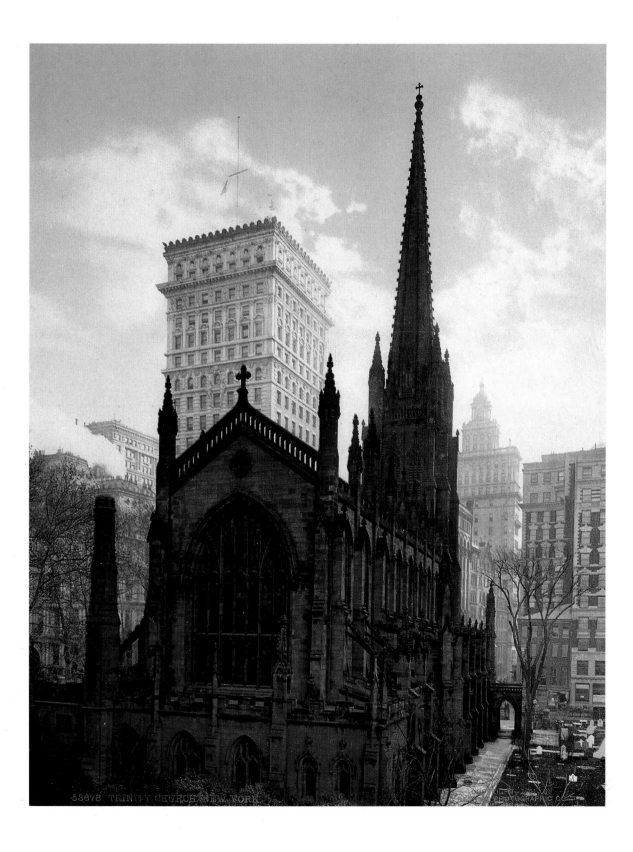

The Trinity Church, its weathered spires piercing the New York air, was originally constructed at the head of Wall Street in 1697. This structure dates from 1846.

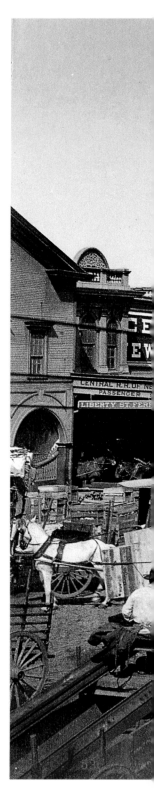

The West Street rail and ferry terminals on the Hudson River in Manhattan, New York City, as produce and people line up for loading and unloading.

The gentle curve of the elevated railway at 110th Street in upper Manhattan, New York City.

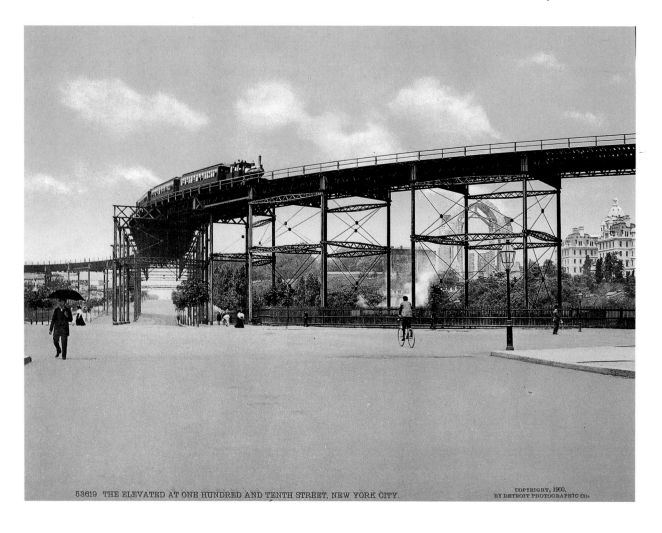

53619 THE ELEVATED AT ONE HUNDRED AND TENTH STREET, NEW YORK CITY.

COPYRIGHT, 1900,
BY DETROIT PHOTOGRAPHIC CO·

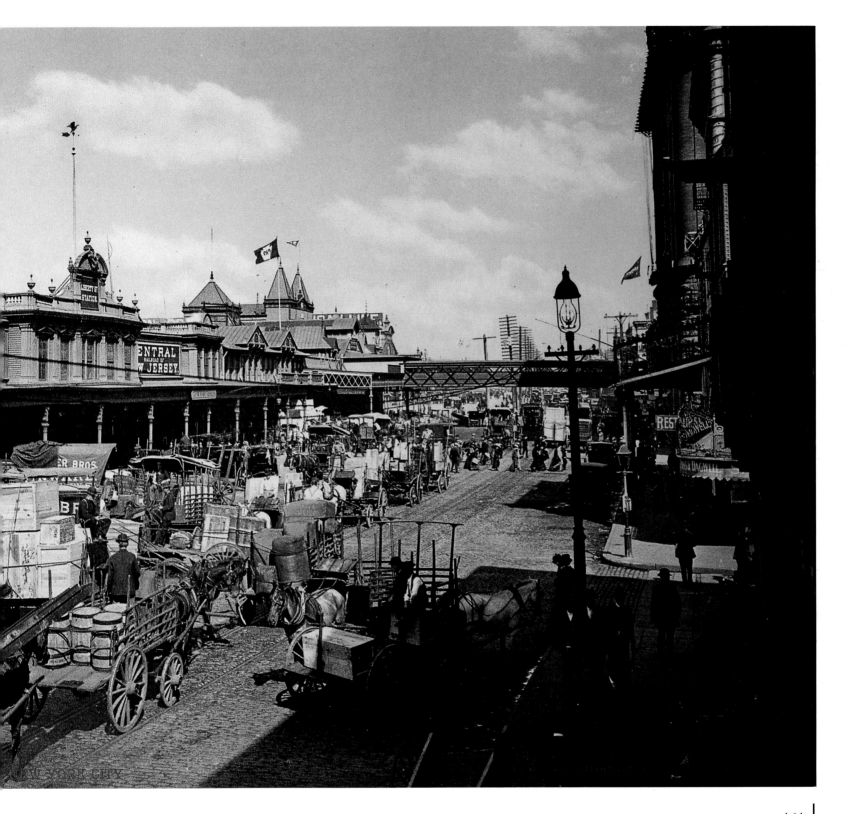

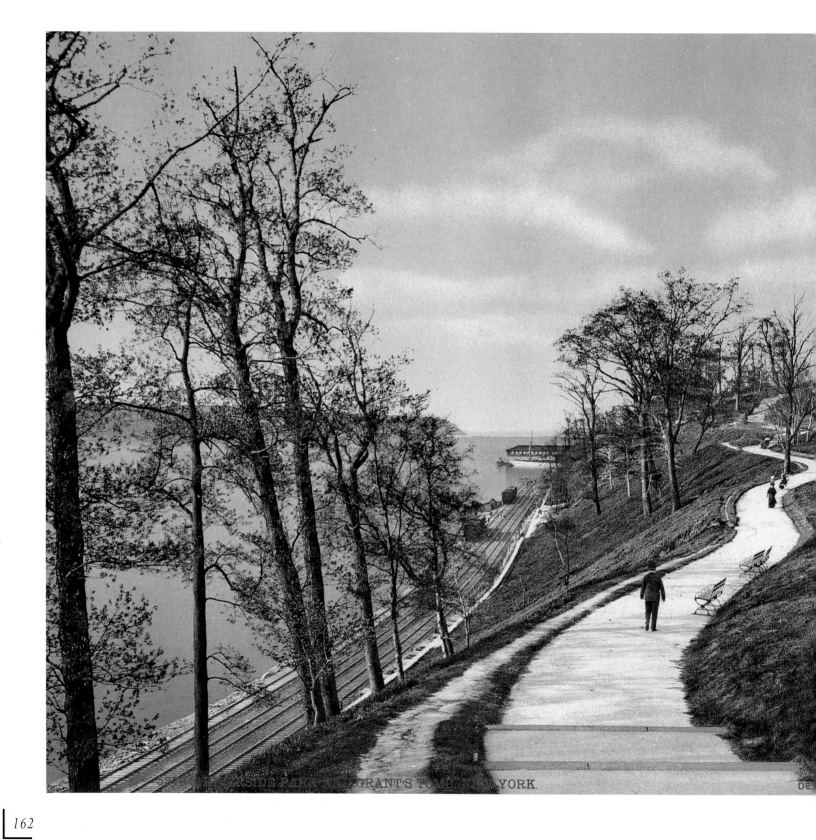

RIVERSIDE PARK AND GRANT'S TOMB, NEW YORK.

In Riverside Park along the Hudson River, a promenade leads to Grant's Tomb, completed in 1897, on the upper West Side, where the remains of Gen. Ulysses S. Grant, 18th President, are interred.

Children pose for the camera in Madison Square park, while in the background the old Madison Square Garden advertises the Horse Show.

An overhead view of Trinity Church and cemetery, showing the once dominant edifice overshadowed by towering skyscrapers shortly after the turn of the century.

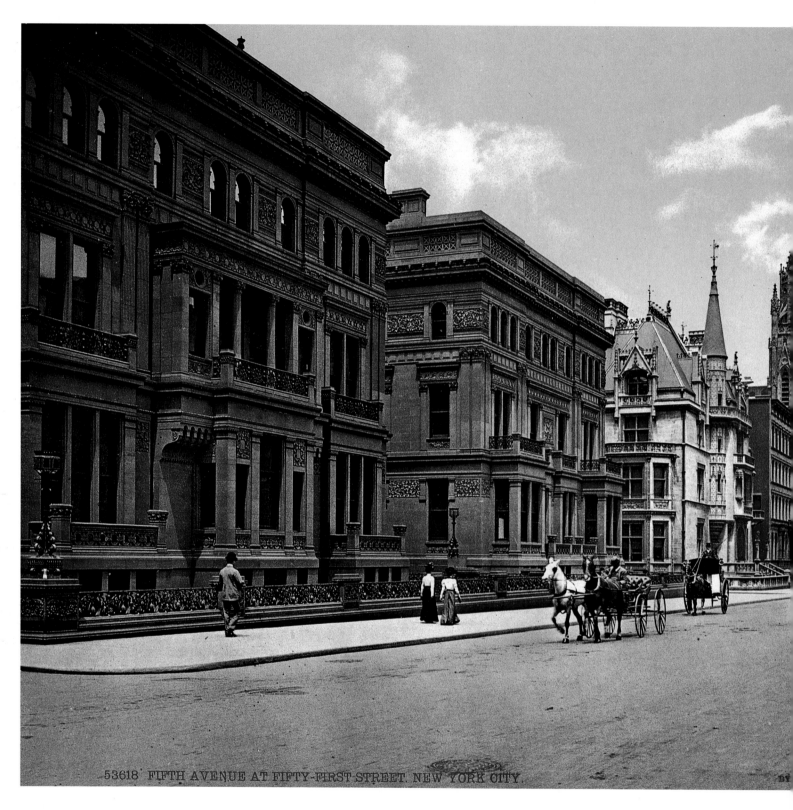

53618 FIFTH AVENUE AT FIFTY-FIRST STREET, NEW YORK CITY.

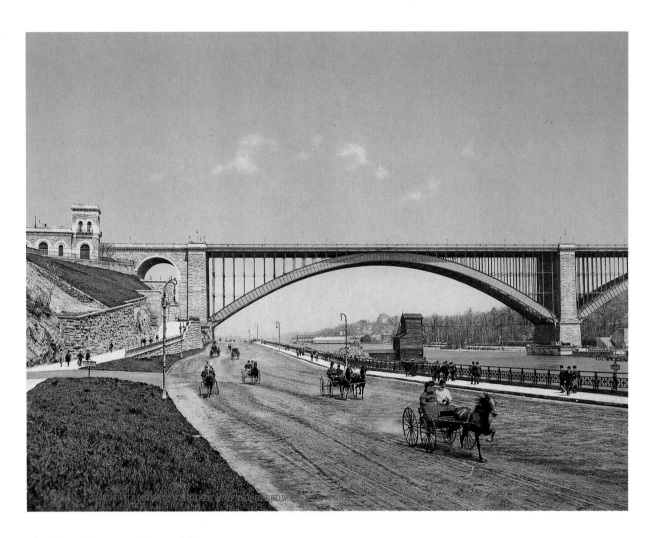

The old Washington Bridge and the riverside 'Speedway,' predecessor of today's automotive highway.

Elegant mansions line Fifth Avenue near the intersection of 51st Street in Manhattan.

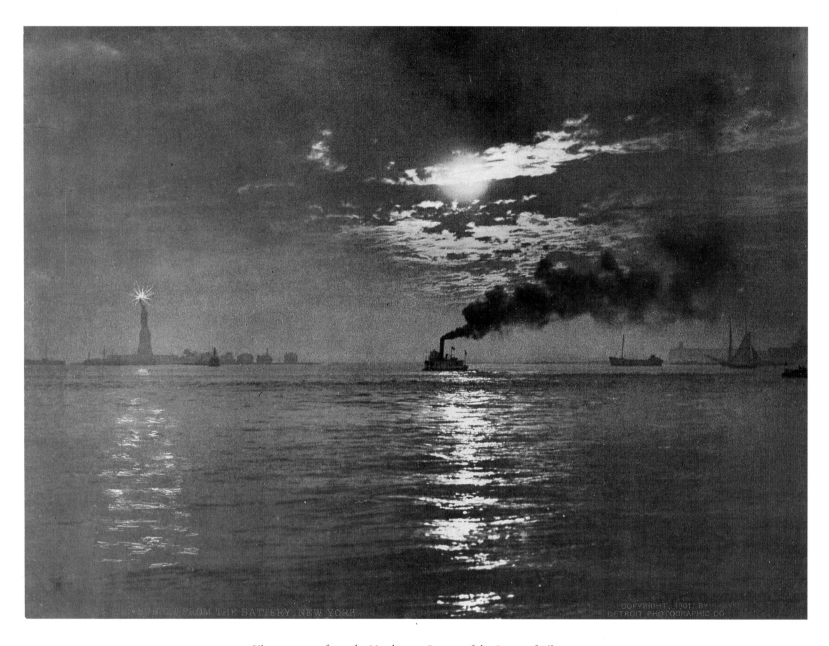

View at sunset from the Manhattan Battery of the Statue of Liberty,
opened to public view in 1886 on Bedloe's Island in New York Harbor.
The 151-foot statue was assembled in America from 225 tons of copper
fashioned in France. Miss Liberty's starburst flame is the result of creative
manipulation by the Detroit Publishing Company.

Brooklyn's Coney Island, with its seaside rides and arcades and its crowded sandy beach, was known far and wide as the granddaddy of American amusement parks, accessible to any and all New Yorkers no matter their income or social standing.

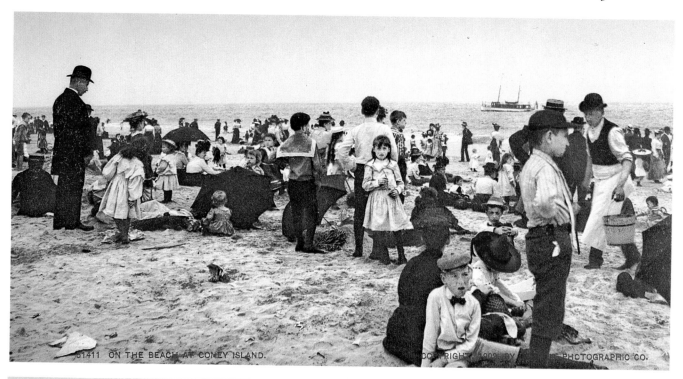

51411 ON THE BEACH AT CONEY ISLAND. COPYRIGHT, 1902, BY DETROIT PHOTOGRAPHIC CO.

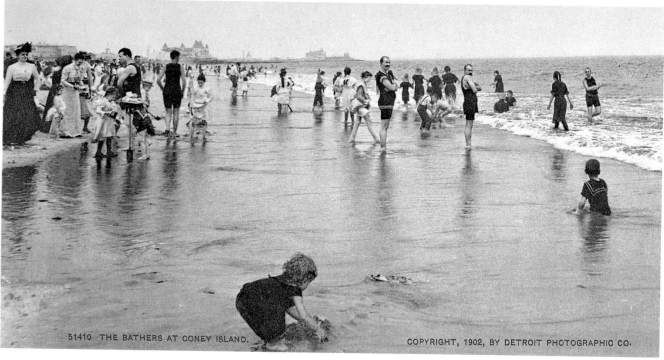

51410 THE BATHERS AT CONEY ISLAND. COPYRIGHT, 1902, BY DETROIT PHOTOGRAPHIC CO.

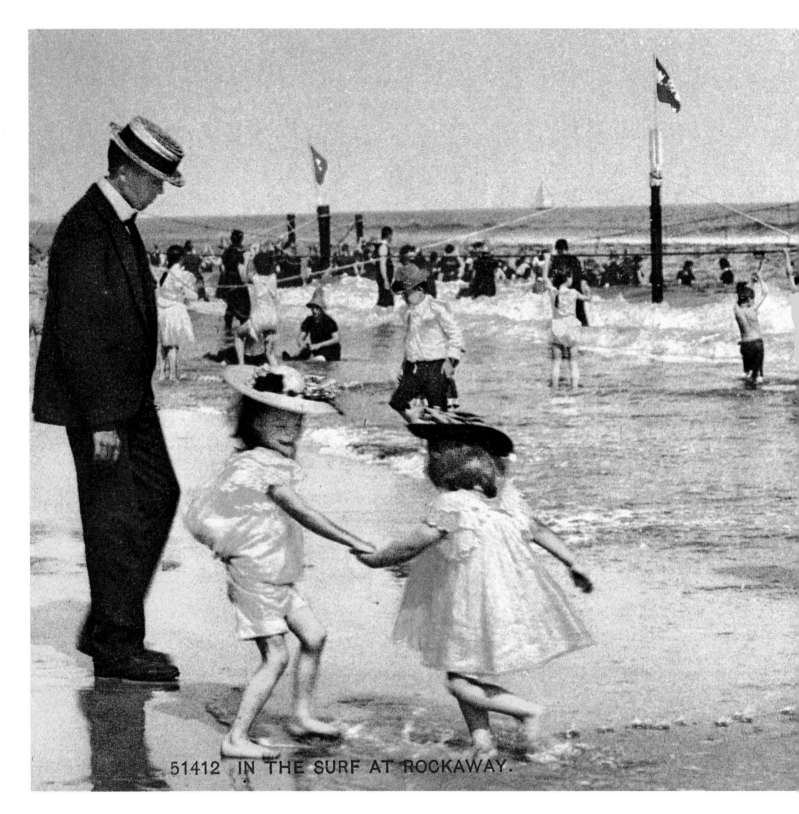

51412 IN THE SURF AT ROCKAWAY.

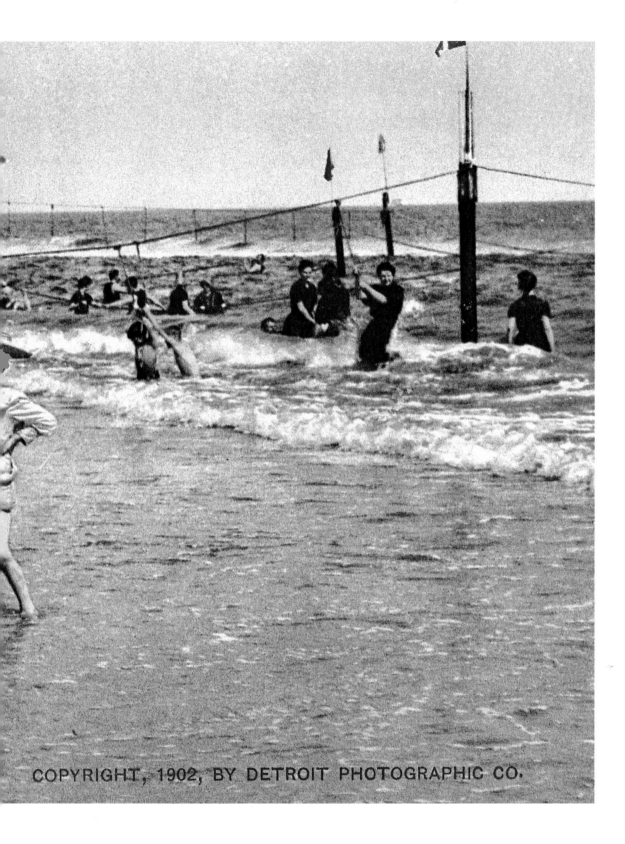

A young father supervises his ebullient charges as they dance in the surf at Rockaway Beach in Queens, another of New York City's summer playgrounds.

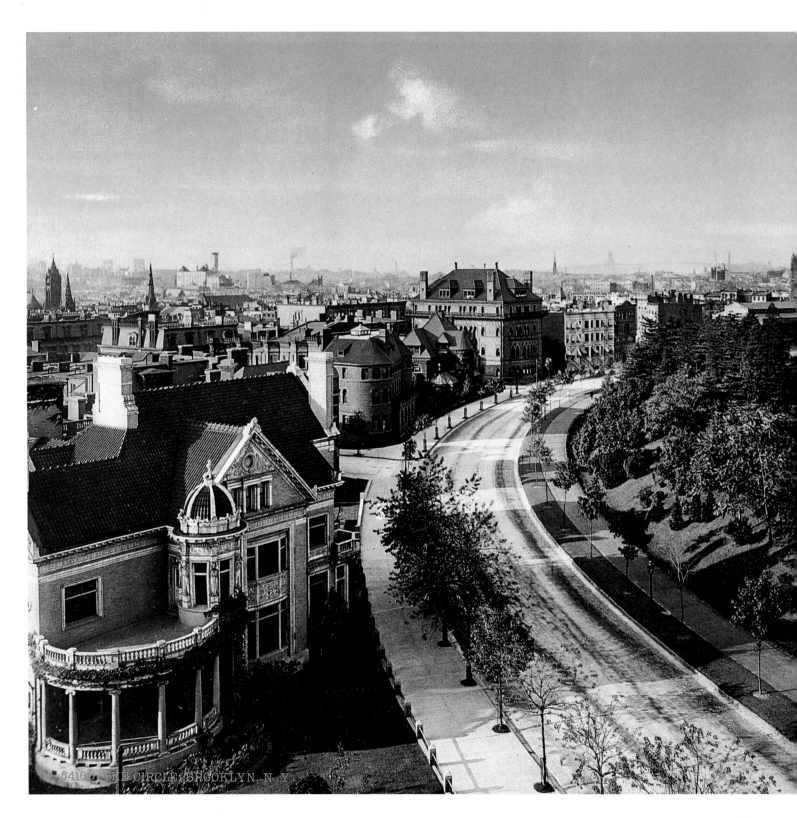

5410. THE CIRCLE, BROOKLYN, N. Y.

'The Circle' shows some of the ornate Victorian architecture popular in Brooklyn's residential areas at the end of the nineteenth century. In the far distance, the famous Brooklyn Bridge to Manhattan, completed to great fanfare in 1883.

RIGHT *Two young customers surrounded by aromas at a chestnut roasting stand in downtown Manhattan.*

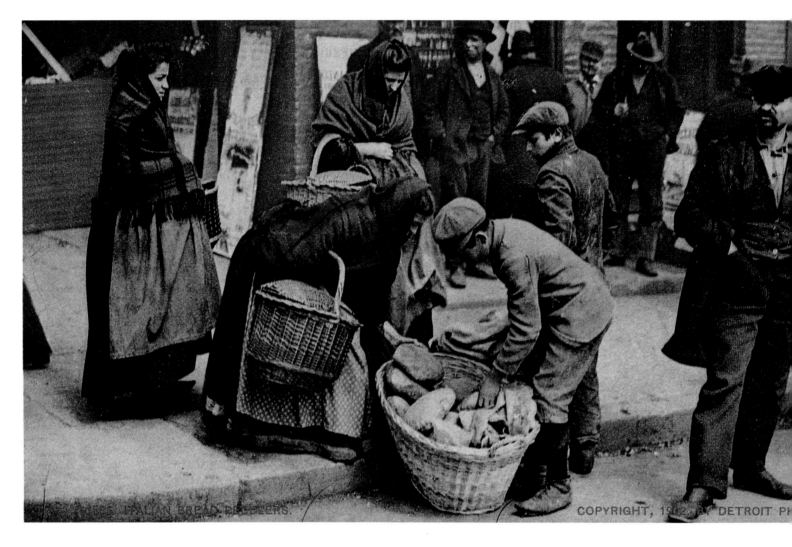

COPYRIGHT, 1902, BY DETROIT PH

ABOVE *Italian bread peddlers ply their trade on the busy streets of Manhattan in New York City.*

RIGHT *A sidewalk haberdasher displays his wares on Manhattan's Lower East Side, New York City.*

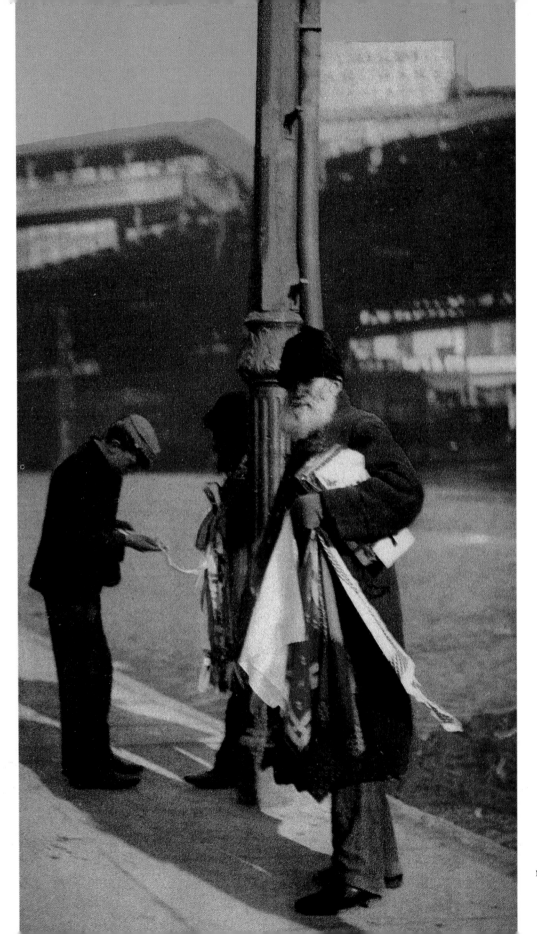

Capital Art in Washington, D.C.

FOR SEVERAL YEARS during his time as chief photographer for the U.S. Geological Survey, William Henry Jackson lived in Wasington, D.C. As a result, he was intimately familiar with the symbols of pomp and power that were woven into its architectural fabric. At the turn of the century, Jackson returned more than once to the nation's capital to make photographs; as his notes from the time attest, his purpose was to render faithfully for those who had never seen Washington the delicate colors of the world's most famous seat of democracy. Back in Detroit, those notes would be used to guide specially trained craftsmen in converting black-and-white originals into full-color.

The photographs themselves display a high degree of visual sophistication and a strong sense of history. Note, for example, the adroit spatial juxtaposition of the White House with a foreground statue of Andrew Jackson and a distant Washington Monument. It was Jackson, the country's seventh president (1829-37), who mandated that indoor plumbing be installed in the presidential residence, originally called 'The Palace' in architect James Hoban's original plans, but it was left to Theodore Roosevelt, the 26th president (1901-19), finally and officially to bestow the name 'White House' in 1902, even though the elegant Palladian exterior was first ordered painted white by James Madison, the fourth president (1809-17), to cover an exterior blackened by fire set by the British in 1814.

The Library of Congress, to which Jackson felt a special affinity, was moved in 1897 out of the Capitol and into its own new and appropriately ornate building, making it the world's largest library. Under its golden dome, the library of Congress is home to such treasures as a Gutenberg Bible, the first and second drafts of Abraham Lincoln's Gettysburg Address, Thomas Jefferson's rough draft of the Declaration of Independence, and untold numbers of books, manuscripts, musical transcriptions, movies, magazines, newspapers and other materials deposited with the Library over the years for copyright registration. Included in its collections today are many thousands of glass-plate negatives from the archive of William Henry Jackson, representing all of his work east of the Mississippi.

ABOVE *Endymion, the beautiful shepherd of Greek mythology who so moved Selene, the moon goddess, that she gave him perpetual sleep. Library of Congress ceiling arch painting by H. O. Walker.*

RIGHT *In 1897, not long before this photograph, the Library of Congress was moved from the Capitol building into its own ornate gold-domed edifice in Washington, D.C., the nation's capital.*

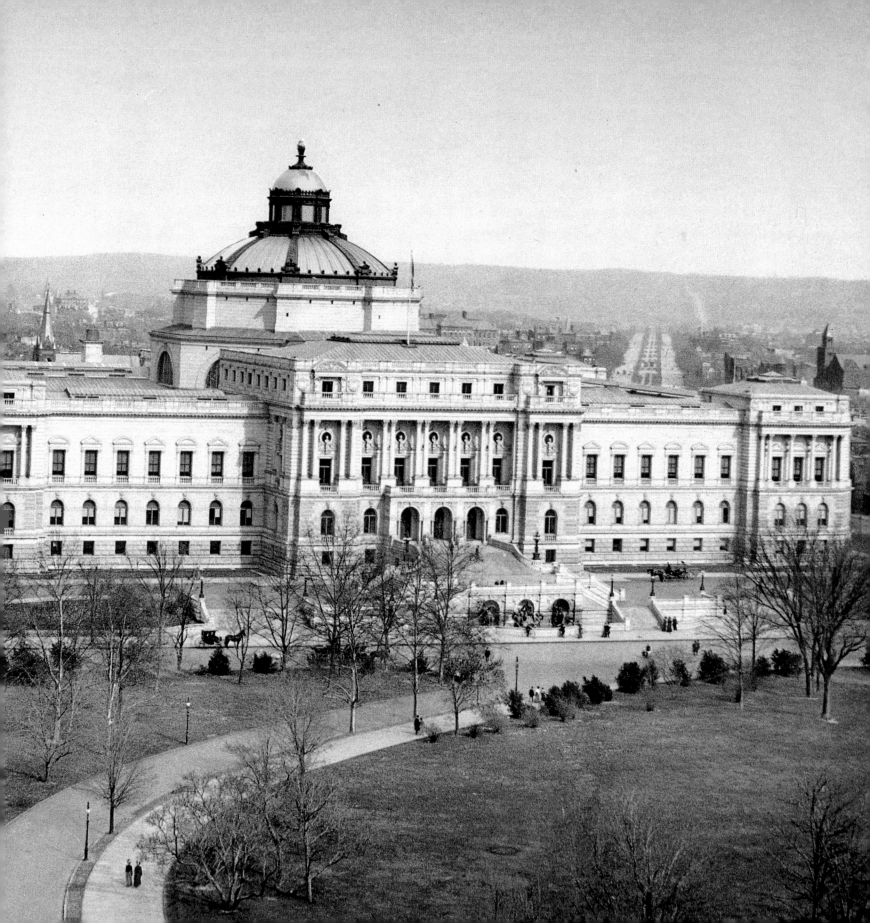

LEFT *The central reading room of the Library of Congress is located in the Rotunda under its soaring dome.*

The ornately cast and carved central stair hall of the Library of Congress brings to mind a palace of knowledge in the land of democracy.

LIBRARY OF CONGRESS. CENTRAL STAIR HALL

Melpomene, the Muse of tragedy in Greek mythology,
as painted beneath a ceiling vault in the Library of Congress.

Ganymede, the beautiful boy of Greek mythology who was carried off by an eagle at the bidding of Zeus, as painted by H. O. Walker in the Library of Congress.

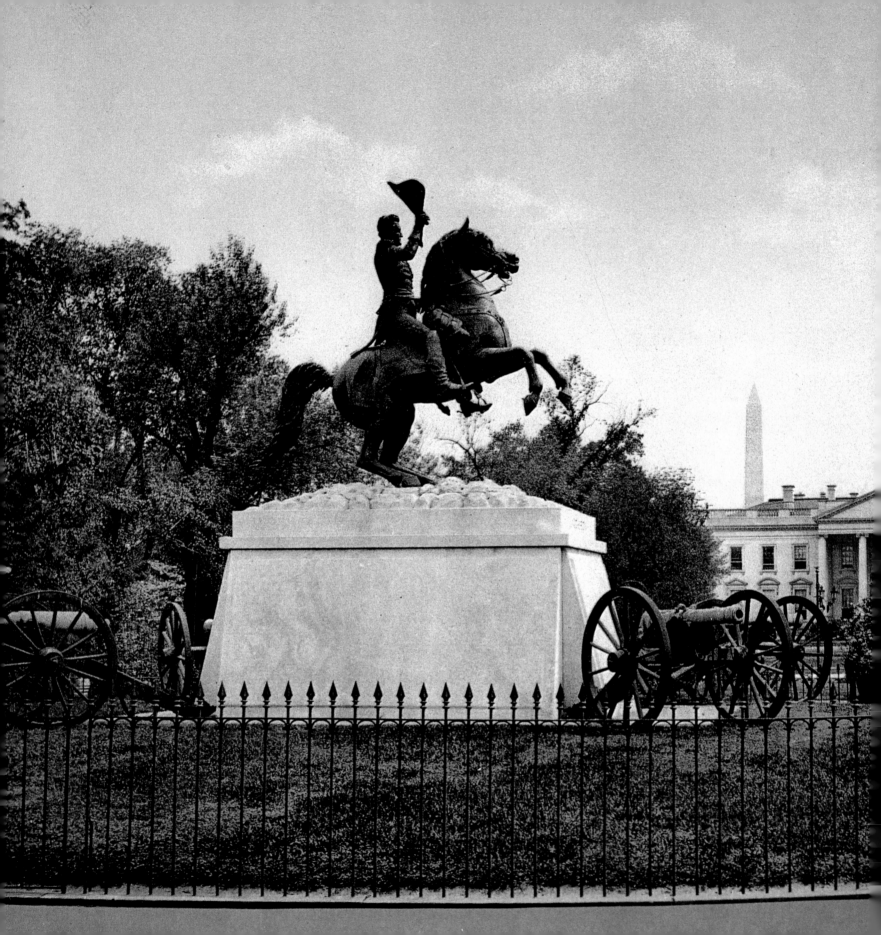

A statue of Andrew Jackson, the seventh president of the United States who was known as 'Old Hickory,' seems to tip its hat toward the White House from Lafayette Square. In the background can be seen the Washington Monument.

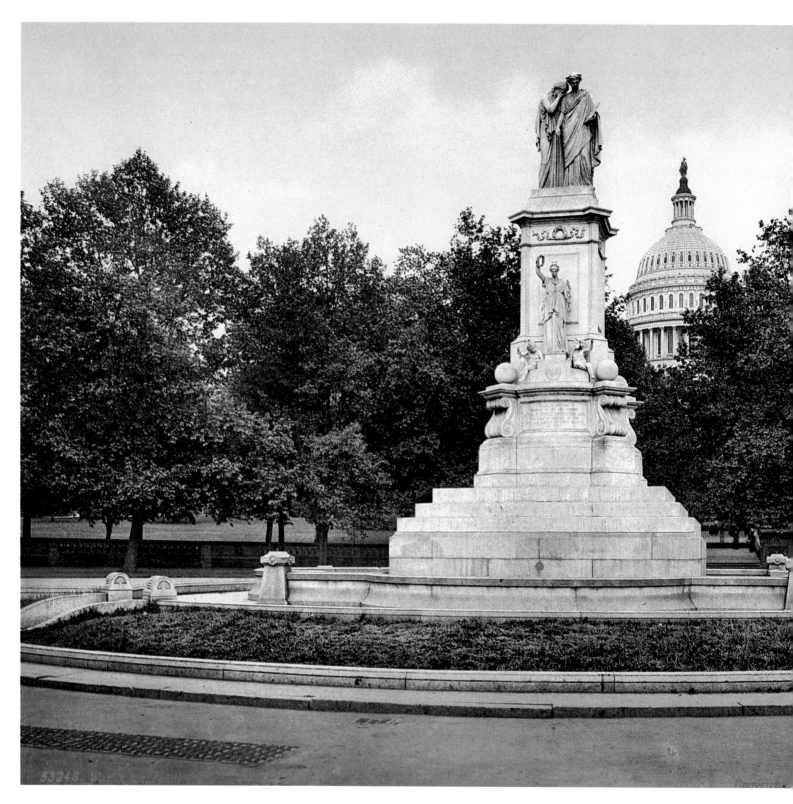

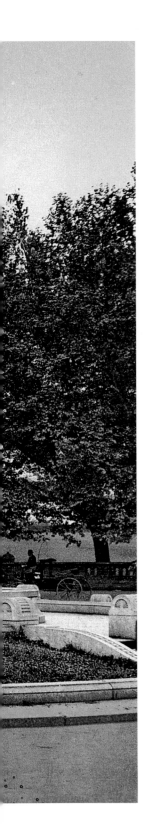

*This Washington, D.C. monument honors the Marquis de
Lafayette and the legendary Sword of Freedom. Lafayette, a
French soldier and statesman, was a friend of George
Washington and fought on many fronts for the cause of
independence in the American Revolution.*

LEFT *The Naval Monument photographed to show the
white-domed United States Capitol building on
Capitol Hill in the background.*

Great Lakes Cities

THE GREAT LAKES – Erie, Huron, Michigan, Superior and Ontario – gouged by glaciers and together forming the largest body of fresh water in the world, were in the nineteenth century the lifelines of America's upper midwestern states, linking them not only to each other, but to the East Coast and Europe via the Erie Canal and the St. Lawrence River. Chicago, the largest and most famous of the lakeshore cities, seemed, at the turn of the century, half frontier town and half modern metropolis. Until Mrs. O'Leary's cow kicked over her lantern and started the disastrous Chicago Fire of 1871, the city was mired in the bog upon which it was built: flimsy wood structures were no sooner erected than they began to sink into the mud of an uncontained Lake Michigan. After the fire, more modern architectural principles took hold: the water was held at bay, and a new Chicago of concrete and steel was supported by bedrock. The shining Chicago that could boast prominence in education, culture and industry was also home to bloody stockyards, filthy slums, open prostitution and enormous political corruption.

Farther north along the shores of Lake Michigan lies Milwaukee, Wisconsin, whose rapid growth in the second half of the nineteenth century was due primarily to German immigration, which by 1900 accounted for nearly three-quarters of the city's population and was responsible for making Milwaukee the beer brewing capital of America. Like Chicago, Milwaukee at the turn of the century was a major port for the grain and meat products of the Great Plains. Unlike Chicago, it managed to retain more of its original small-town flavor. Other lakeshore cities, such as Detroit, Michigan and Cleveland, Ohio, for example, had histories similarly dependent on the Lakes' proximity. Detroit, founded as a French fur trading post, became at the end of the 1800s a center of metal-working and carriage fabrication, easing its eventual transition to automobile manufacturing. In 1899, the Olds Motor Company began operation, to be followed shortly by Ford and Packard plants, and ultimately by others. Cleveland, on the other hand, was originally laid out like a Connecticut village, and was once known as the Forest City, so

ABOVE *The Appleton Paper Mills spew smoke into the Wisconsin air.*

RIGHT *The locks at Sault Ste. Marie, Michigan, were designed to move heavy Great Lakes shipping.*

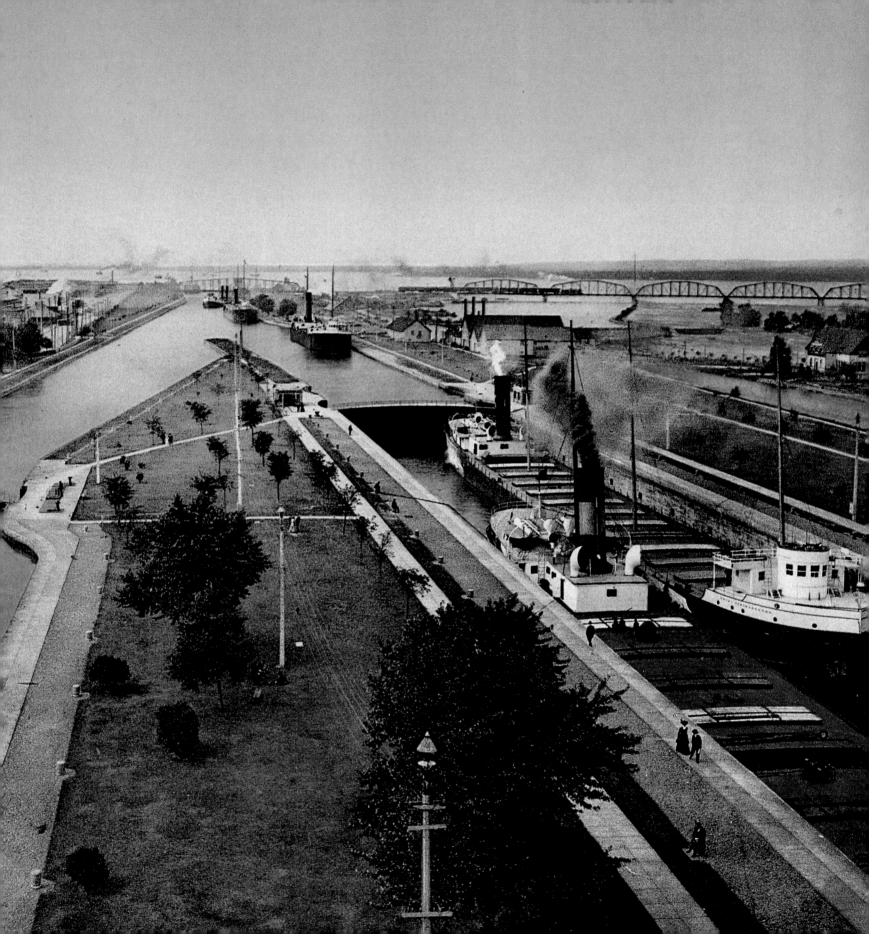

thick were its trees. When John D. Rockefeller located his Standard Oil headquarters there, following the establishment of his first refinery, Cleveland became a major industrial center and home to such progressive architecture as the vertical, enclosed shopping arcade, predecessor to today's ubiquitous mall.

Within a single generation, between 1870 and 1900, the population of the United States had doubled, from 38 million to 76 million, and a significant portion of this growth took place in newly emergent urban centers, particularly in the north central states. In 1870, only one fifth of the population lived in cities; by 1900, that proportion had grown to one third. For example, in the thirty years just prior to the turn of the century, Chicago's population increased 470%, Cleveland grew 310%, and Minneapolis, Minnesota, soared 1,460%!

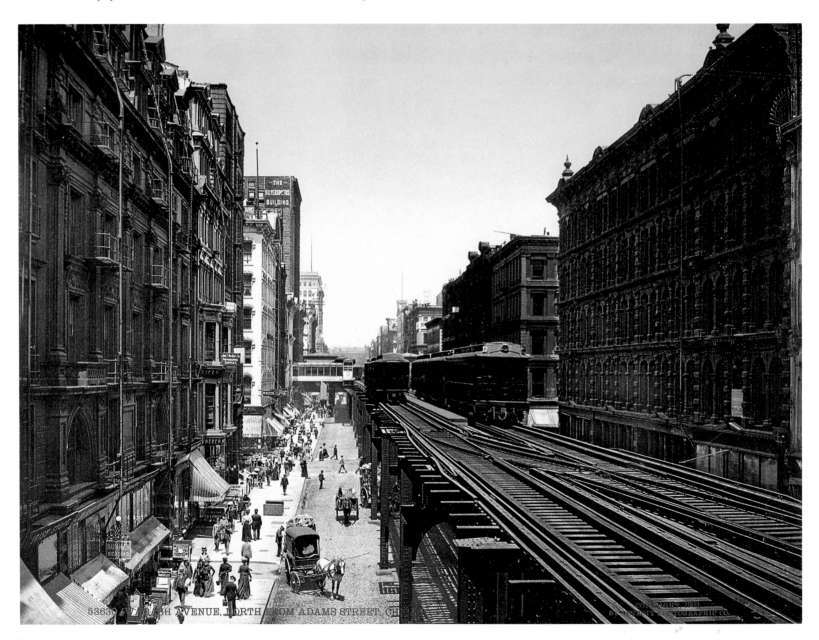

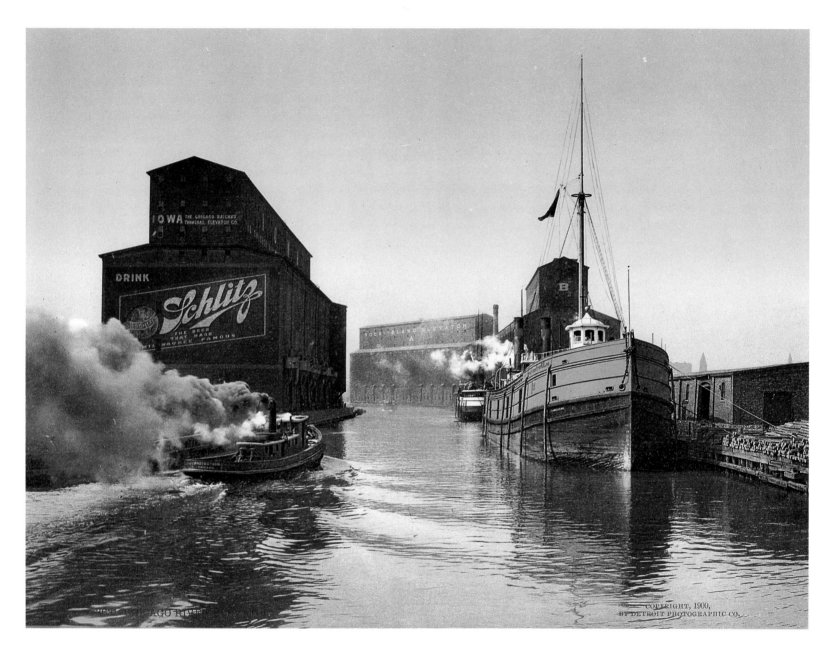

*Lake Michigan was a lifeline for business shipping. Here
the Chicago River terminals are shown hard at work,
which includes advertising the beer that made Milwaukee
famous.*

LEFT *Like New Yorkers, many Chicagoans used mass
transit, such as this elevated rail line on Wabash Avenue,
to get around their large and crowded metropolis.*

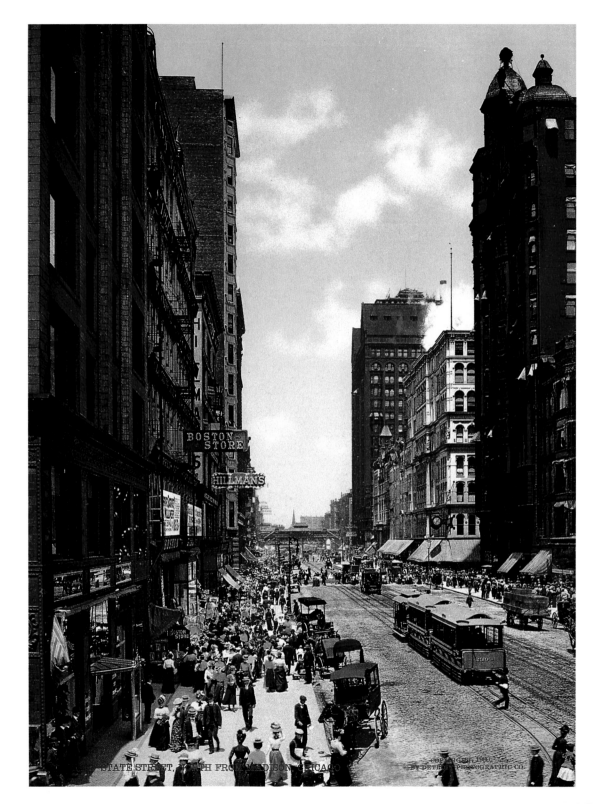

STATE STREET, NORTH FROM MADISON, CHICAGO

COPYRIGHT 1900,
BY DETROIT PHOTOGRAPHIC CO.

Chicago, Illinois has been long known as America's Second City. At the turn of the century, the sidewalks of State Street bustled with summer shoppers and the street with buggies and trolleys.

Milwaukee, Wisconsin, the large lakeport city that kept a quiet façade even as it entered the twentieth century. Here, the camera looks down Wisconsin Street.

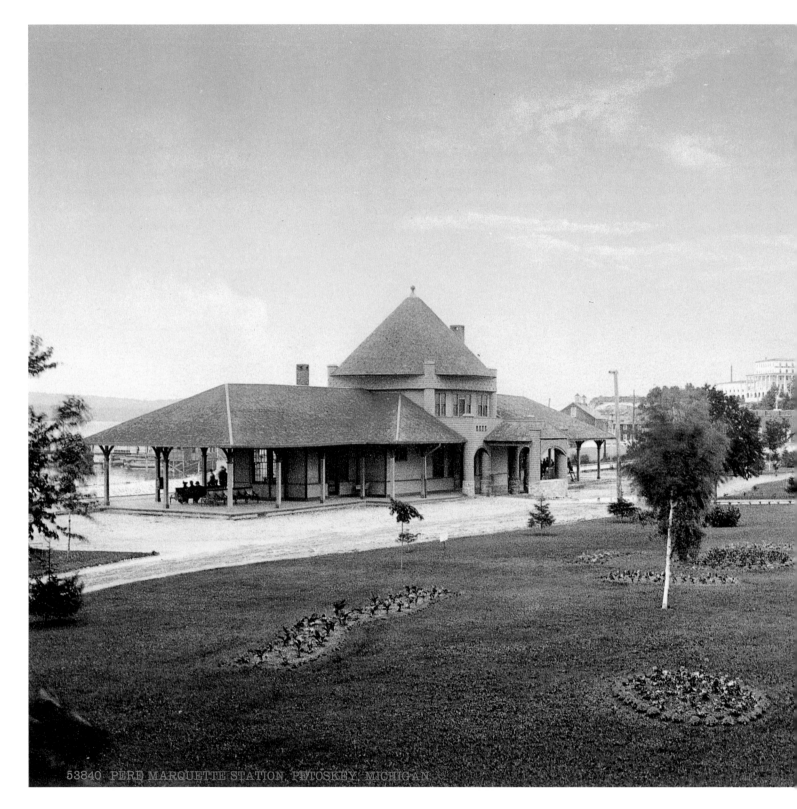

53840 PERE MARQUETTE STATION, PETOSKEY, MICHIGAN

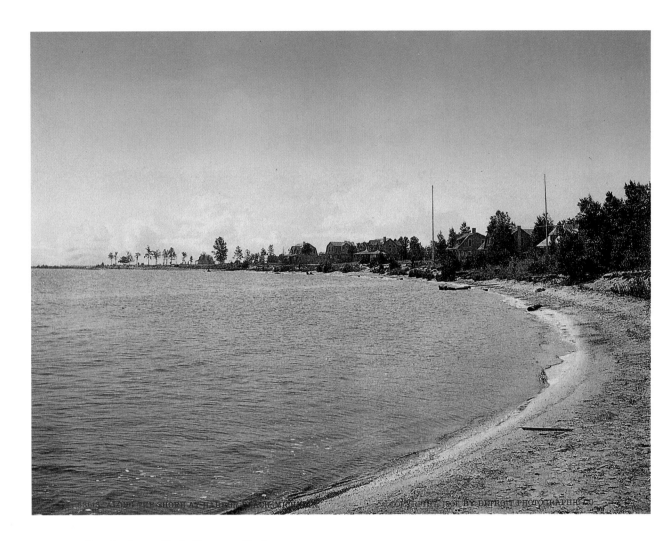

Cottages line the shore of Lake Huron at Harbor Beach, Michigan.

LEFT *People await the arrival of a train at the Pere Marquette Station, Petoskey, Michigan, on Little Traverse Bay, Lake Michigan.*

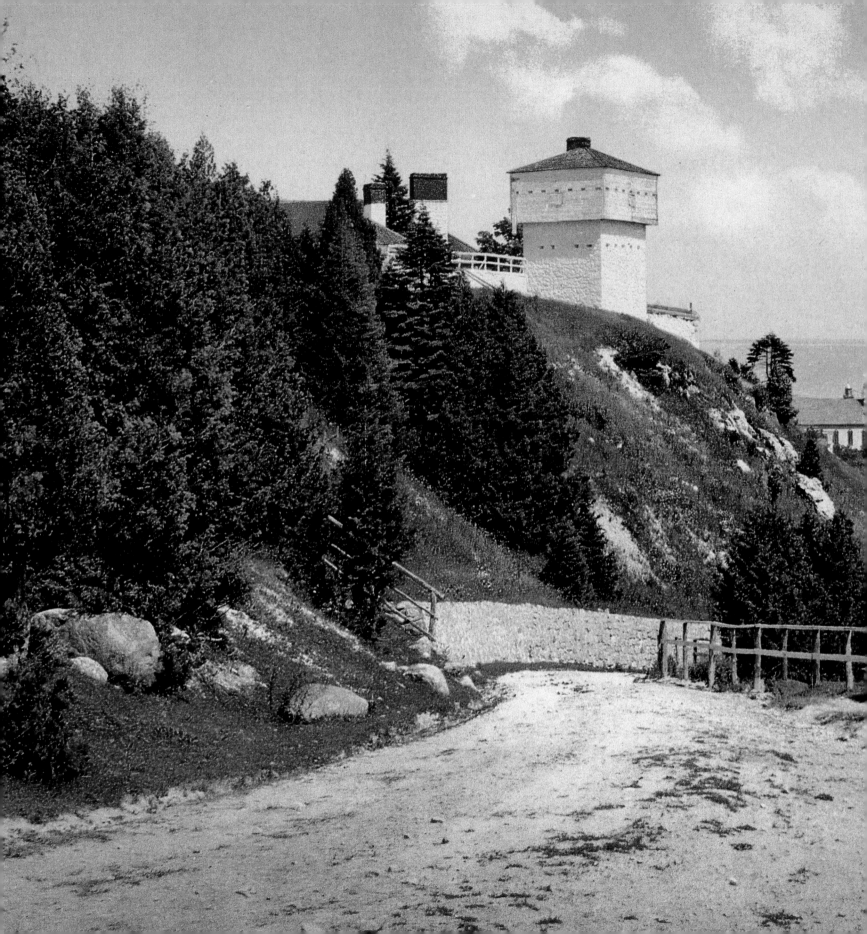

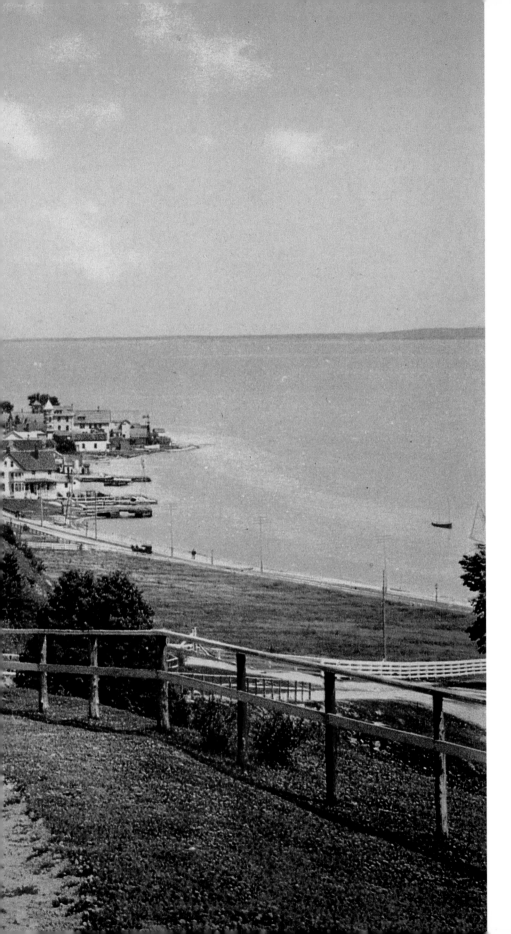

Overlooking Lake Huron, the Old Block House and Harbor on Mackinac Island, Michigan.

ABOVE *Three girls peer across the water toward the Field Columbian Museum in Jackson Park, Chicago, Illinois, site of the 1893 World's Fair.*

RIGHT *The sculptural walkways at Juneau Park on Lake Michigan speak of the civilized approach to life in Milwaukee, Wisconsin.*

LEFT *Protected by jetties, the beach and docks of Petoskey Harbor, Michigan, at Little Traverse Bay on Lake Michigan.*

An idyllic outing on the Grand Canal at Belle Isle, Detroit, Michigan.

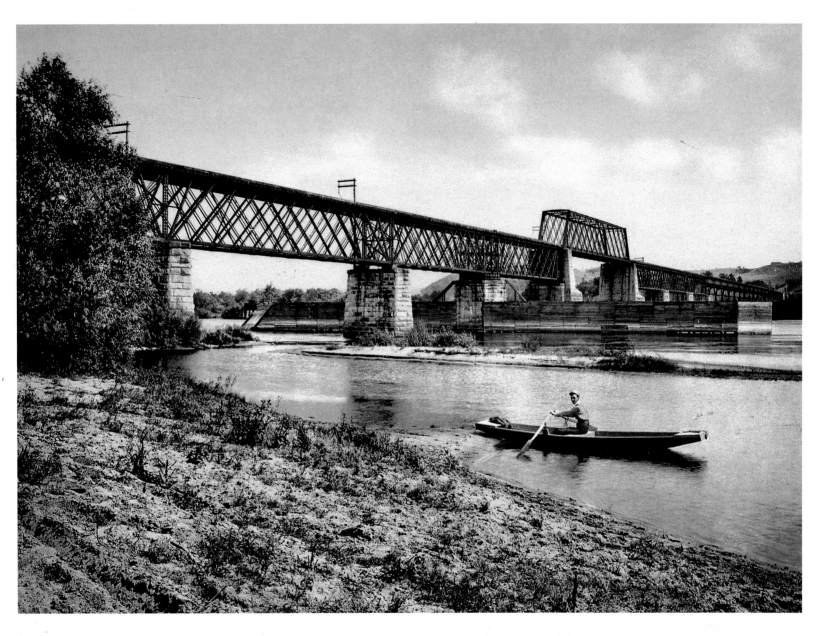

*A skuller beaches his craft on the Wisconsin River beneath
a railroad overpass near Merrimac, Wisconsin.*

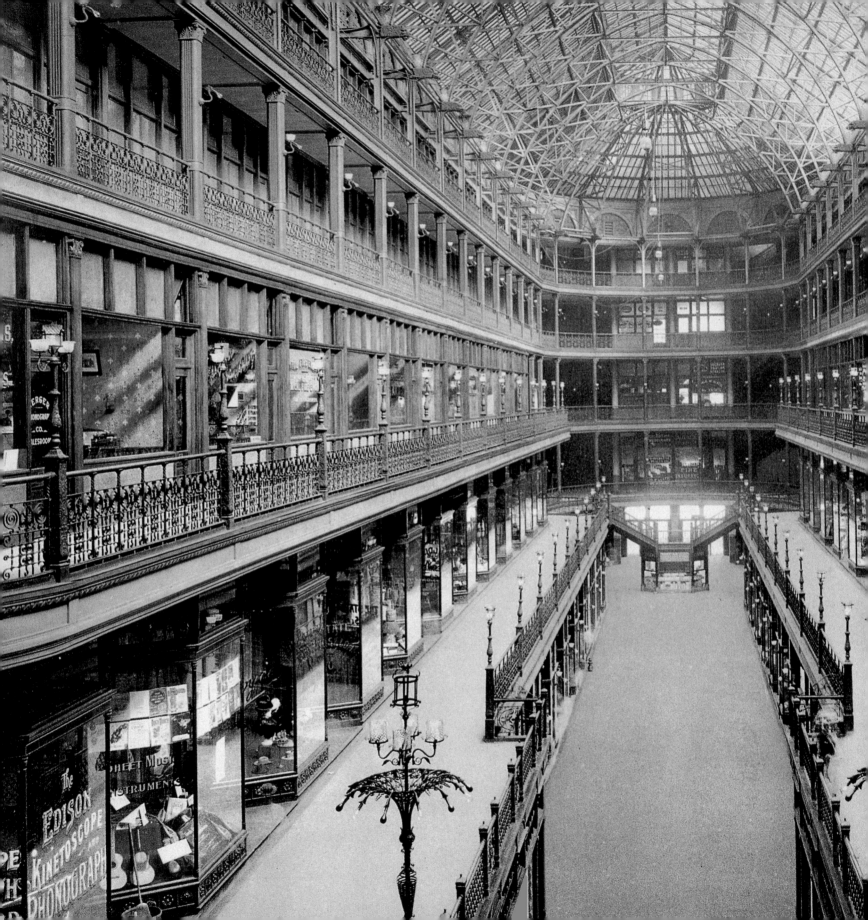

A multi-tiered, glass-roofed shopping arcade in Cleveland, Ohio.

The Old South Seen Anew

MUCH OF William Henry Jackson's late nine-teenth-century photographic work was done on commission for eastern railroads and resorts. In the decades following the Civil War, a network of new rail lines had been built throughout the South in hopes of capitalizing on the economic reconstruction that was still taking place as late as the 1890s. Attracted by cheap labor in the wake of the collapse of the plantation economy, plus an already well developed system of deepwater shipping ports, northeastern indus-trial interests saw clear financial advantages to investing in the New South.

But at the heart of this so-called New South, the elegance, charm and civility of the Old South remained. Tourism flourished, aided in no small measure by the region's incom-parable natural beauty, as depicted in the Photo-chrom views offered by the Detroit Publishing Company. Aesthetic skills honed in the great open spaces of the American West were put to good use by Jackson in the mossy confines of Florida's inland swamp country, for example, a primeval paradise of sorts to which he seems to have been inexorably drawn once he com-pleted his original assignment to photograph for the Ponce de Leon Hotel in St. Augustine.

From the ancient tangle of a rubber tree in tropical Key West to the blatant commercialism of the old port city of New Orleans; from a white-hot cotton gin in Mississippi to the flag of all the American states flying over Charleston, South Carolina – where the shot that started the Civil War was fired – the South shows itself to be a place steeped in endlessly fascinating contradictions as well as tradition and history. In that respect, this portfolio of photographs serves as a fitting final chapter for a photographic portrait of America at the dawning of the twentieth century.

ABOVE *A cannon turned up to the sky at Vicksburg, Mississippi marks the surrender on July 4, 1863, of 30,000 Confederate soldiers to a superior force under Union Gen. Ulysses S. Grant, thereby marking the beginning of the end of the bloody conflagration known as the War Between the States.*

RIGHT *Named after the Spanish explorer who discovered Florida in 1513 while searching for the fabled 'fountain of youth,' the Ponce de Leon Hotel was a landmark in the old city of St. Augustine, Florida's first permanent European settlement.*

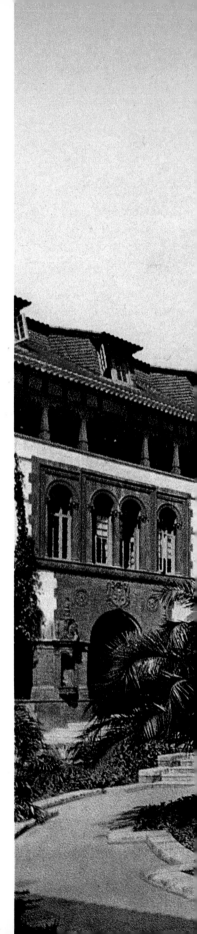

The multiple trunks of an ancient rubber tree near the U.S. Navy barracks in Key West, Florida.

In a long view taken from Lookout Point, the camera follows the tree-lined Tennessee River as it curls past the city of Chattanooga, Tennessee.

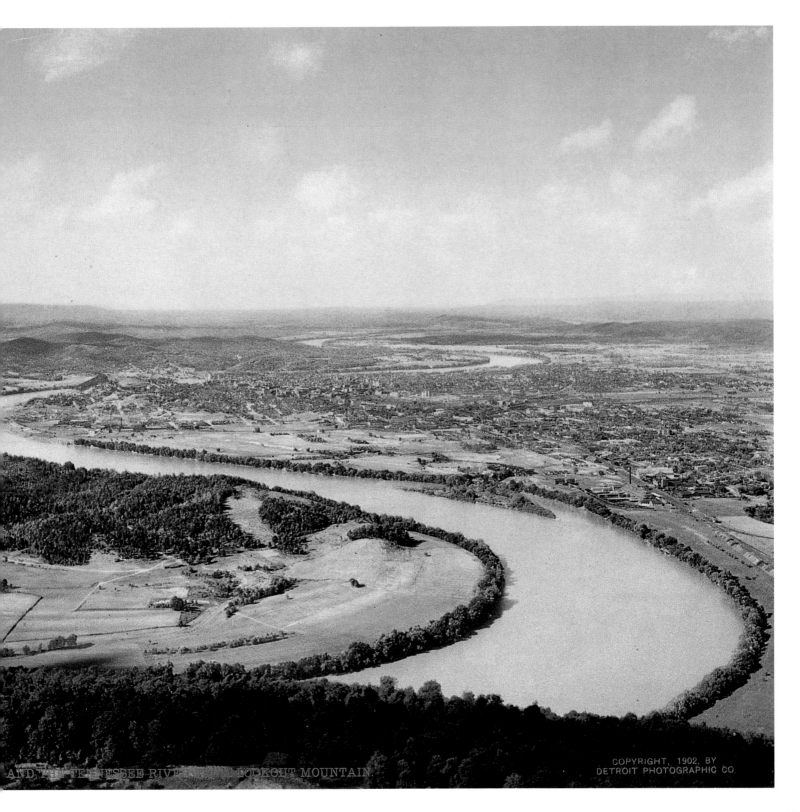

AND THE TENNESSEE RIVER. LOOKOUT MOUNTAIN.

A small steam-driven launch navigates the alligator-filled Rice Creek in Florida.

Misenor's Landing on the Tomoka River, inland Florida.

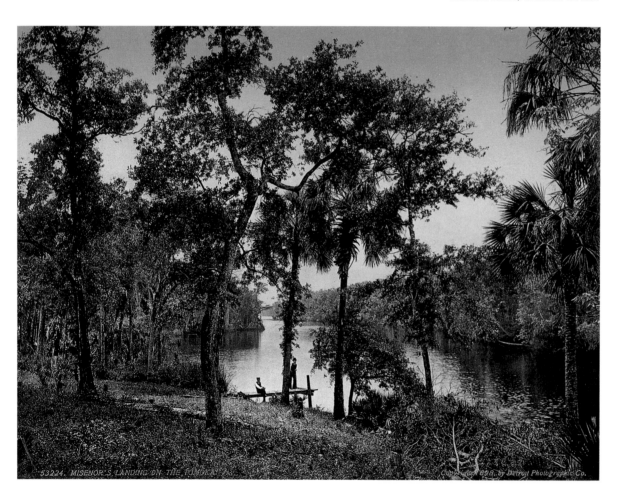

53224. MISENOR'S LANDING ON THE TOMOKA, FLA.

Copyright 1898, by Detroit Photographic Co.

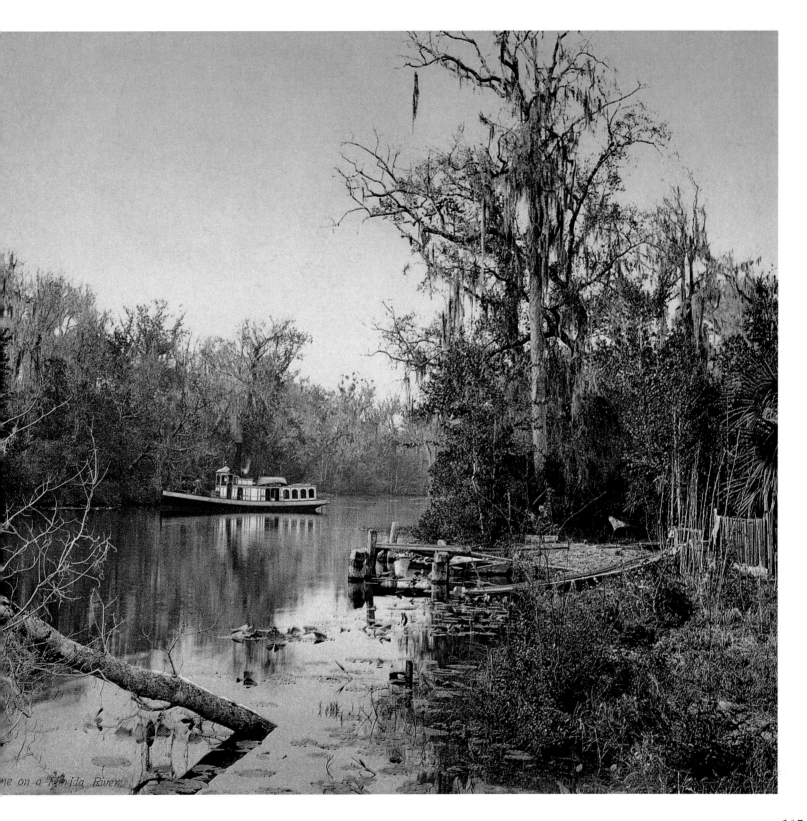

...ne on a Florida River.

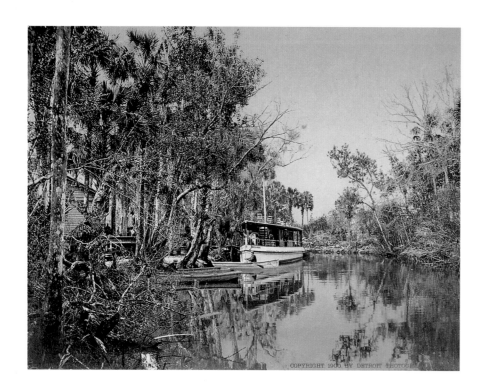

A sightseeing boat awaits passengers at Tomoka Landing, on the Tomoka River, Florida.

Hard at work in a blizzard of cotton in a typical cotton gin at Dahomey, Mississippi.

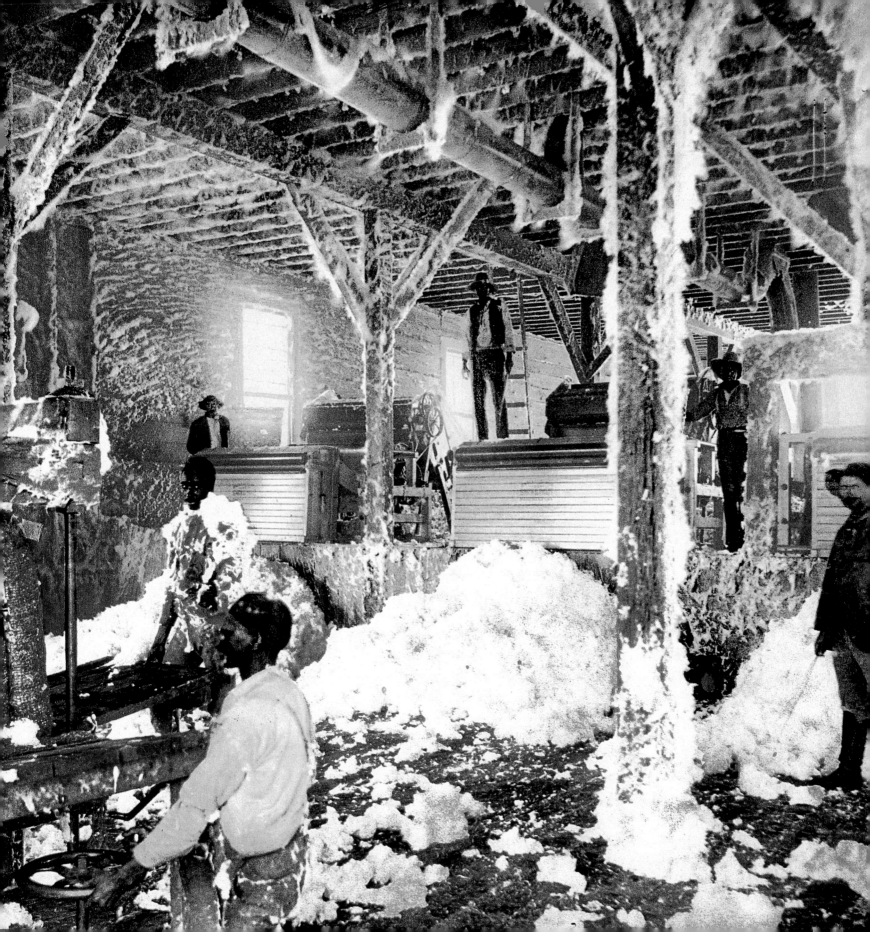

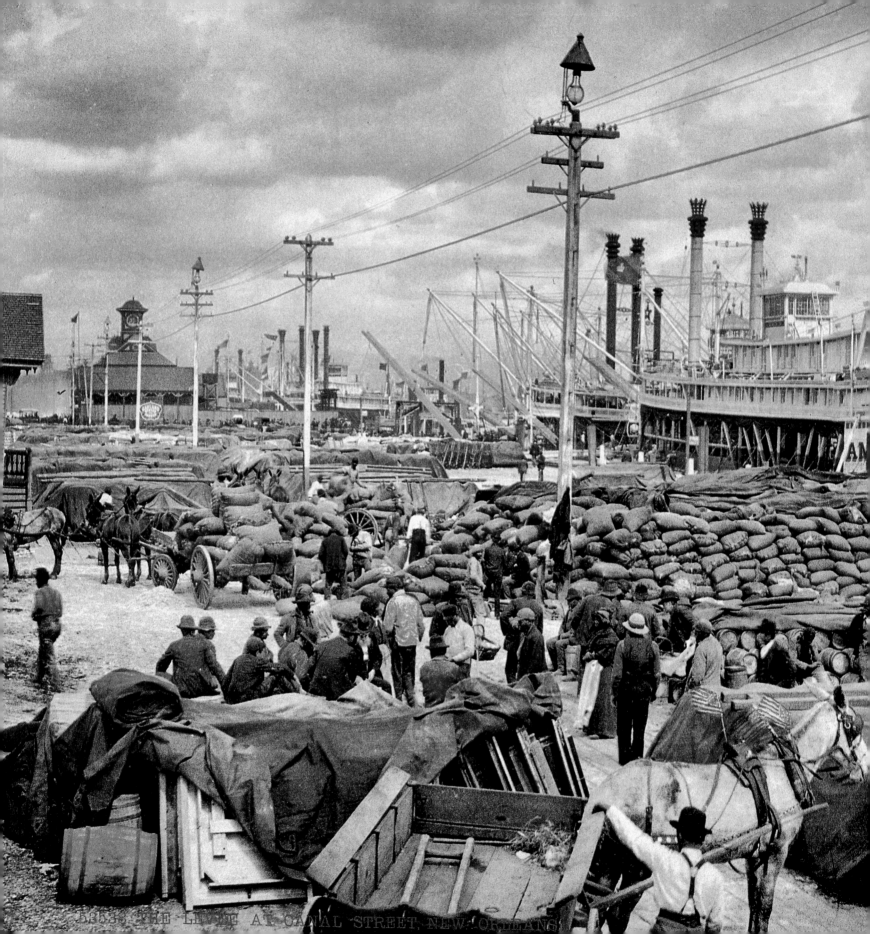

THE LEVEE AT CANAL STREET, NEW ORLEANS

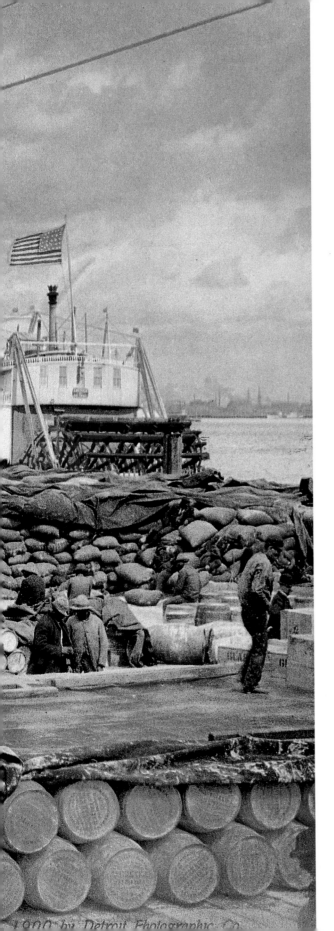

The fishing fleet unloads the morning catch of oysters at the Levee, New Orleans, Louisiana.

LEFT *A commercial dock loaded with produce at the Canal Street Levee, Mississippi River, New Orleans, Louisiana.*

ON THE SAVANNAH RIVER.

Tall-masted commercial sailing ships and power-driven tugboats ply the Savannah River at the old port of Savannah, Georgia.

An earthen levee holds back the mighty Mississippi River at Chalmette in New Orleans, Louisiana.

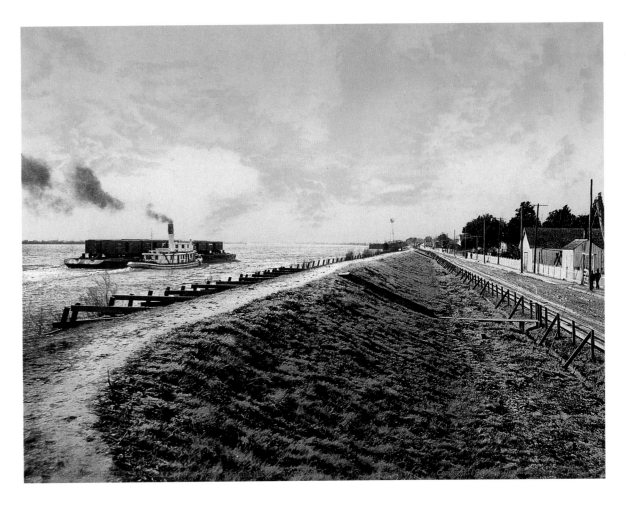

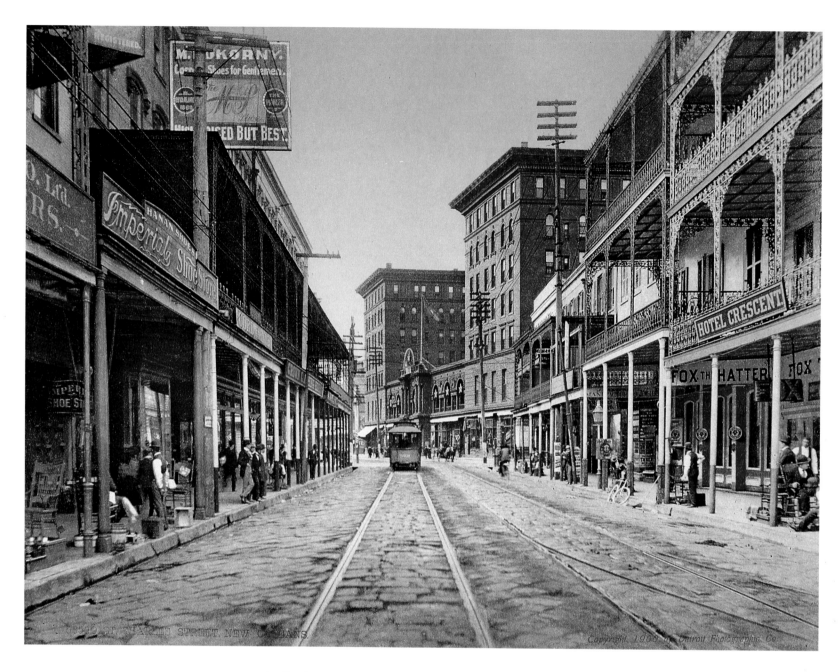

*St. Charles Street, with its wrought iron balconies, cobbled streets
and busy storefronts offers a typical picture of the city of
New Orleans, Louisiana at the turn of the century.*

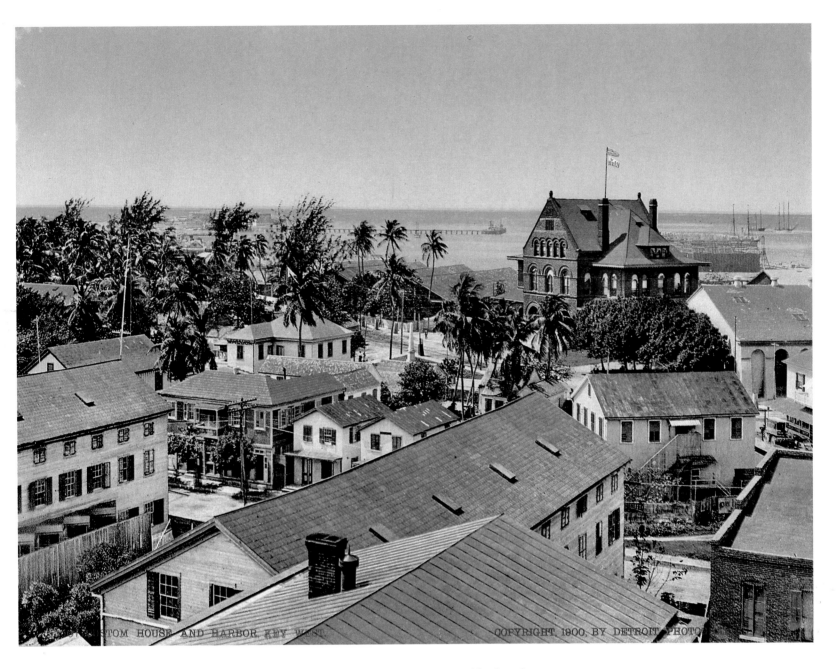

CUSTOM HOUSE AND HARBOR, KEY WEST. COPYRIGHT 1900, BY DETROIT PHOTO

An overhead view of the Custom House and harbor of Key West,
Florida's second oldest settlement and the southernmost of the Florida Keys.

54062 OLD FRENCH COURT, NEW ORLEANS, LA.

Canal Street, one of the more wide-open thoroughfares, complete with trolleys, in the old city of New Orleans, Louisiana.

LEFT *A courtyard in the old French Quarter in New Orleans, Louisiana.*

This view down Bull Street shows one of the garden squares around which the old part of the eminently civilized city of Savannah, Georgia was built.

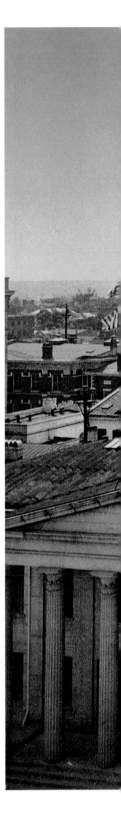

Vacationers from the north enjoy the lush sub-tropical gardens of the Royal Ponciana Hotel in Lake Worth, Florida.

1898, by Detroit Photographic Co.

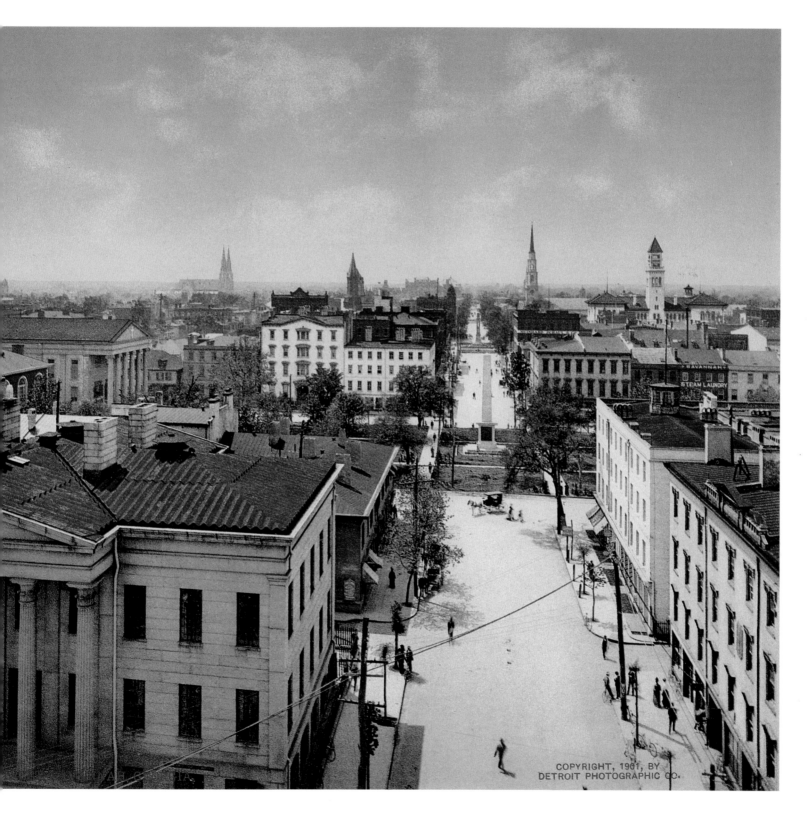

COPYRIGHT, 1901, BY
DETROIT PHOTOGRAPHIC CO.

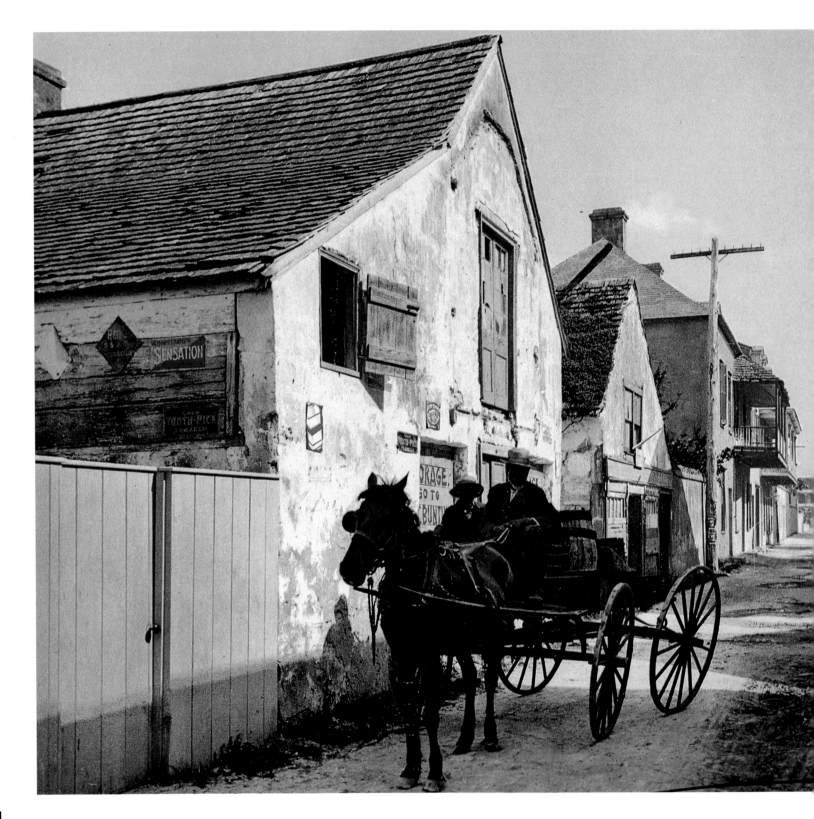

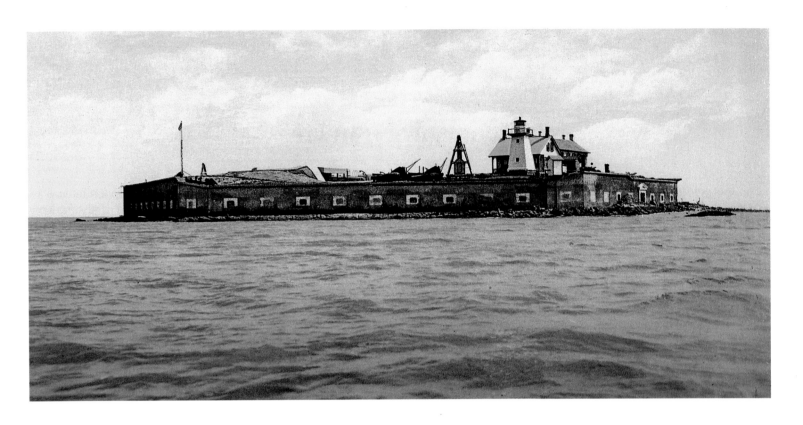

A view of Fort Sumter, off Charleston, South Carolina, where in 1861 the first shots were fired by the Confederacy in the War Between the States.

LEFT A horsedrawn carriage and its passengers wobble slowly along Charlotte Street in St. Augustine, Florida's oldest settlement.

RIGHT 'Old Glory' flies above Fort Moultrie in Charleston, South Carolina, at the dawn of the twentieth century.

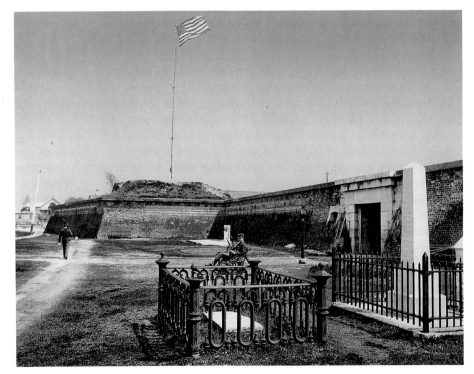